BOSTON

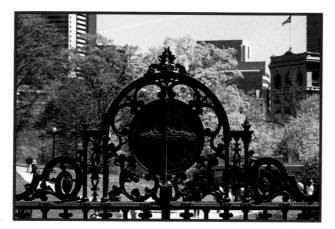

To Jacqueline,
I hope I can take you
some day. It's a wonderful
city and I miss you when I'm
here alone.

Cam
xoxo

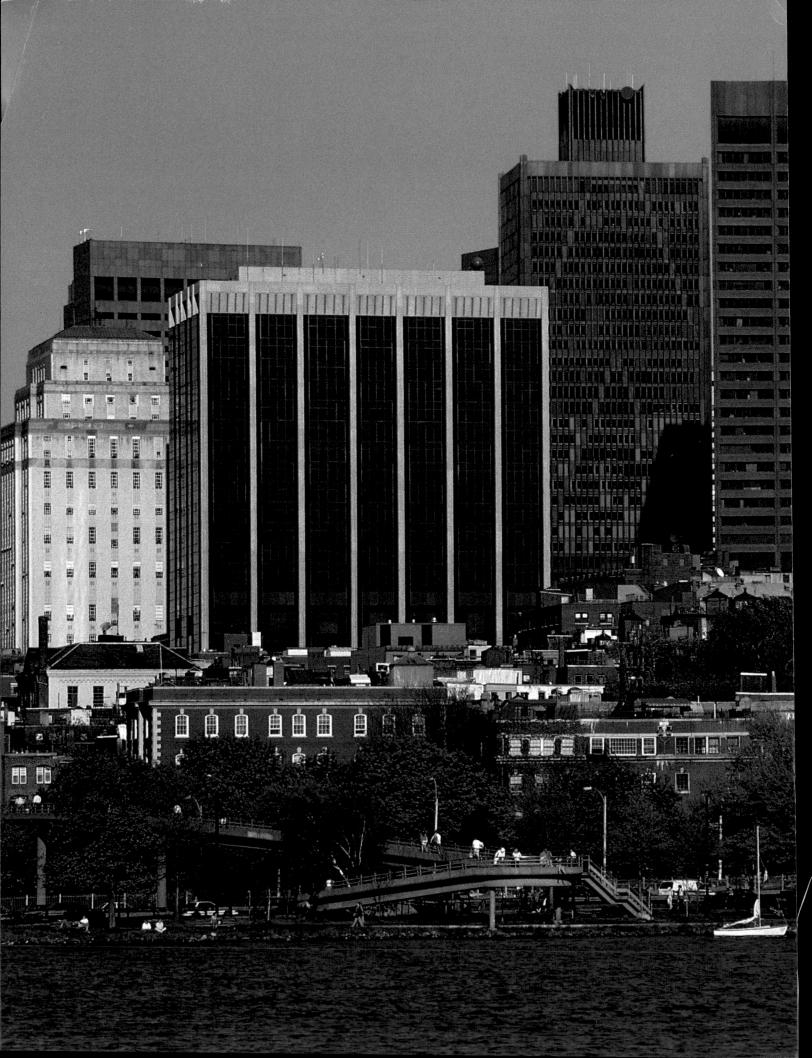

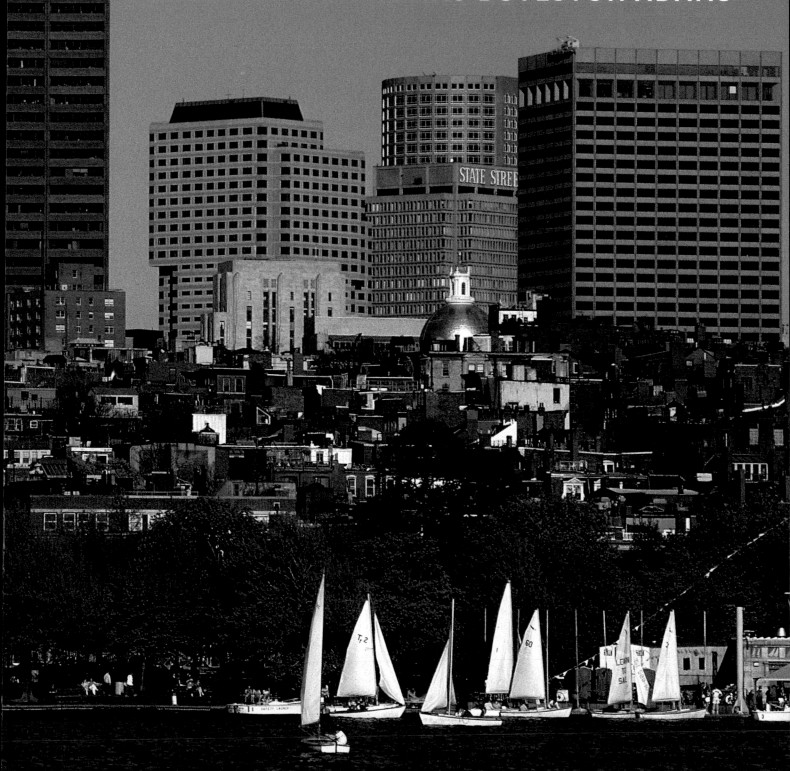

BOSTON

PHOTOGRAPHS BY SANTI VISALLI
FOREWORD BY THOMAS BOYLSTON ADAMS

UNIVERSE

Page 1: Boston Public Garden
Pages 2–3. Boston skyline viewed across the Charles River from Cambridge
Page 5: Spectators at the Boston Marathon

Published in the United States of America in 1995 by
Universe Publishing
A Division of Rizzoli International Publications, Inc.
300 Park Avenue South
New York, NY 10010

Clothbound edition first published in the United States of America in 1988 by
Rizzoli International Publications, Inc.

95 96 97 98 99 / 10 9 8 7 6 5 4 3 2 1

Library of Congress catalog card number: 95-060814

Design by Gilda Hannah

Printed in Korea

To my Mother

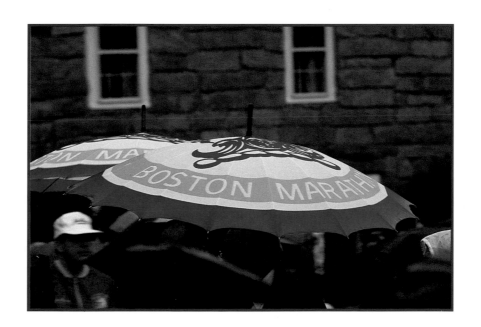

FOREWORD

THOMAS BOYLSTON ADAMS

S pace and architecture express the soul of a city. The busy ant, except for foraging and fighting, spends its life in the dark; all the evidence of its existence is a mound of dirt. Only by an effort of will can humanity avoid the same catastrophe.

Boston began as a vision in the mind of John Winthrop, leader of a company of English Puritans intent on establishing a better society in a new world. As his ship, the *Arbella,* bobbed its way across the Atlantic in the spring of 1630, he addressed his shipmates, turning a text from the Sermon on the Mount to the special purpose of their voyage: "We must consider that we shall be as a City upon a Hill, the eyes of all people are upon us."

Beacon Hill, rising high on the island that the Indians called Massachusetts, was the solid answer to the vision. The sole inhabitant was an Englishman named Blaxton who had lived there for six years, at peace with the mainland Indians, building a house, planting an orchard, and enjoying his own company. According to legend, he sold out for a small sum and rode away on the back of a bull, followed by three cows.

Forty-five acres of open land were set aside for the common good. The rest was turned over to the enterprise of the people. They settled wherever they could, along the many coves of the shore, wherever they might scratch a living from the earth or throw out a wharf to catch a living from the sea, with fishing or with trading. Boston became a great town, the greatest in America. Waterfront property became valuable. As more land was needed, the hills were shoveled into the shallow places until the island became part of the mainland. But through all the changes of time and topography, the inhabitants have continued to respect the original effort of will that created the open space. The Boston Common was held sacred. It still is.

The same process was repeated across the Charles River. So that their kind of civilization might continue, the first settlers determined they must have a college. Many of them being graduates of Cambridge in England, they called the place Cambridge, set aside land for a common and, adjoining it, land for a yard for the buildings that would be needed for education.

The year was 1636 and thus they stated their purpose: "After God had carried us safe to New England and we had builded our houses, provided necessaries for our livelihood, reared convenient places for God's worship, and settled the Civil Government, one of the next things we longed for and looked after

was to advance learning and perpetuate it to posterity. Thus the Lord was pleased to direct the hearts of the magistrates to think of erecting a School or College and that speedily to be a nursery of knowledge in these deserts and supply for posterity."

Ideas are more durable than houses made with hands, whether of wood, stone, or steel. Nothing tangible remains of Winthrop's Boston except a wall of the Paul Revere House in North Square. All that is left—and that all is a very great deal—is the open space of two commons, a few burying grounds, the severe style of a New England meetinghouse as shown by the Old South on Washington Street, and the patterns of old streets that keep traffic slow and make a paradise for pedestrians—and *education!*

Boston remains a city elevated in space because of the stubborn foundation of its principal feature, Beacon Hill. Beacon Hill defies even the motorcar. Its steeps and its corners baffle the most arrogant yuppie in a red two-seater. On a winter day of ice and snow the only safe person is a pedestrian equipped with crampons. Although the hill's top was dumped long since into the surrounding waters to make more land, a new top was provided by the genius of Charles Bulfinch, who in 1798 created Massachusetts' new State House and crowned it with a golden dome. That dome is still a beacon for all to see from its best vantage point, the Boston Common, or from the Cambridge shore of the Charles River, or from Storrow Drive that enters the city from the northwest.

Under the golden dome of the State House work the elected representatives of the people of Massachusetts. The governor's office is decorated in the high style of the period of late Federalism as interpreted by Bulfinch, and the Senate chamber is his rendering in architecture of the dignity and the obligation of the legislator to create and uphold the law. The state library is near at hand, a reminder of the duty of public servants as expressed in the Constitution of 1779, written by John Adams and still in force: "Wisdom and knowledge, as well as virtue, diffused generally among the body of the people, being necessary for the preservation of their rights and liberties it shall be the duty of Legislatures and Magistrates, in all future periods of this Commonwealth, to cherish the interests of literature and the sciences and all seminaries of them: especially the university at Cambridge, public schools, and grammar schools in the towns; to encourage the arts, to inculcate the principles of general benevolence, public and private charity, sincerity, good humour, and all social affections and generous sentiments among the people."

The progress of the soul of Boston through the centuries can be traced in space and architecture in well-defined epochs. The first is Puritan, of which only the spirit of the architecture is left within the city. Church steeples still greet the eye at street corners and open spaces. The Park Street Church spire dominates its corner of the Common with authority as firm as if Christopher Wren himself had come to Boston to build it in a personal rivalry with Bulfinch's State House.

Puritan Boston was the heart of a theocratic commonwealth settled around the shores of the Massachusetts Bay. Salem on its North Shore was, if possible,

more rigid in its views of standards of human conduct. Plymouth on its South Shore retained something of the special quality of great-mindedness of its spiritual founder John Robinson and his disciple William Bradford. Bradford's history of Plymouth Plantation is expressed in language as eloquent as the King James Bible: "As one small candle can light a thousand so the light here kindled hath shone unto many, yea, in some sort to a whole nation!"

The Puritan Commonwealth was for its first hundred years truly an independent nation. It fought its own wars, mostly against Indians but sometimes against other immigrants: English, French, Dutch, or Spanish. It levied its own taxes and made its own laws. It elected its town governments, legislatures, and governors. A passion for independence and education are its legacies. They are still expressed across spaces of open water and open land from the Custom House Tower at its international terminus on the harbor to its new towers along the Charles at Cambridge that reach to Harvard's greatest tower, Memorial Hall.

In the eighteenth century the commercial success of Boston attracted more and more the attention of the British Parliament. Royal governors came—to be violently opposed like Sir Edmund Andros, who was sent back to England in chains, or to be admired like William Shirley, because he skillfully organized resistance to the expansion of the French Empire.

The Colonial period was serious, reflecting its Puritan foundation, and handsome, a distant reflection of the opulent eighteenth century in Europe. The Old State House, the Old North Church, and King's Chapel express it grandly. What a small house in the city was like is suggested by that of the silversmith and dispatch rider Paul Revere. It has been carefully restored, although its Sabbath-day neatness may give too glowing a picture of what Boston was like without plumbing other than the wash of the tides.

The Federalist period began with the Constitution of 1787 and extended for a long generation afterwards, and is known in Boston as the age of Charles Bulfinch. He redesigned the city, its streets, its spaces, and its houses. The front of the State House and its great dome are his work. Faneuil Hall he did over. St. Stephen's in the North End is his design as are the granite Bulfinch wing of the Massachusetts General Hospital and many houses on Beacon Hill. His Tontine Crescent is gone, but Franklin Street in its broad sweep still suggests its former magnificence.

What followed after the Civil War is both tragic and magnificent. It is tragic because steam, machinery, and the exigencies of war destroyed much of what was old and also good. Worst of all it destroyed space. The narrow streets of Boston were overwhelmed by man-made mountains of ugly brick.

It was magnificent because it saw the advent of great new architecture with the creation of a new city where had been the tidal flats of Back Bay. Trinity Church was built by H.H. Richardson and the Boston Public Library by McKim, Mead and White. Commonwealth Avenue with its fine houses, designed with characteristic individualism, was laid out. The Public Garden was made to add to

the glory of the Common's open space. The emerald ring of parks around Boston was created by Frederick Law Olmsted.

Towers and spaces delight the eye; they are the symbols by which the past lives and molds the future. Across Copley Square from the towers of Trinity Church, broad steps lead into the Boston Public Library. Flanking the staircase beyond its bronze doors are two finely sculptured stone lions. At the base of one is engraved "2nd Massachusetts Infantry 1861—1865 Winchester—Antietam—Chancellorsville—Gettysburg—The March to the Sea."

Like the colossal statue of Lincoln in the memorial at Washington, the work of the artist invites the beholder to ponder the words around it. Considered, the words speak for the sculpture. Together they point the way to Memorial Hall in Cambridge, Harvard's deeply felt tribute to the Union dead. Stupendous as is the presence of that great building and the tower above it, its meaning is expressed in the tablets beneath—the names, the dates, the battles. There in the broken light from the stained glass windows the words echo and re-echo as new generations of Harvard men and women pass to and fro on their way to classes. "Never forget what they did here—it is for us the living—that this nation shall have a new birth of freedom."

By 1910 all the great buildings of Boston were built that would be built for the next fifty years. Symphony Hall, Horticultural Hall, the Museum of Fine Arts, Fenway Court, and Mrs. Jack Gardner's Venetian palace were all in place.

There was, of course, building for banks and insurance companies, but in the conservative neo-Classical tradition. The innovative genius that in the previous century had made New England the center of the textile industry and that built railroads to the Pacific Coast seemed to have migrated to the more genteel professions. It was appropriate that by 1920 Henry Cabot Lodge should be senator from Massachusetts and Abbott Lawrence Lowell president of Harvard.

The inner city was in a slow decline. The textile industry was migrating south. Even the Waltham Watch Company, a pioneer in the use of automatic machinery, almost the inventor of mass production of interchangeable parts, was skirting bankruptcy. The company whose railroad watch with the boxcar dial had started the trains on time for a nation moving west was having a tough time competing with the diligent Swiss and their newfangled wristwatch.

Tide after tide of immigration had swept across the old parts of town. Ramshackle buildings were choked with humanity. The lofts of old warehouses hummed with the machinery of sweatshop industry. The attics of the fashionable districts were crowded with a superfluity of servants. The Italians took over the North End, the Irish the South End. East Boston was inhabited by a mixed population recruited mostly from Russia and the Balkan countries.

The city that once had held, like Venice, the gorgeous East in fee, that had been the first terminus of the Cunard steamship line across the Atlantic, and banker from New England to South America and Europe, was becoming a gigantic slum. Only Washington Street, by the genius of the Filene brothers and

their famous basement of bargains, still led the world in retailing. Their magnificent porcelain building is their worthy monument.

The decay of Boston's buildings and streets reflected the corruption of its political life. Edwin O'Connor's novel *The Last Hurrah* tells the story. By the end of the Great Depression and the Second World War, Boston seemed little more than the shadow of something that once was great.

The Puritan passion for education saved it. With the building of the Charles River Dam in 1910, the unsavory mud flats which had emerged at every low tide were covered for good with a great reflecting mirror of water. The Massachusetts Institute of Technology seized the opportunity and moved to the Cambridge side. What had been dumps and swamp became the new campus of one of the world's most influential universities. Upriver, Harvard was transformed by the remarkable Harkness gift of the House Plan and by President Lowell's acumen in accepting it. Soon after, Harvard performed one of its periodic revolutions and elected a scientist, James Conant, president.

The new age of science was taking over the Cambridge side of the Charles to the immense advantage of the whole nation, as was positively proved in the terrific crisis of the Second World War. With the end of the war and the mushrooming of the electronics industry along Route 128, the miracle of Massachusetts began to emerge. Old and new money flowed toward education until Boston and its environs—with Raytheon, Polaroid, and Digital Equipment, to name but the largest of a myriad of companies—were employing every able-bodied man and woman in the Commonwealth to such an extent that the companies' founders and stockholders, if they wanted a garden, had to plant it themselves.

But the age of science was slow to cross to the Boston side of the river and came about somewhat by accident. John Hynes, assistant clerk of Boston, by the death of his predecessor became city clerk. Mayor Curley, convicted of mail fraud, was for five months restrained from management of the Office of Mayor. Though he returned to finish out his term, in the election that followed, Hynes won. For two more elections he won on a reform platform. He was succeeded by John Collins in 1959 who, with the help of a group of merchants, bankers, and others prominent in business—appropriately christened "The Vault" by Tom Winship of the *Boston Globe*—created the Boston Redevelopment Authority.

It was a political revolution extraordinary. For the first time since the great waves of immigration began with the famine in Ireland of the 1840s and the repressed revolutions in Europe of 1848, the old Yankee hierarchy joined with all the new races to create a city that would rival any city in the world for culture, creative finance, quality of life, and opportunity.

Edward Logue, who had pulled down and rebuilt New Haven, came to Boston to do the same thing on a grander scale. He was completely supported by Mayor Collins in his every effort and by Monsignor Francis Lally, appointed chairman of the redevelopment authority. Frank Lally, editor of the Boston *Pilot,* was the most beloved Catholic prelate to serve in Boston since the days when

Bishop Cheverus struck up a friendship with that energetic old Yankee aristocrat Josiah Quincy, who built the granite market that bears his name. The *Boston Globe,* under the able and patriotic hands of the third generation of the Taylor family, filled in where the *Pilot* did not go.

The new Boston is too great an achievement to describe adequately in words. It is not perfectly good. What art ever is, especially so complicated an art as the building and rebuilding of a city? The new Boston is remarkable for its respect and care of the old, surprisingly moderate in the excesses of the new. The glass Hancock tower is out of scale with Trinity Church, boxlike skyscrapers on Beacon Hill and downtown do not enhance the view from the Common. But the broad City Hall Plaza and the great new City Hall by Kallmann and McKinnell are a tremendous statement of the renaissance of Massachusetts. No view in New England more moves the heart than that of the spire of the Old North Church, where the lanterns were hung that signaled the beginning of the American Revolution, seen as it now can be seen, for the first time in a century, across the cleared space of the City Hall Plaza under the great protecting arm of the new City Hall.

Boston's new City Hall, set in its ample plaza, is a landmark by which future architecture will be judged. This is an excellent monument of our time; of the denizens of "The Vault"; of the reform administration of Boston; of the people of the town who welcomed change, representatives of the best that the city could offer; and of men and women of diverse race who knew how to work together and to persuade others to work with them for the common good. The outward expression is distinctly masculine. It is of the old Boston, the Puritan. The strong horizontal lines are there, firm, decisive, as the lines of the mouth of the Boston trustee and the square shoulders of a man stepping firmly off to work.

But within there is something different, something new in Boston. The imagination has suddenly escaped. It plays with fantasies. It welcomes all races. It could be Irish, Italian, Greek, Middle Eastern, or African, from any land or anywhere. It delights in diversity. Here is an immense staircase ascending, a great platform where the ages of man are played every day. Here are vaults rising, mysterious spaces high overhead revealing changing shafts of light, suggesting places unseen beyond. Here is room to build. There is no limit here to aspiration.

The visitor to Boston can see in a short walk of half an hour what can be seen in no other city in America: great architecture of three centuries across spaces that invest the soul. Citizens of Boston cannot do better than to sit for an hour with Santi Visalli and see through his camera eye what they thought they had seen but which they have not yet fully perceived.

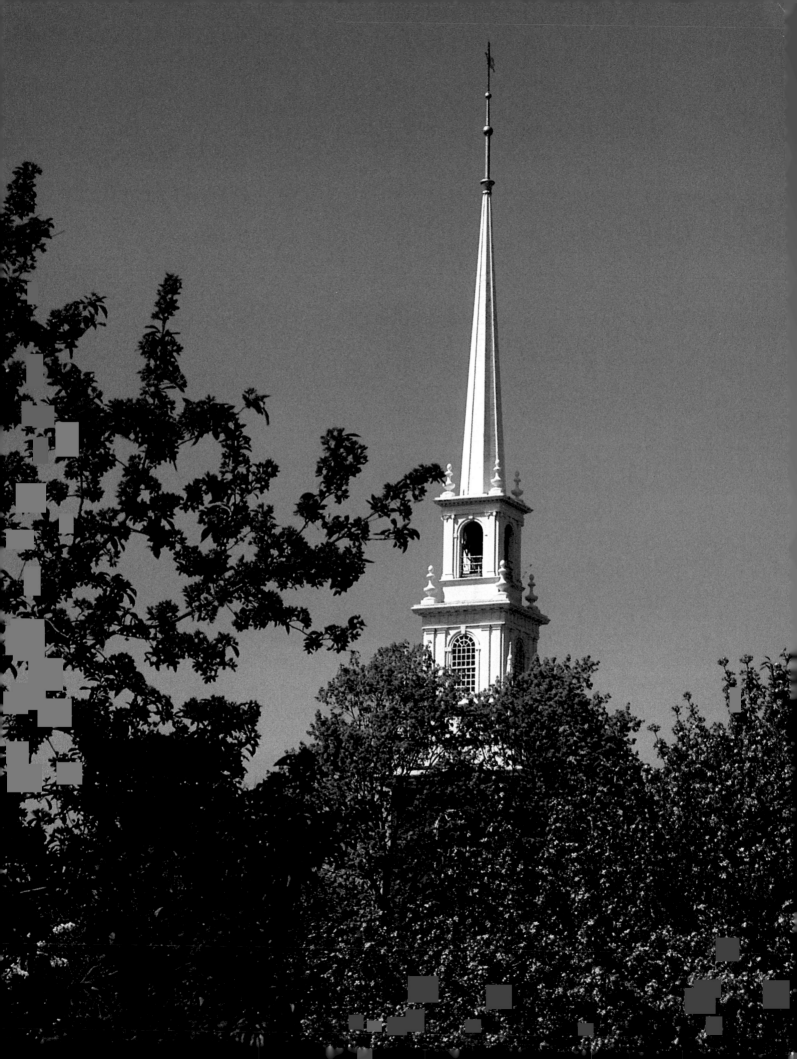

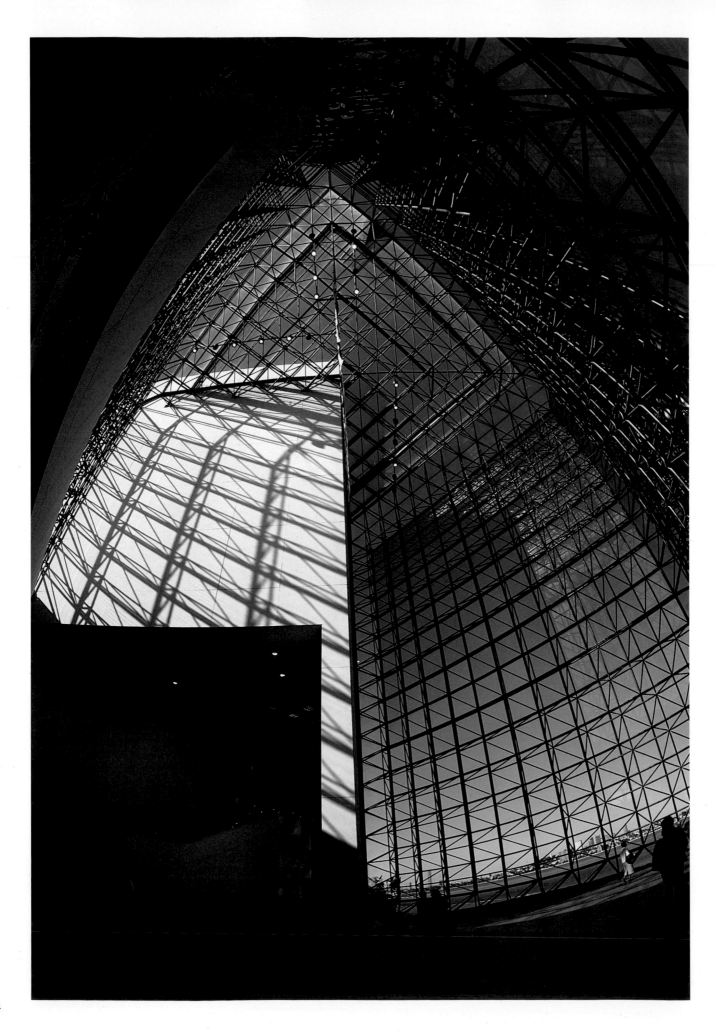

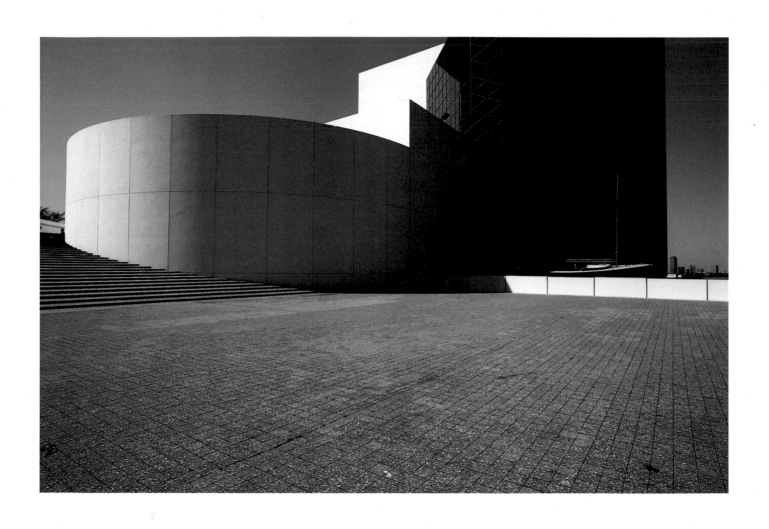

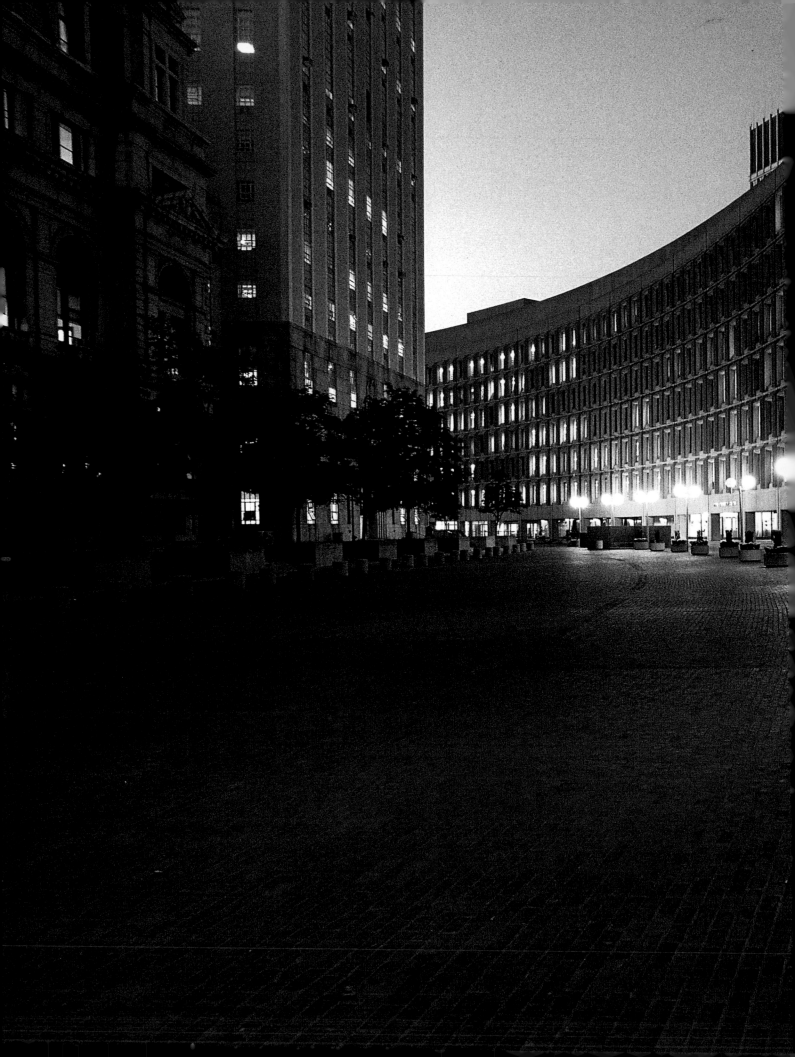

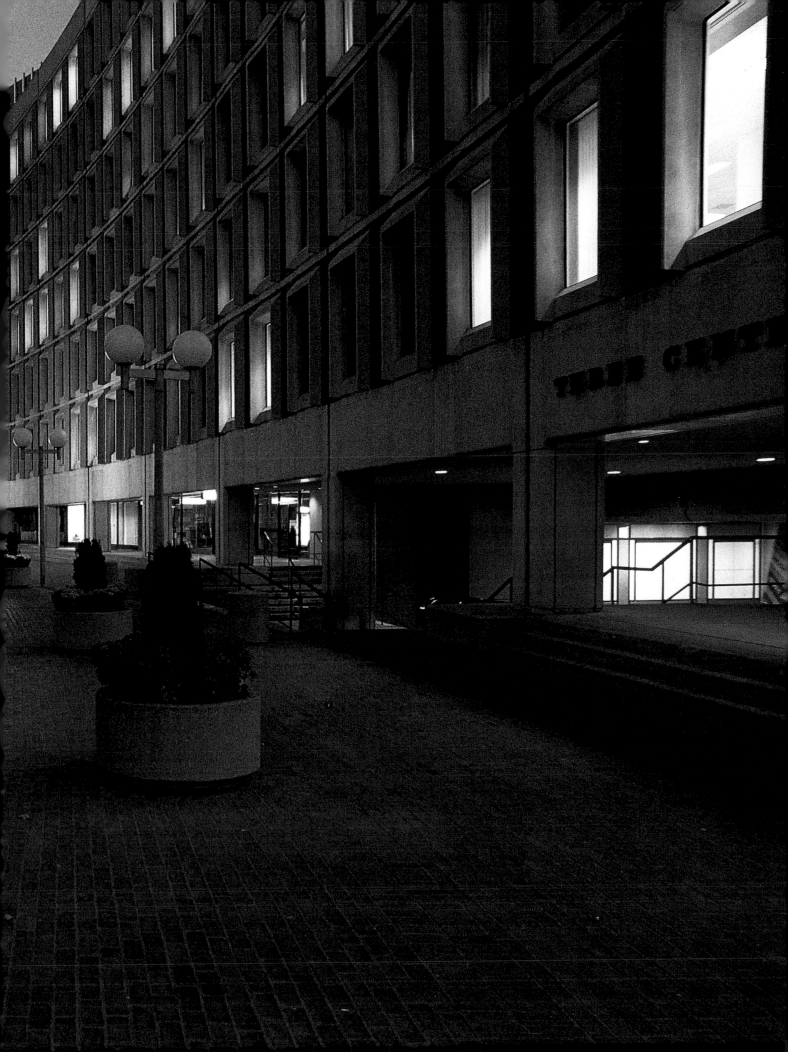

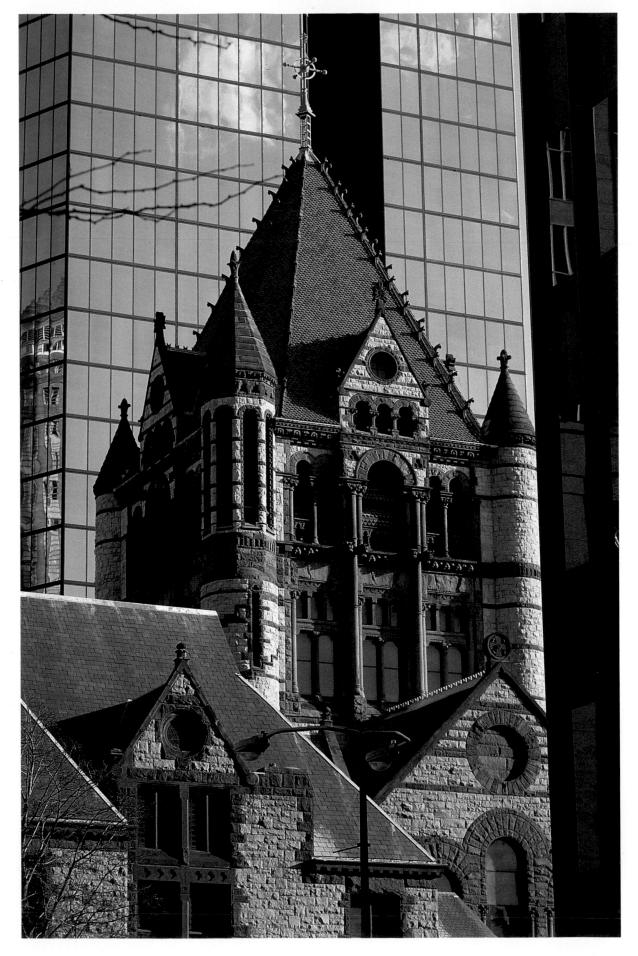

Trinity Church

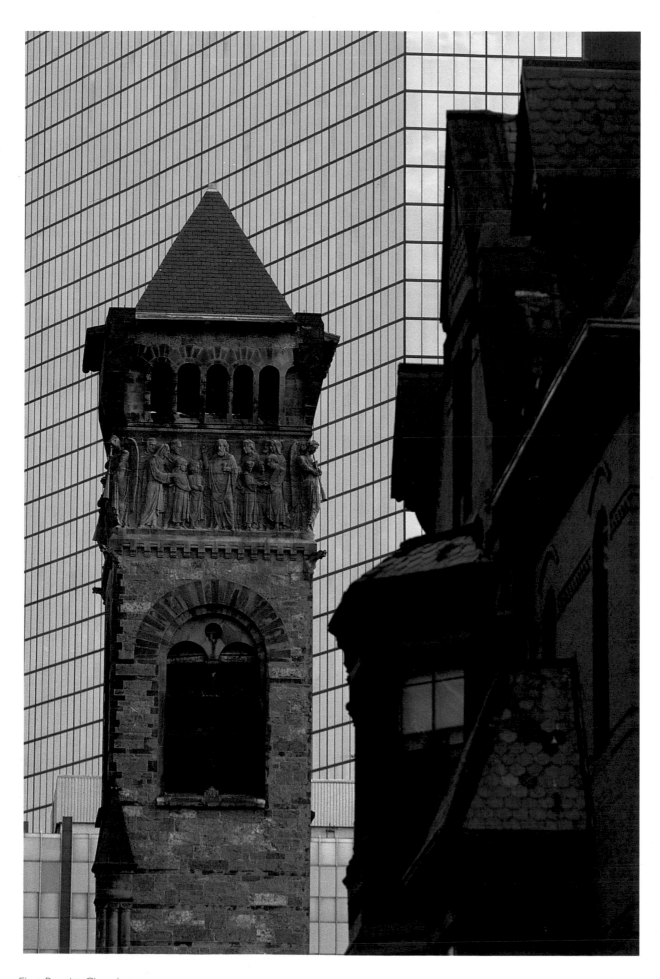

First Baptist Church tower

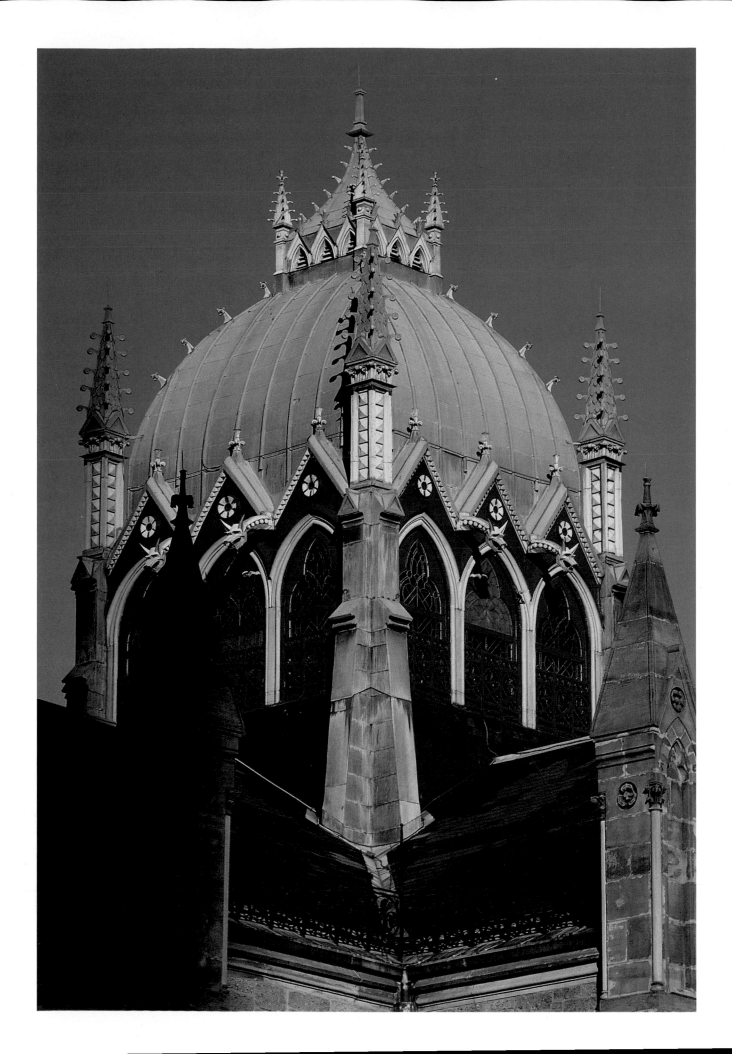

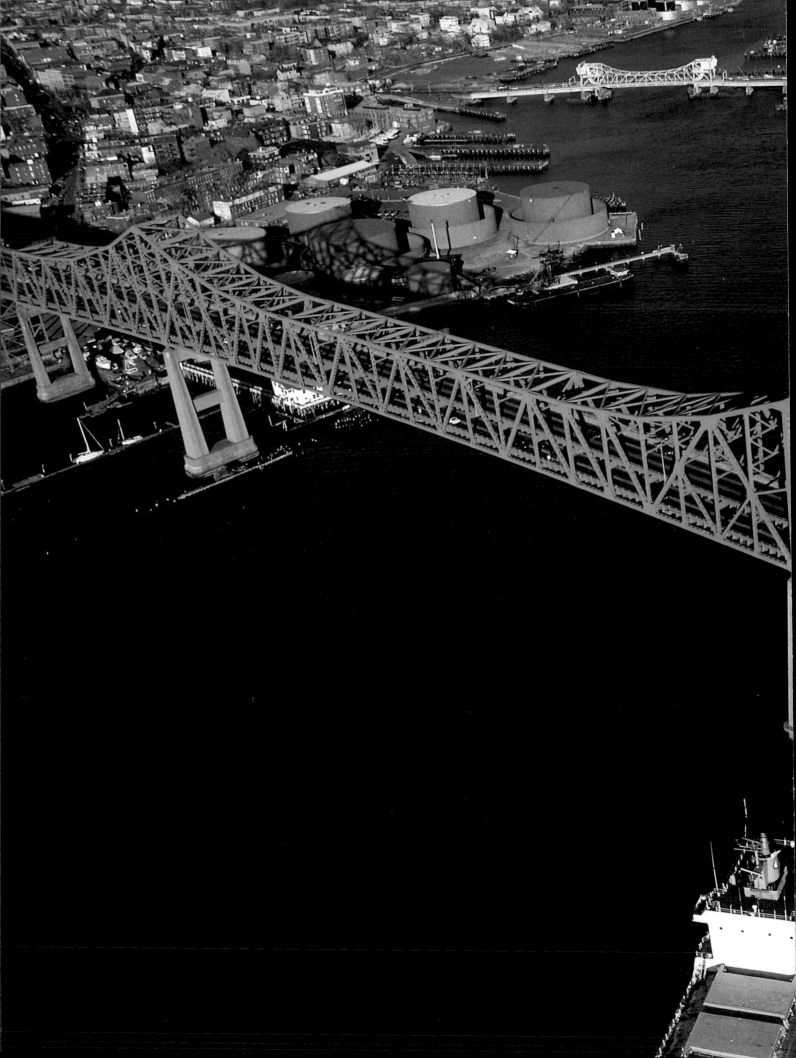

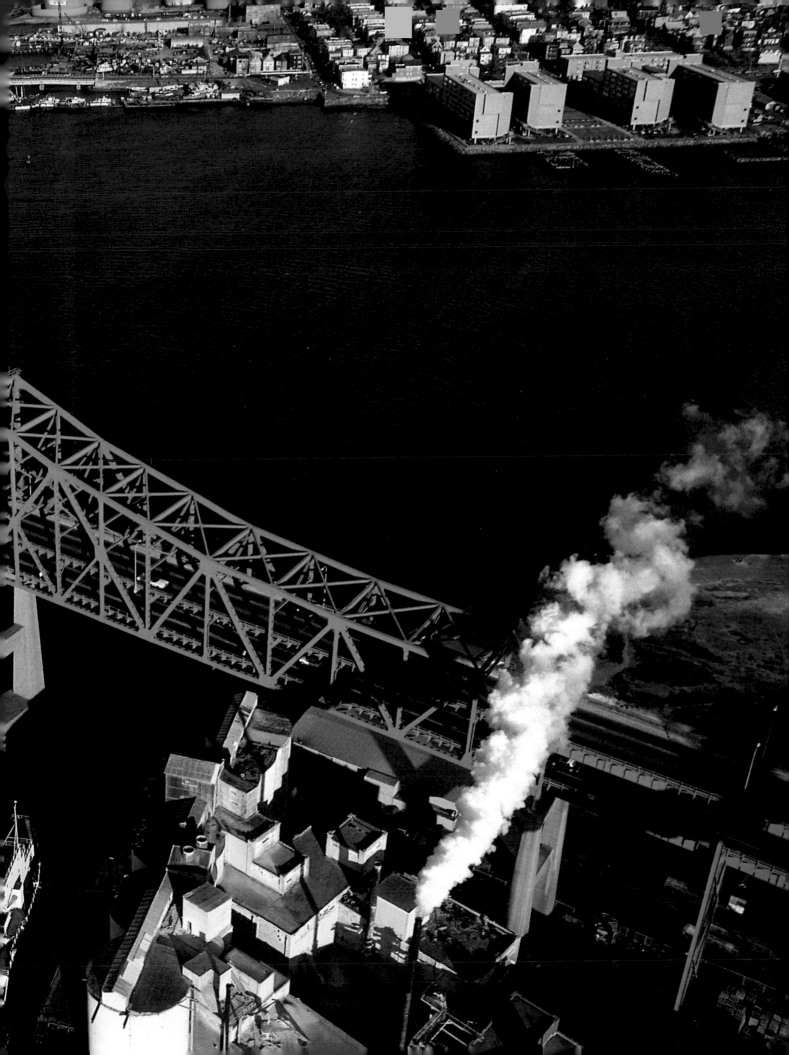

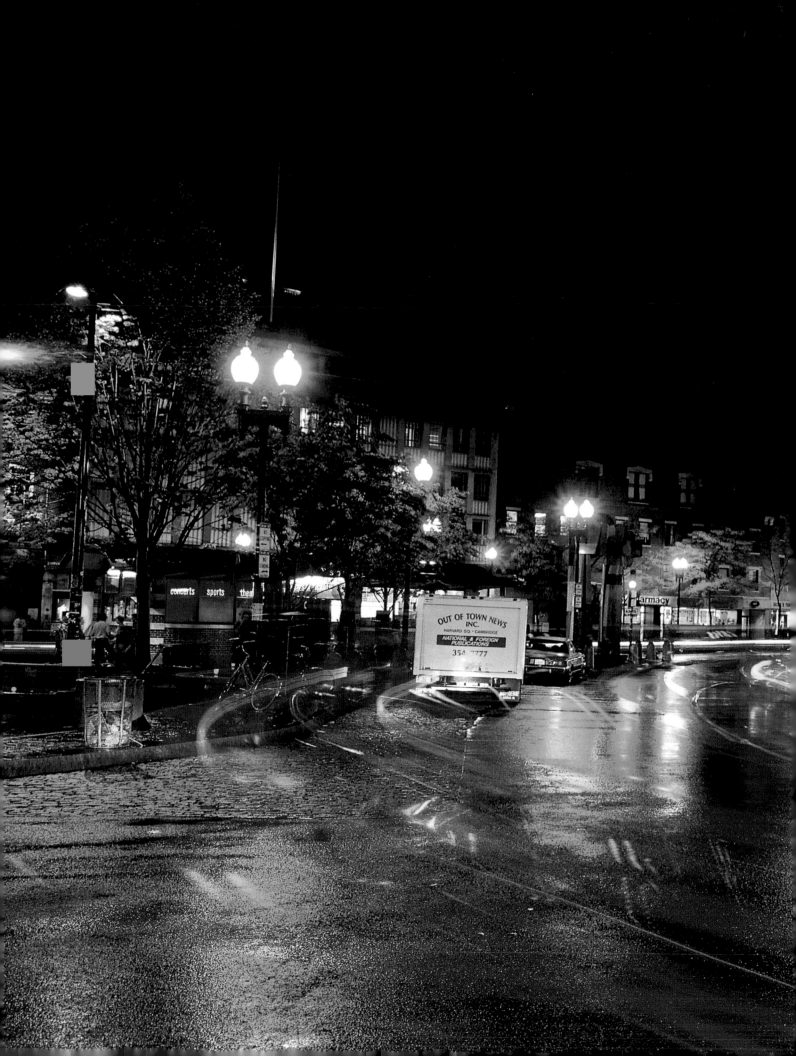

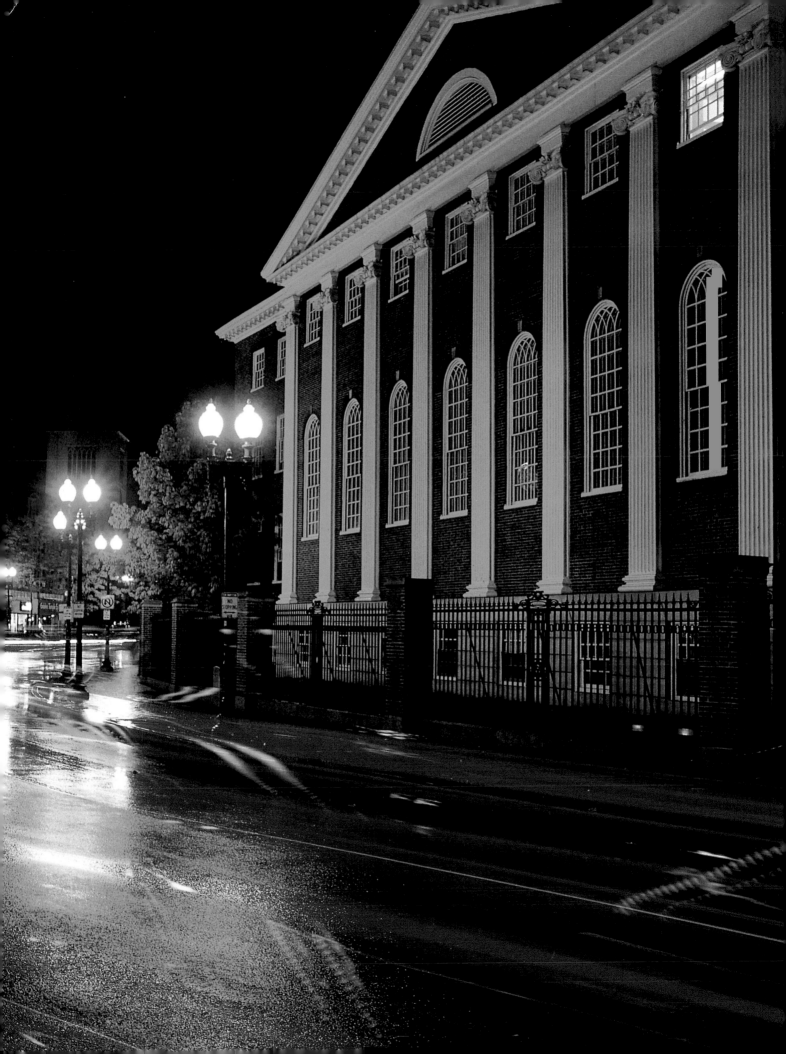

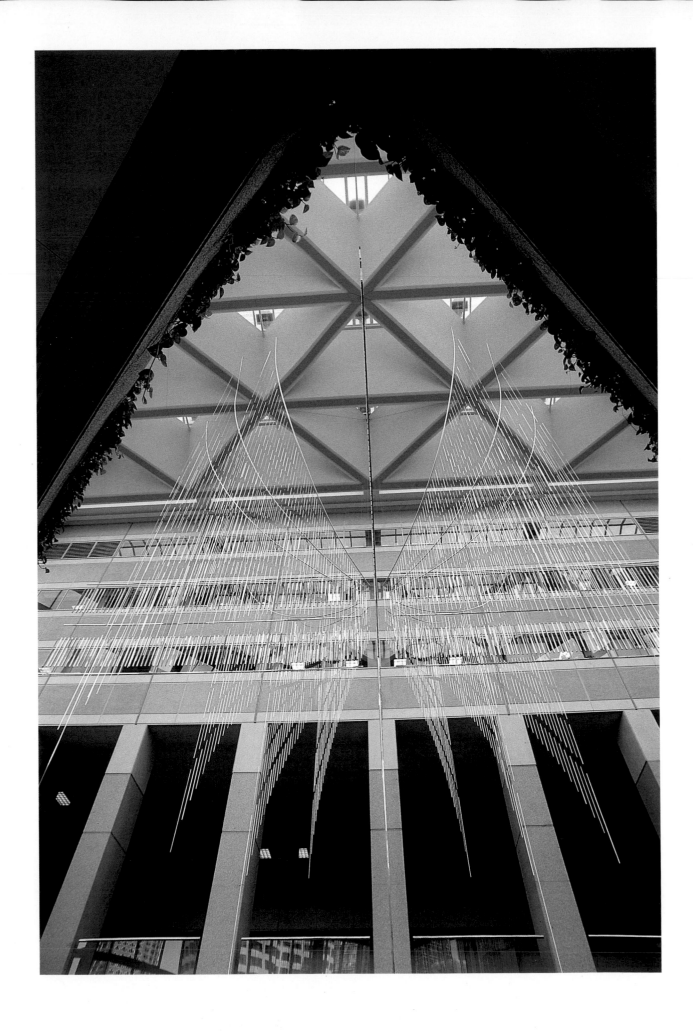

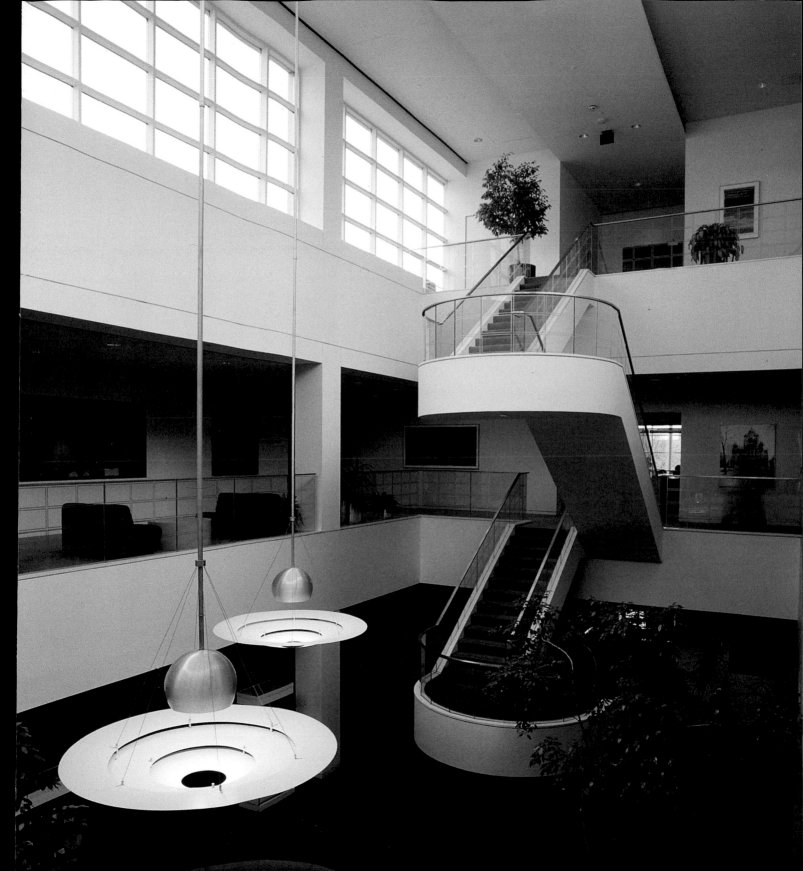

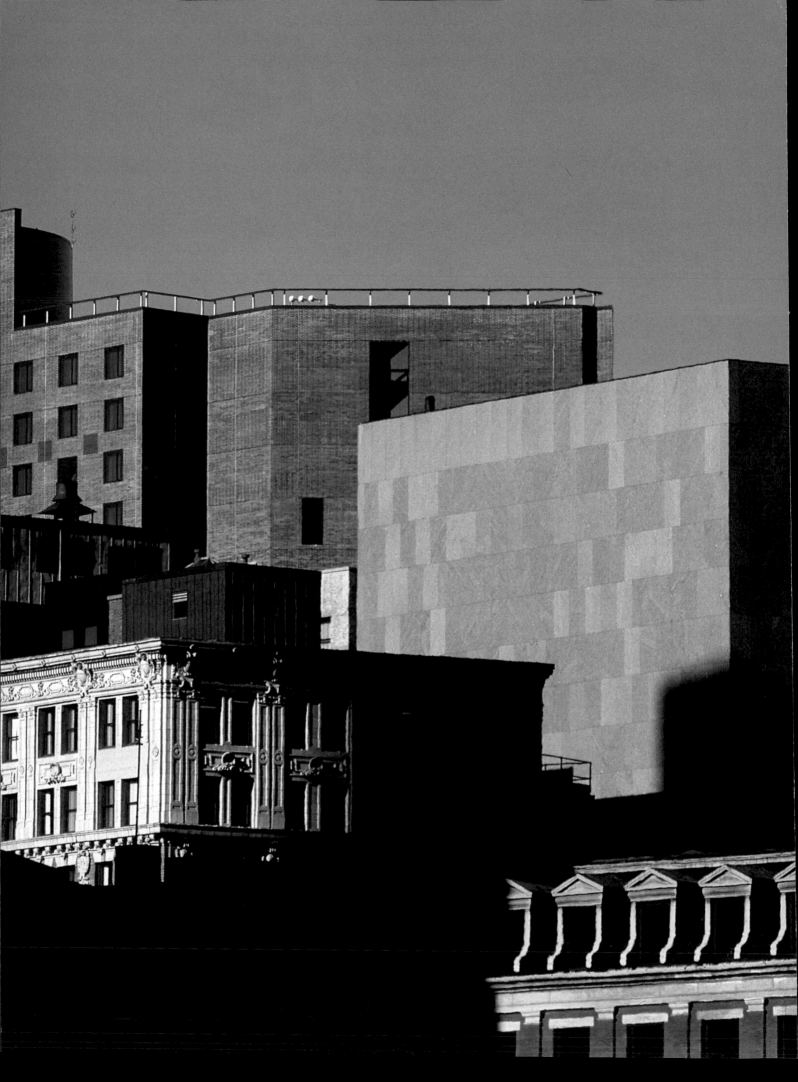

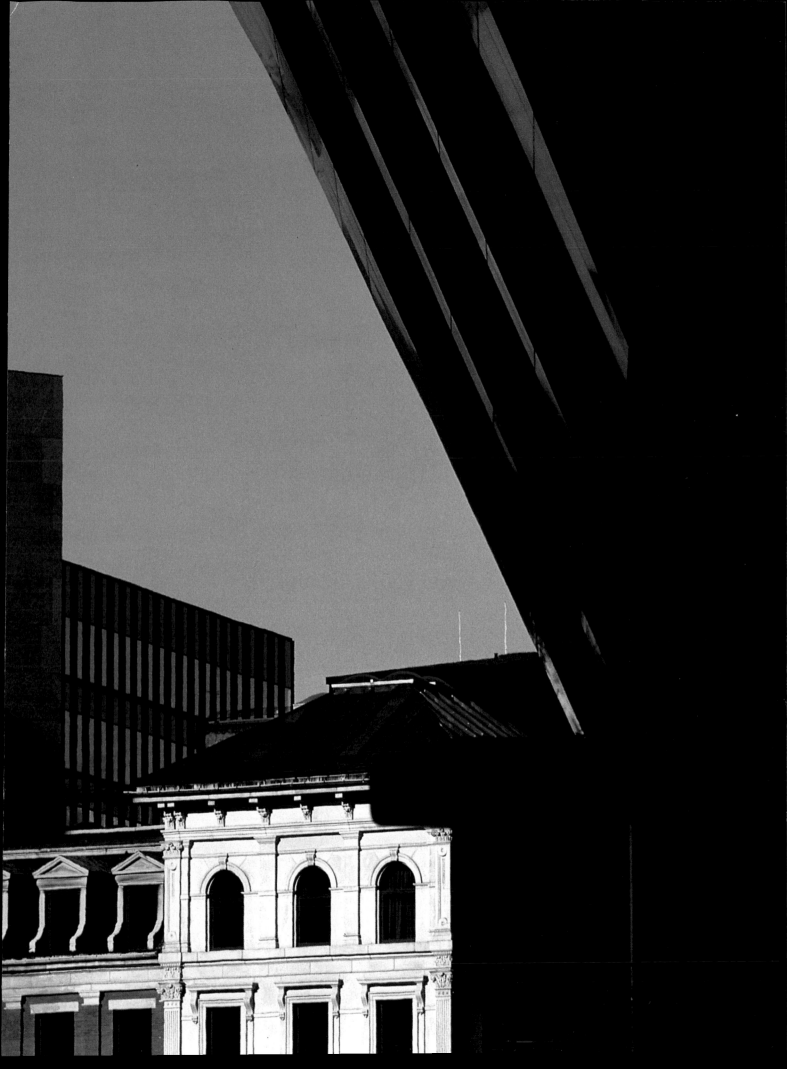

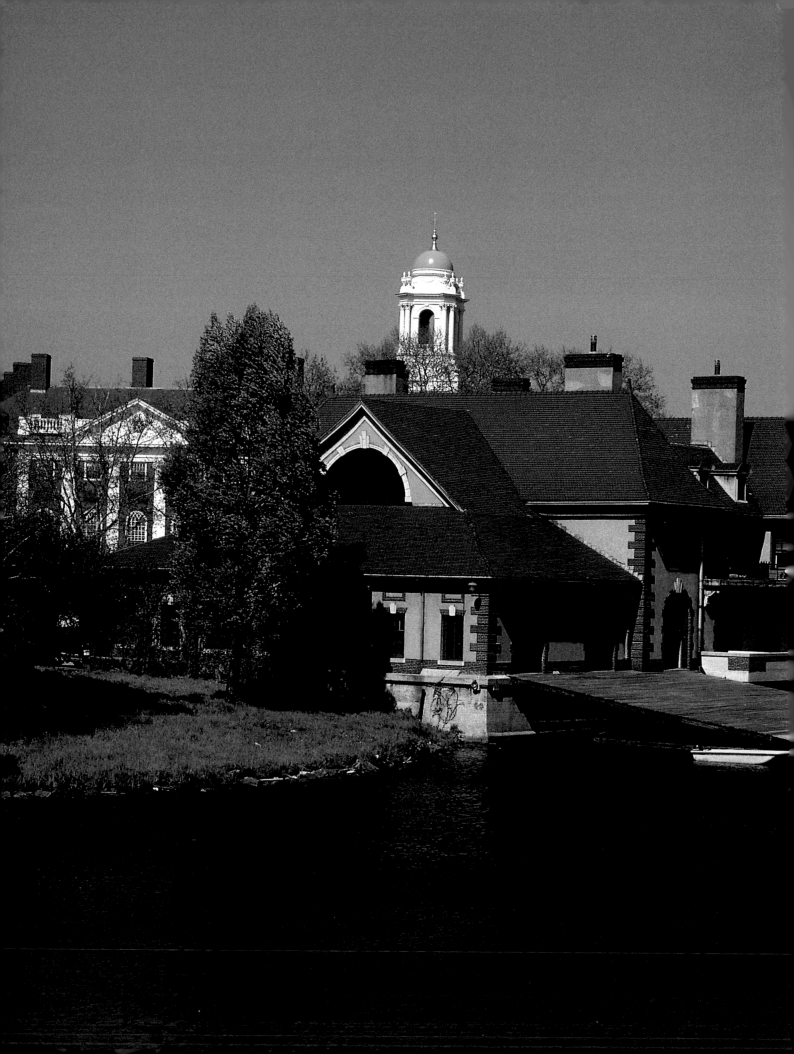

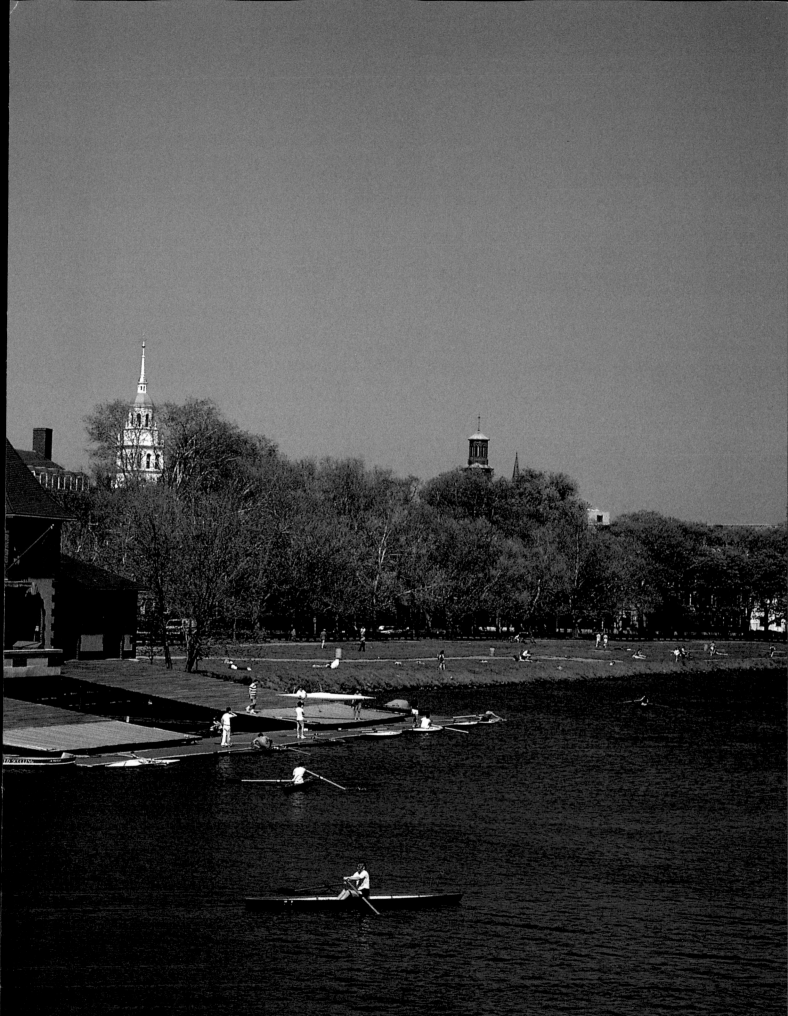

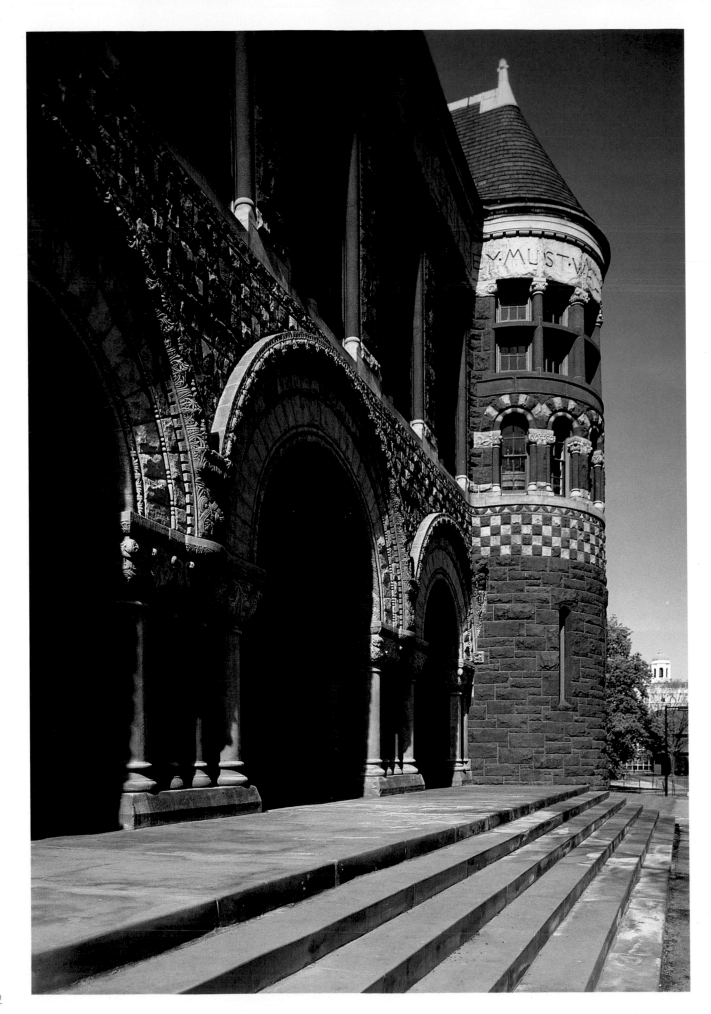

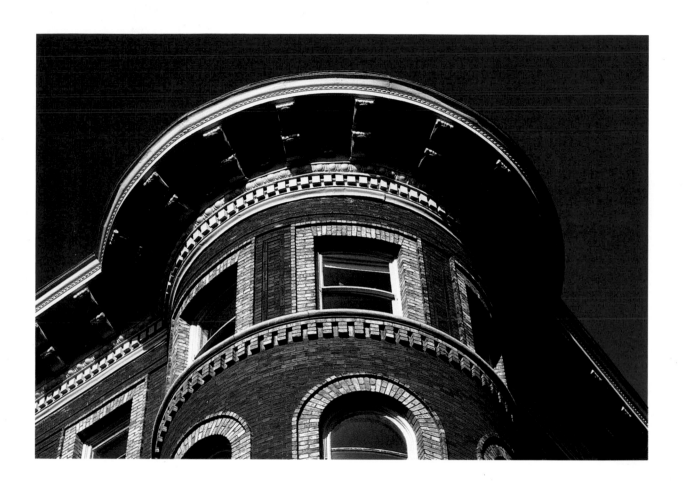

Pages 30–31. Weld Boathouse, Harvard University

Page 32. Austin Hall, by H.H. Richardson, Harvard University

Page 33. Cornice, Ware Hall, Harvard Street

Pages 34–35. New and old Hancock towers, with nineteenth-century row houses and the Union United Methodist Church steeple in the foreground

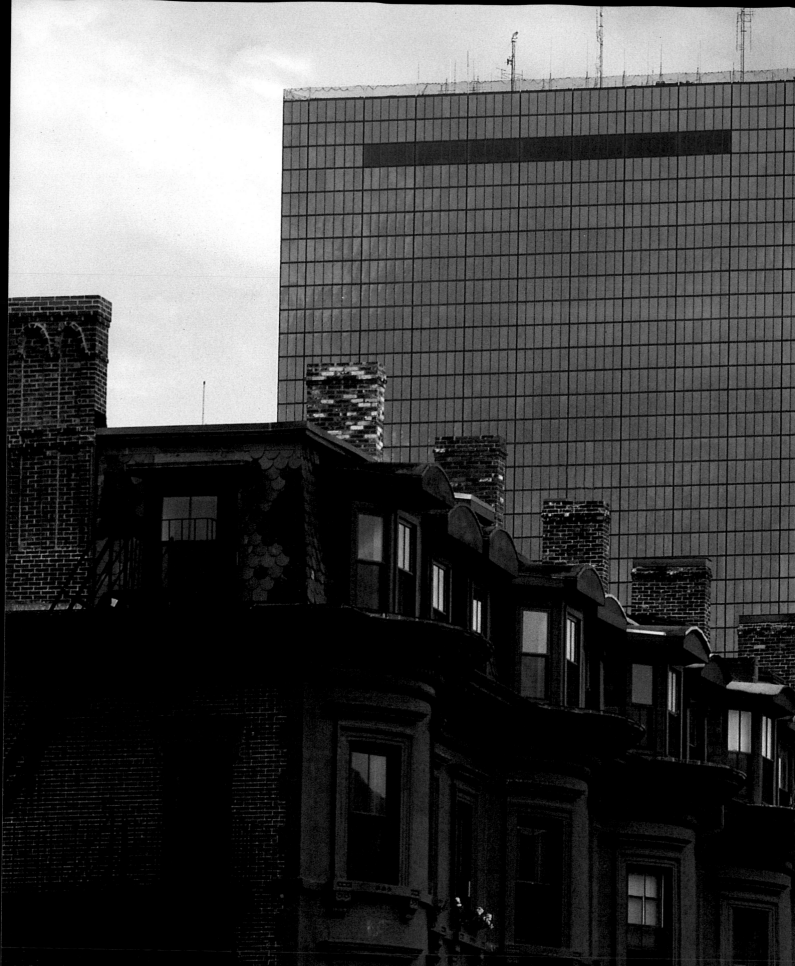

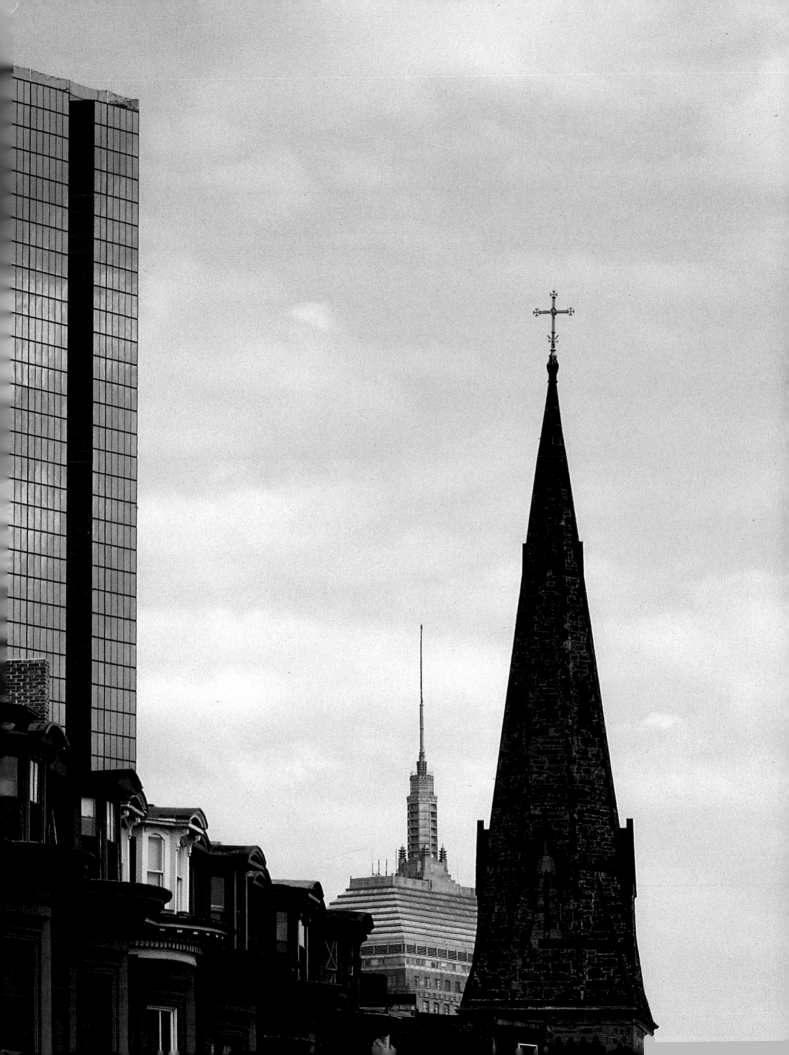

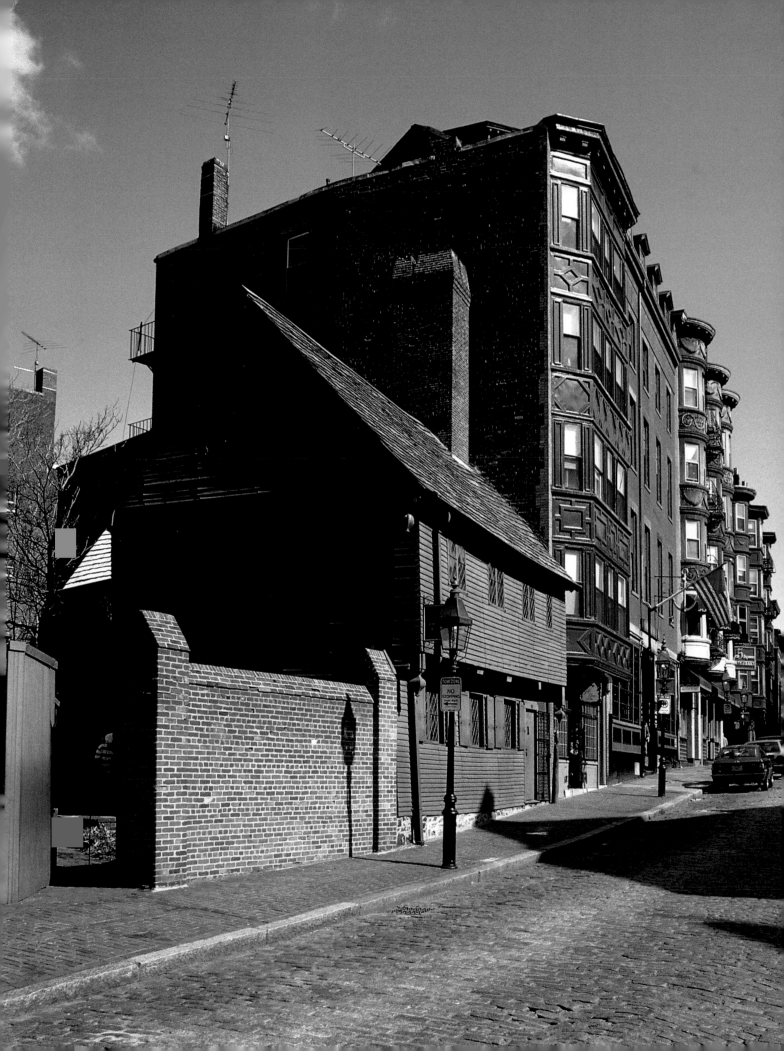

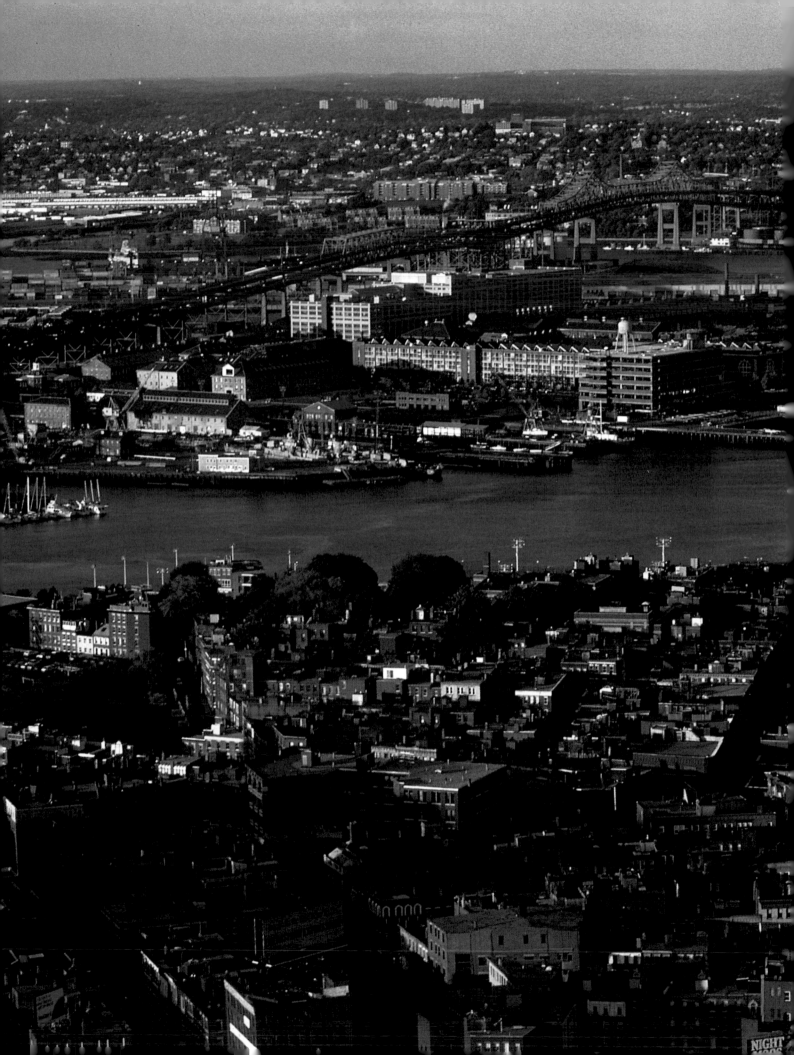

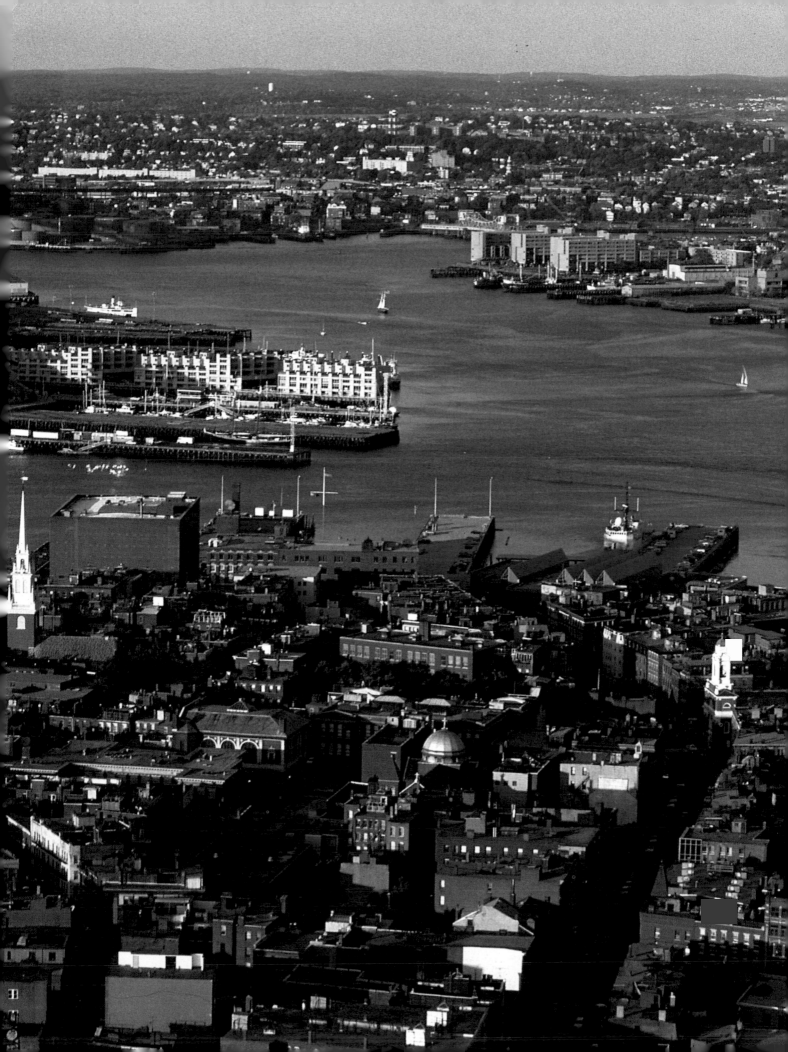

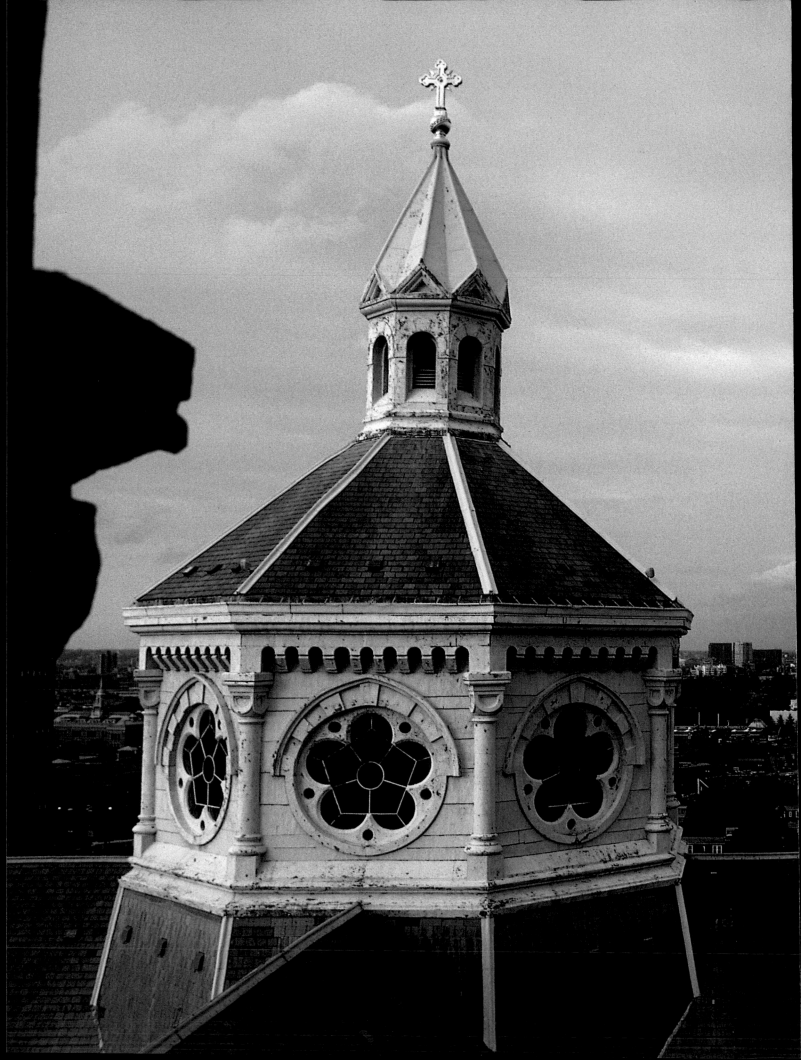

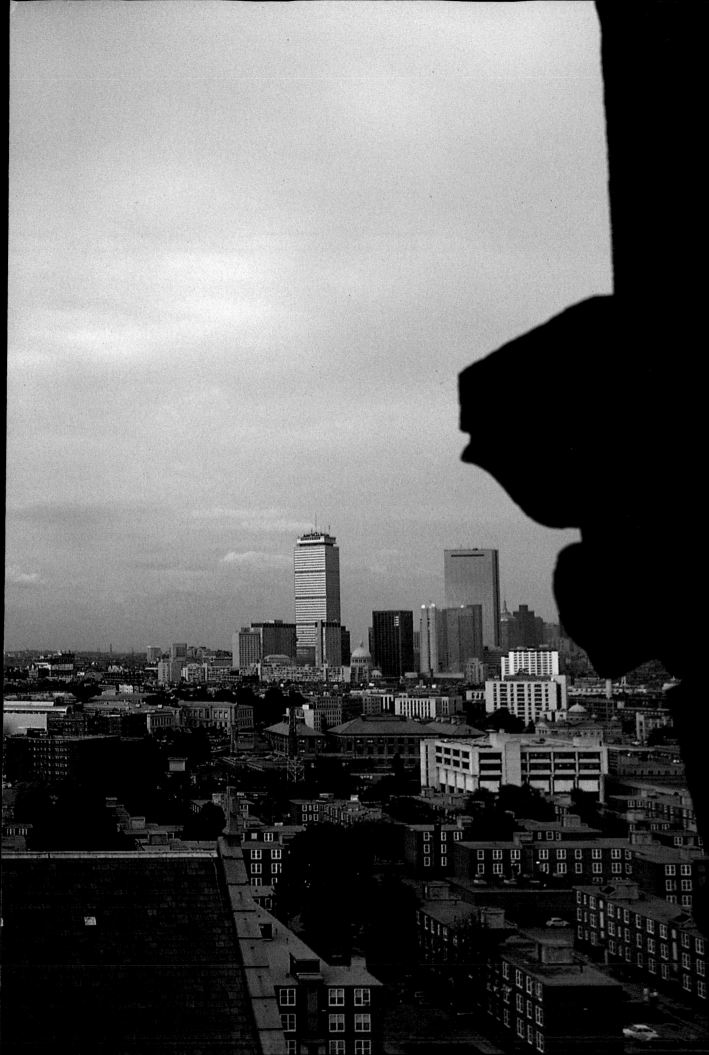

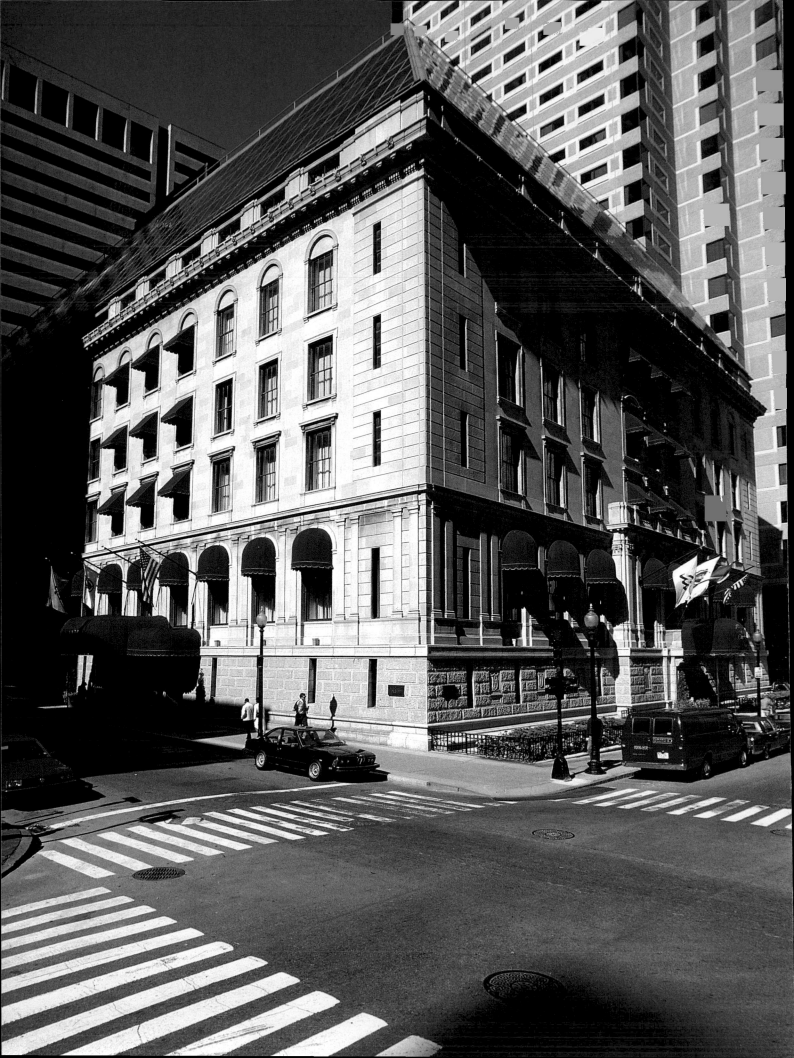

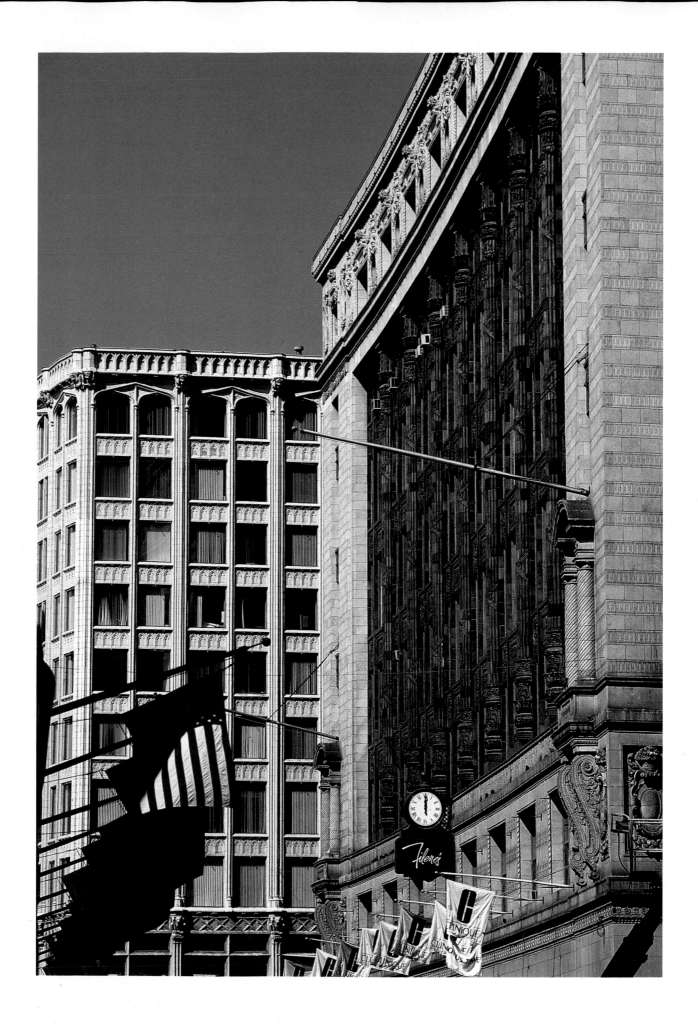

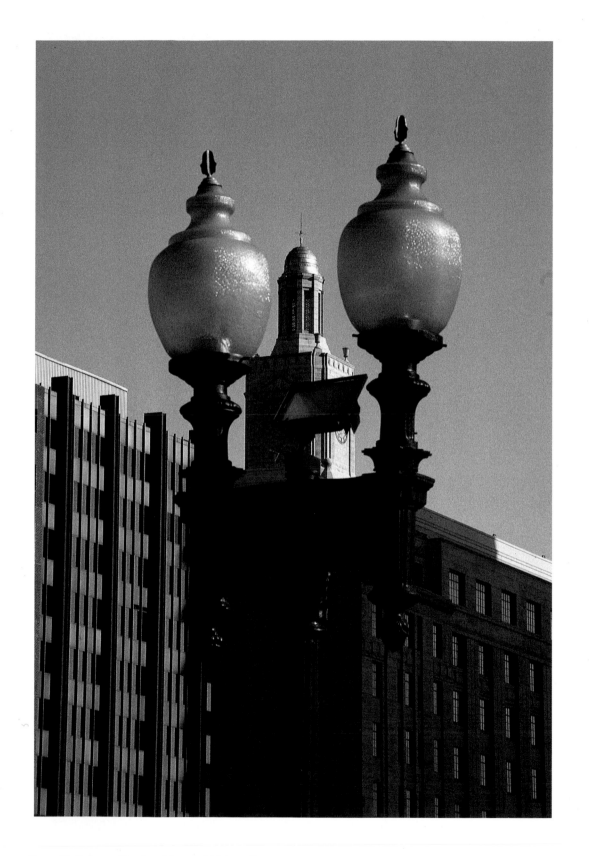

Page 44. Science Center, Harvard University

Page 45. Streetlights, Copley Square

Page 46–47. One International Place, lobby

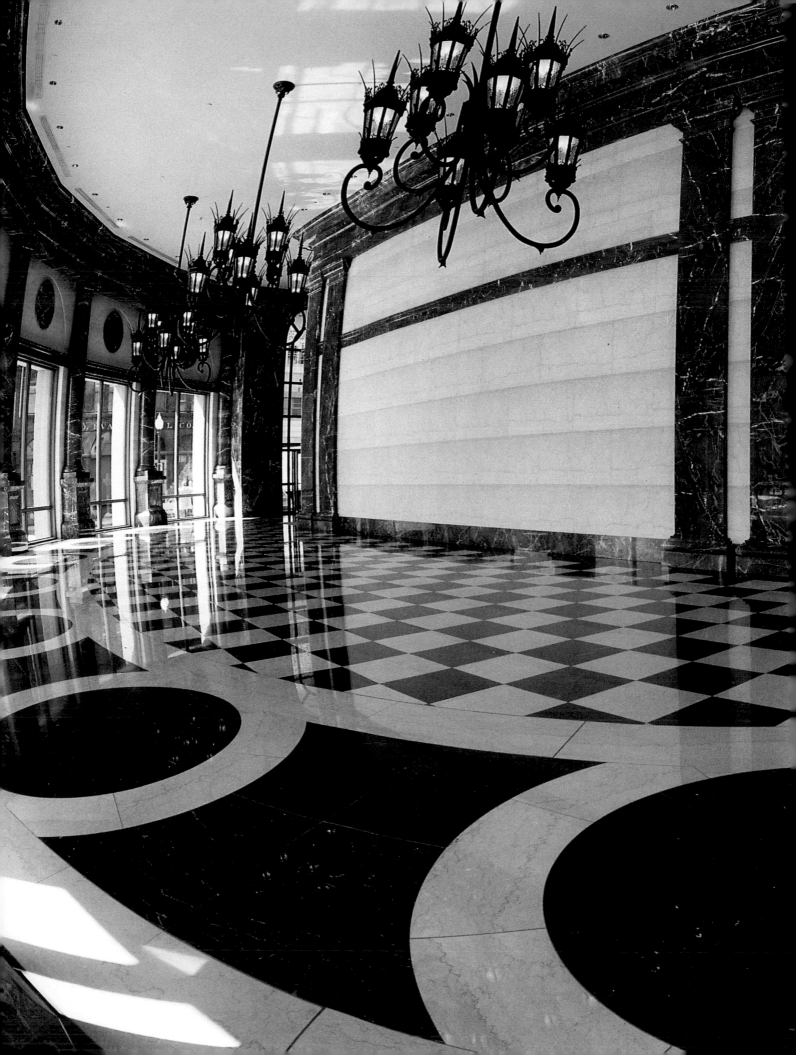

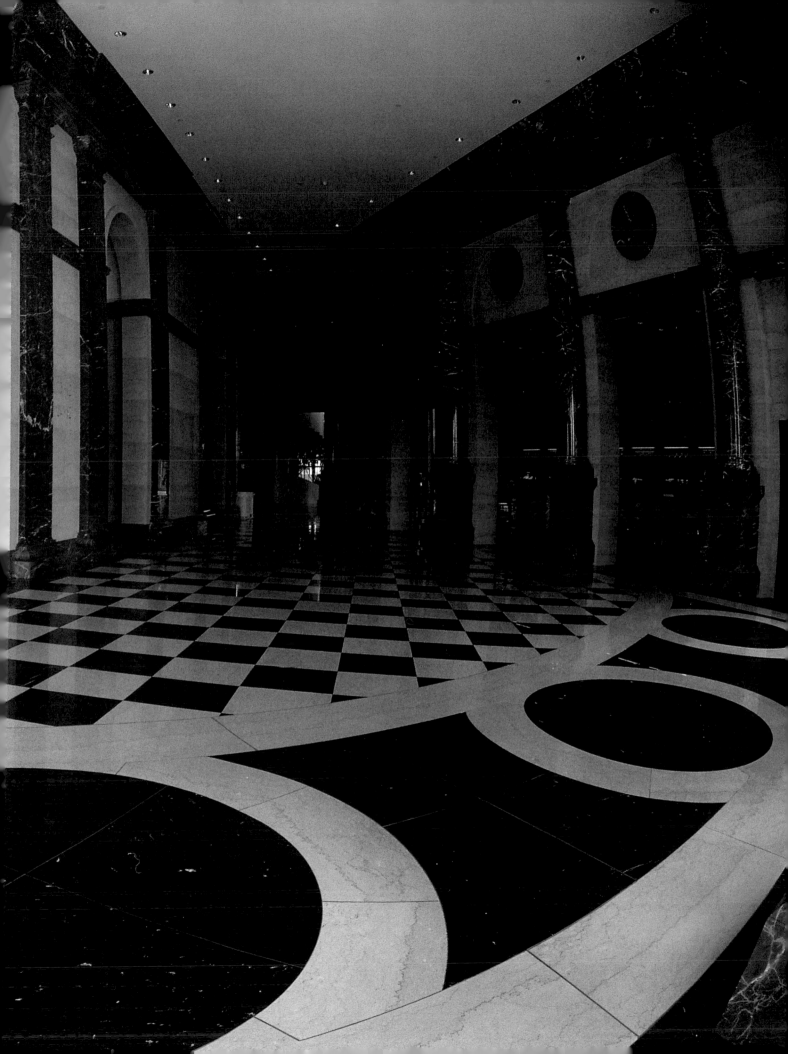

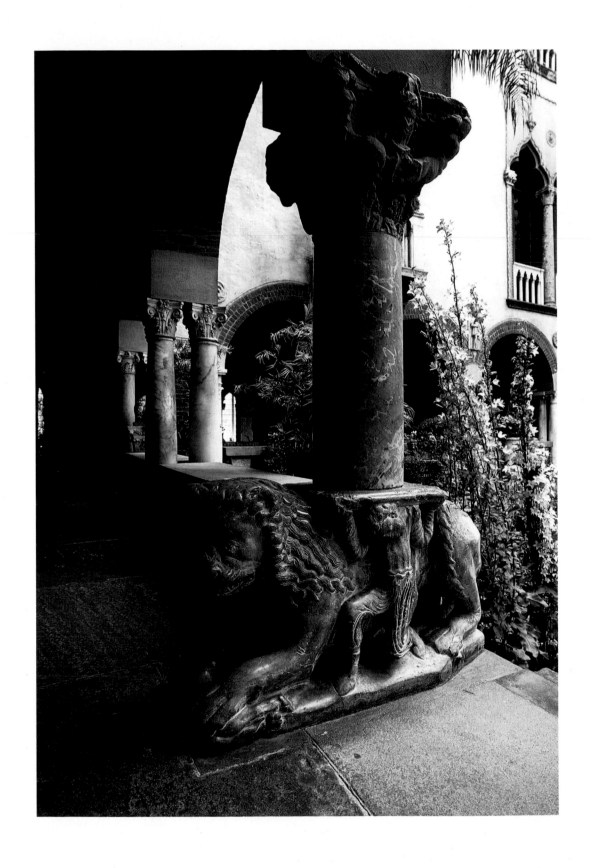

Pages 48, 49. The Court, Isabella Stewart Gardner Museum

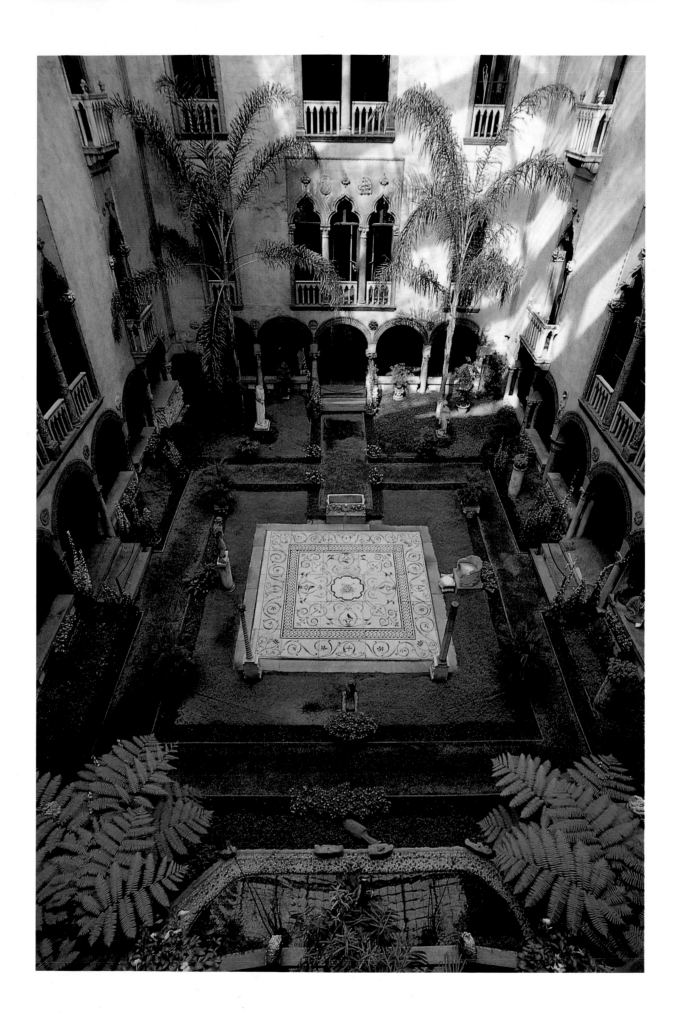

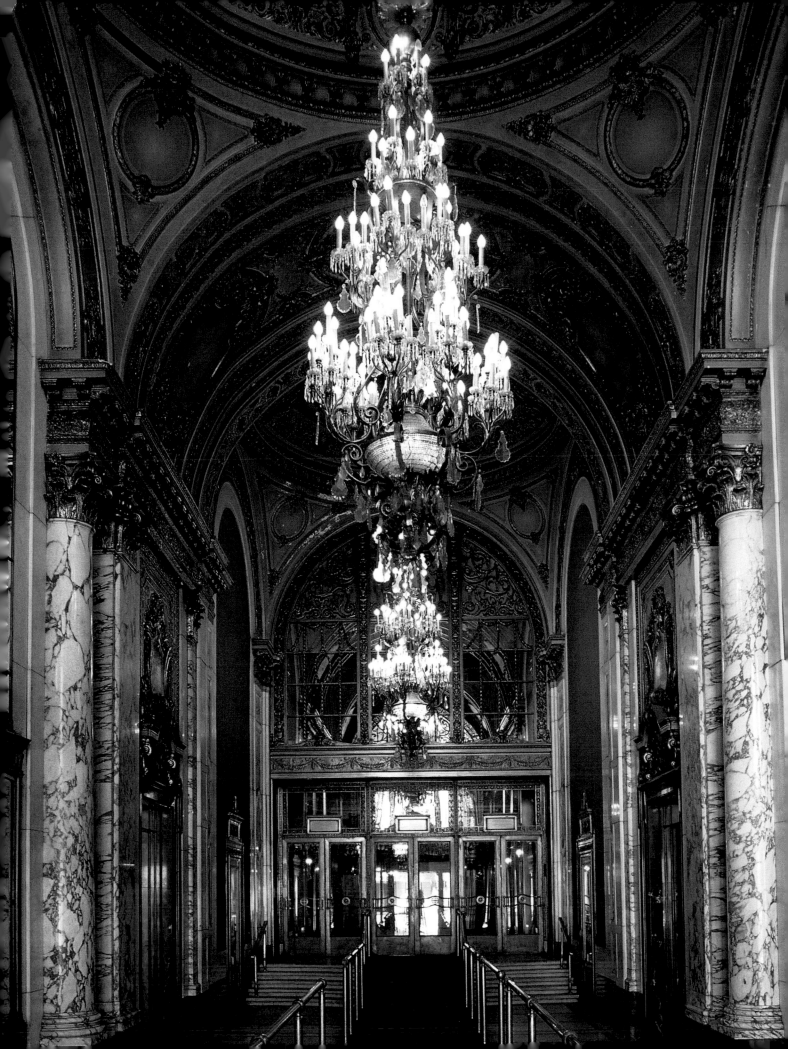

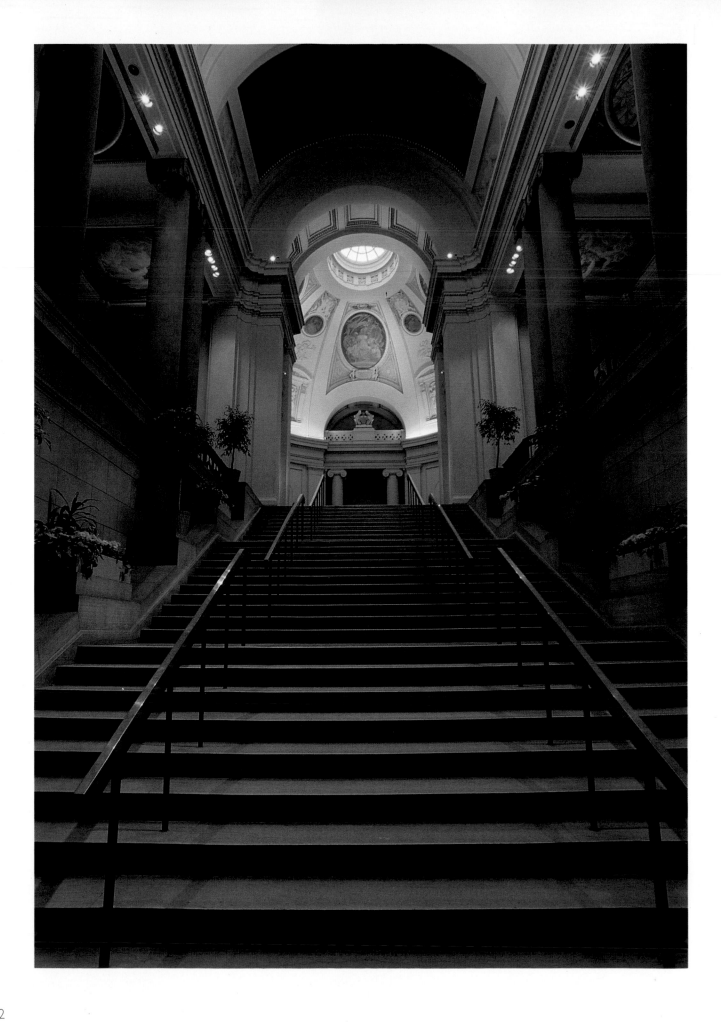

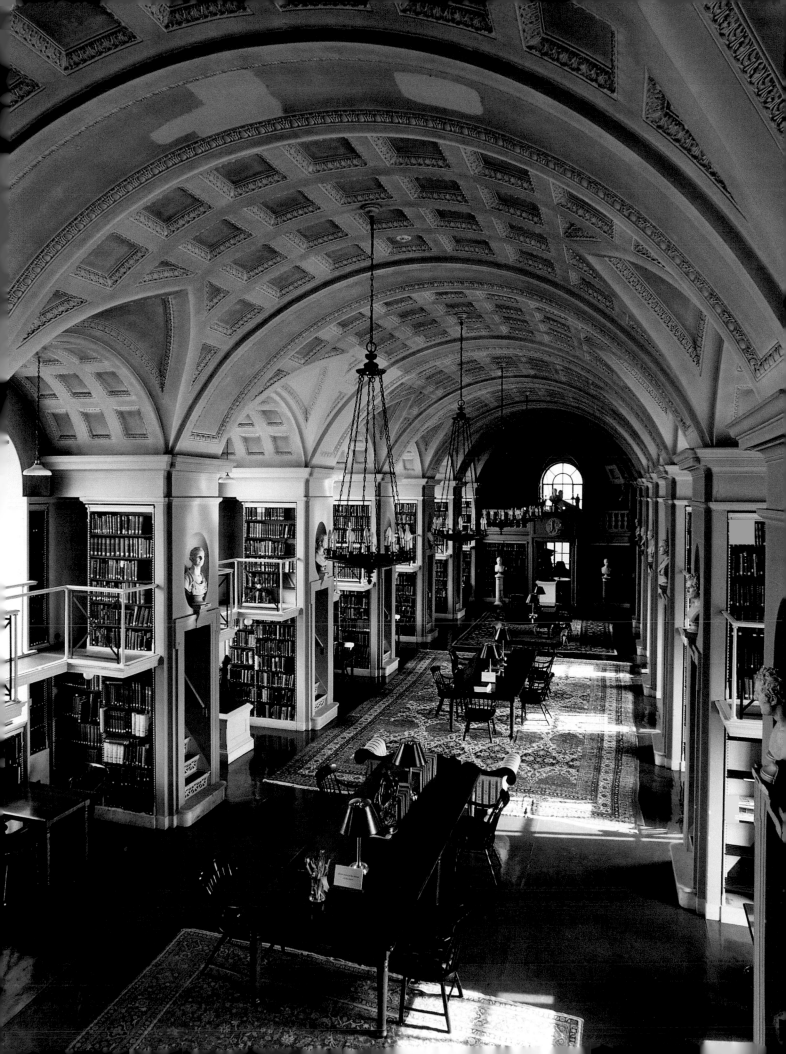

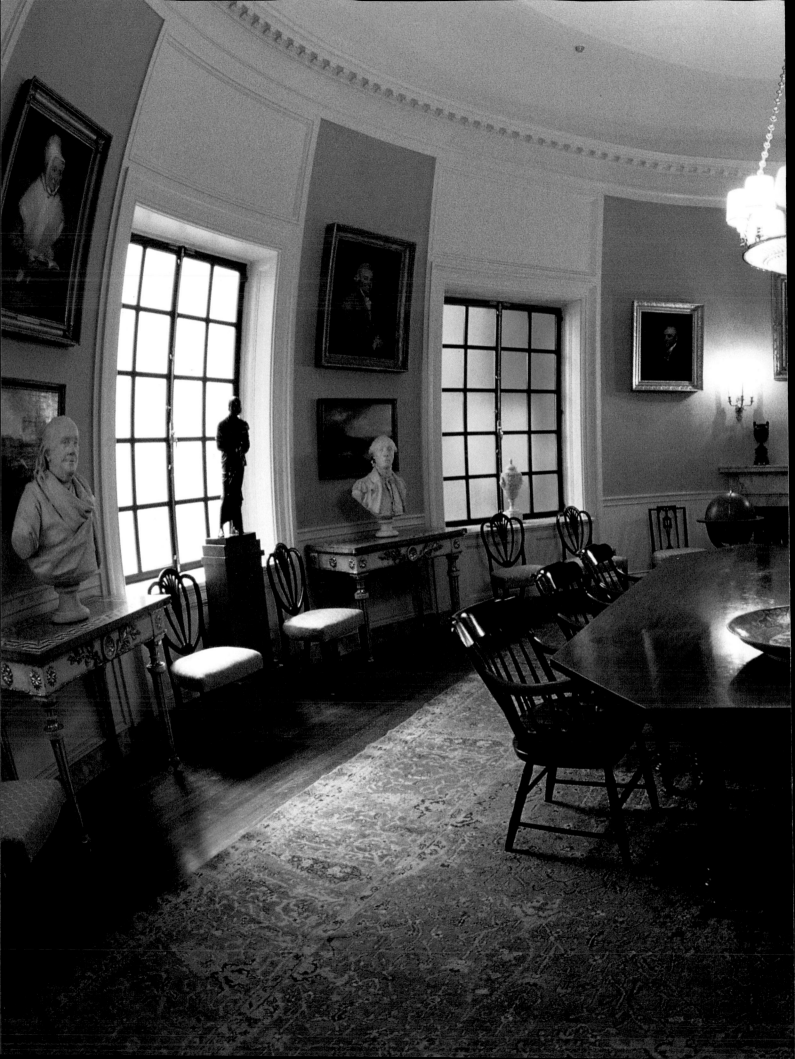

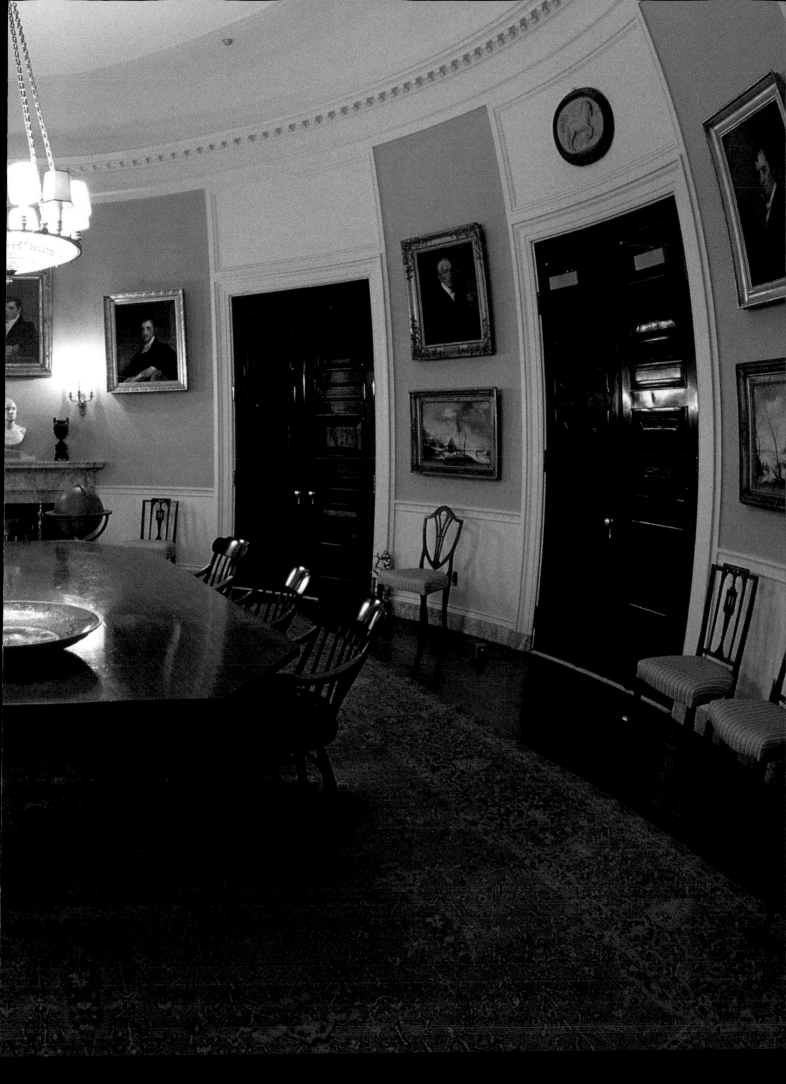

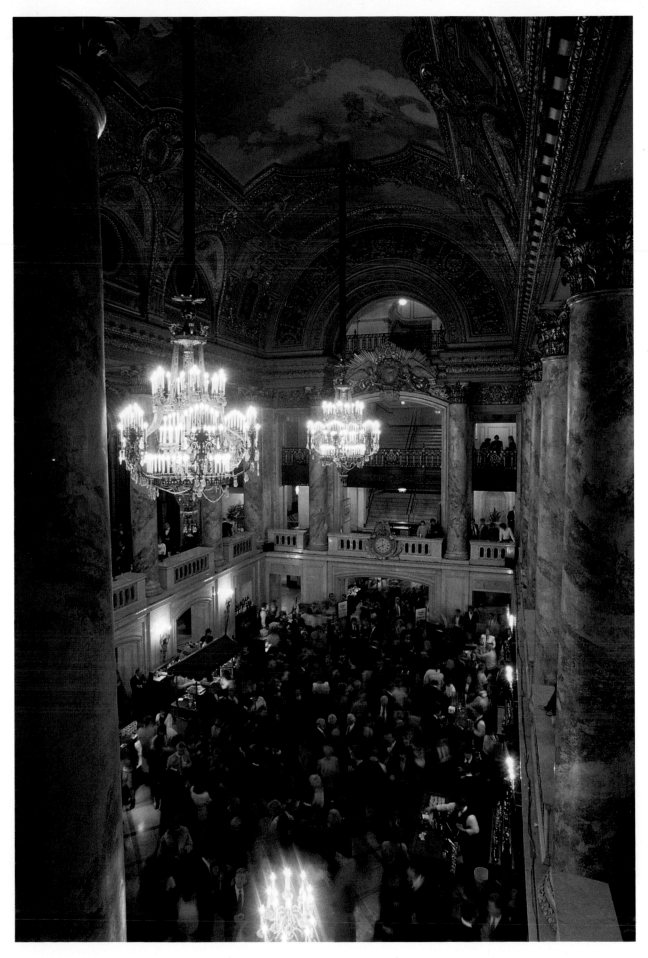

The Wang Center for the Performing Arts

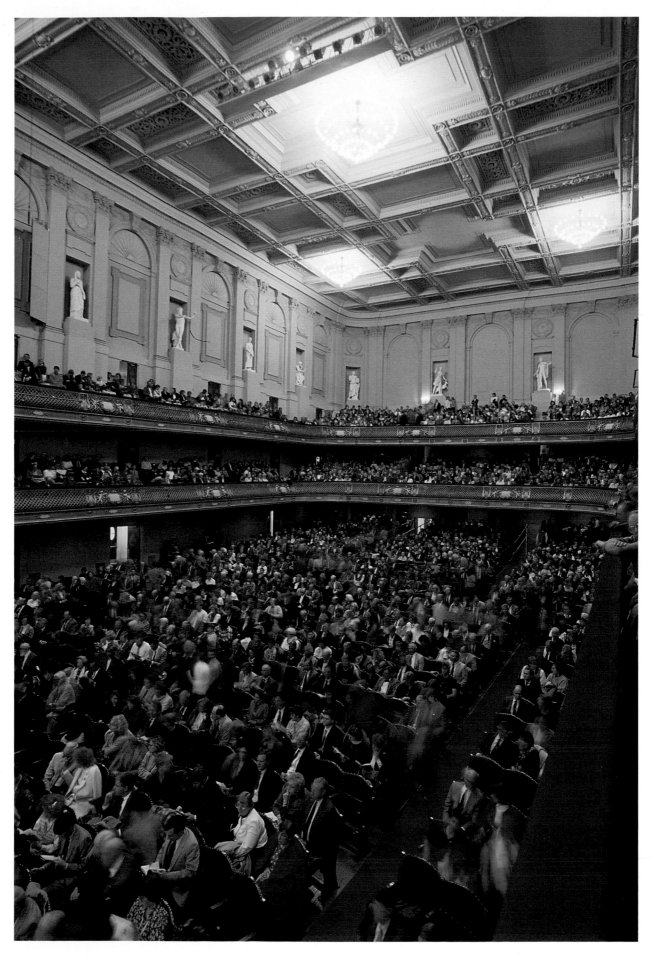

Symphony Hall

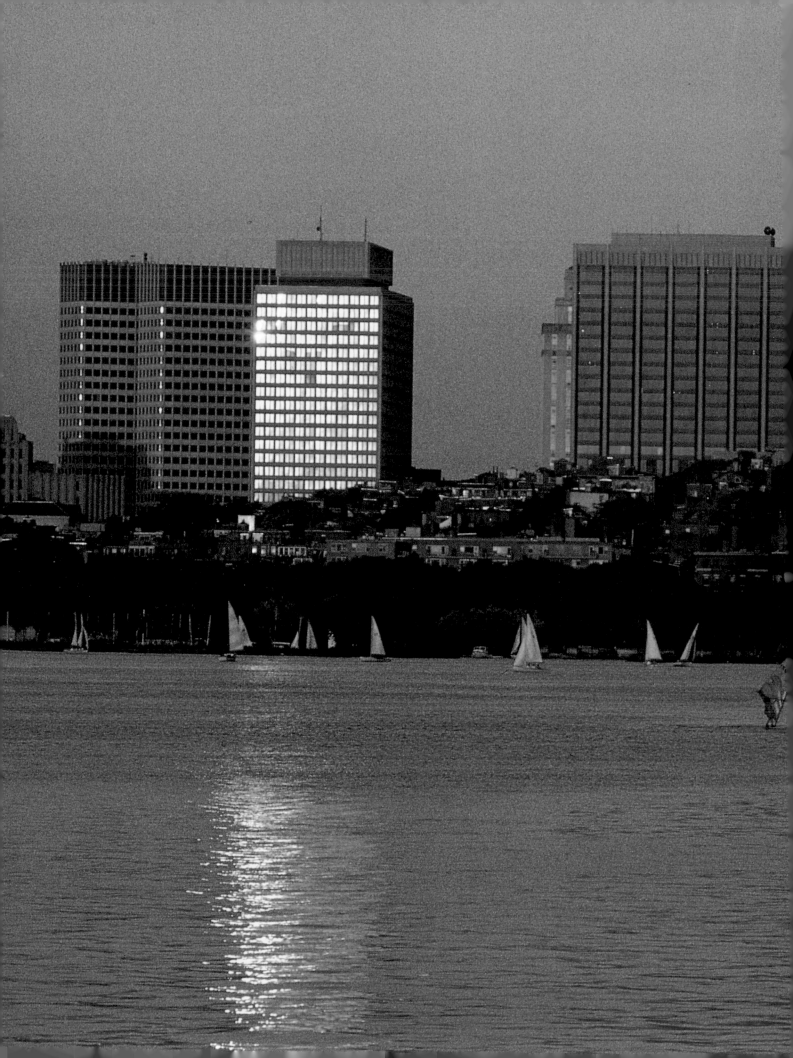

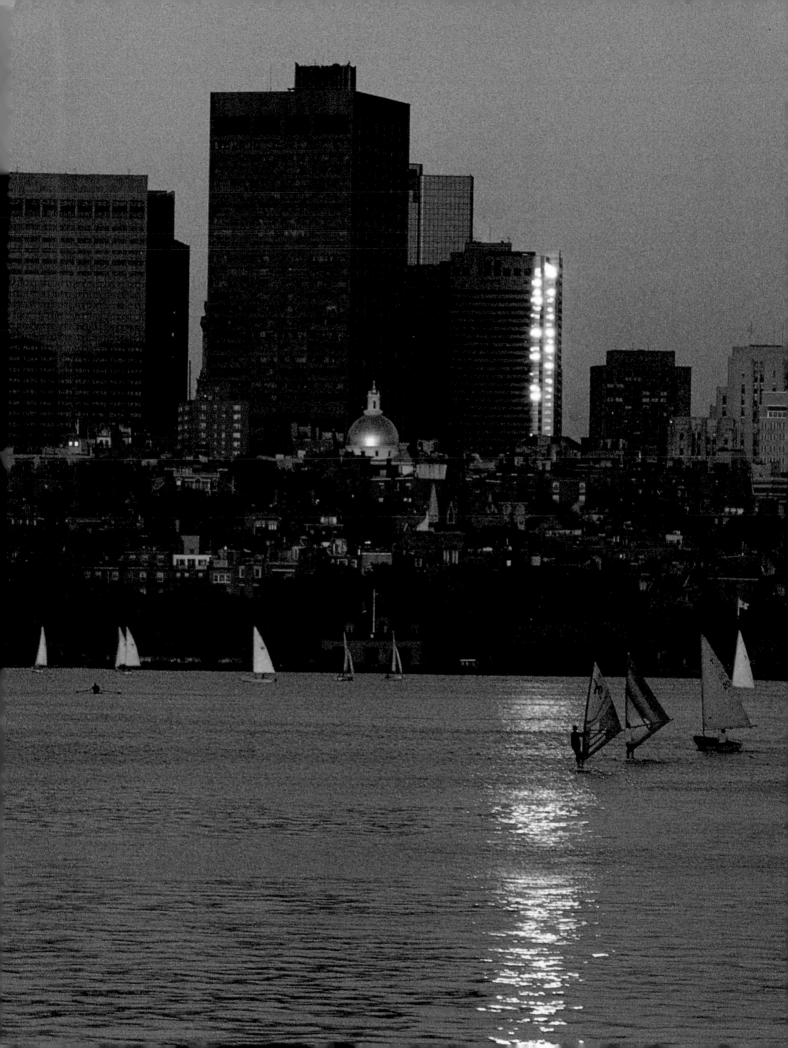

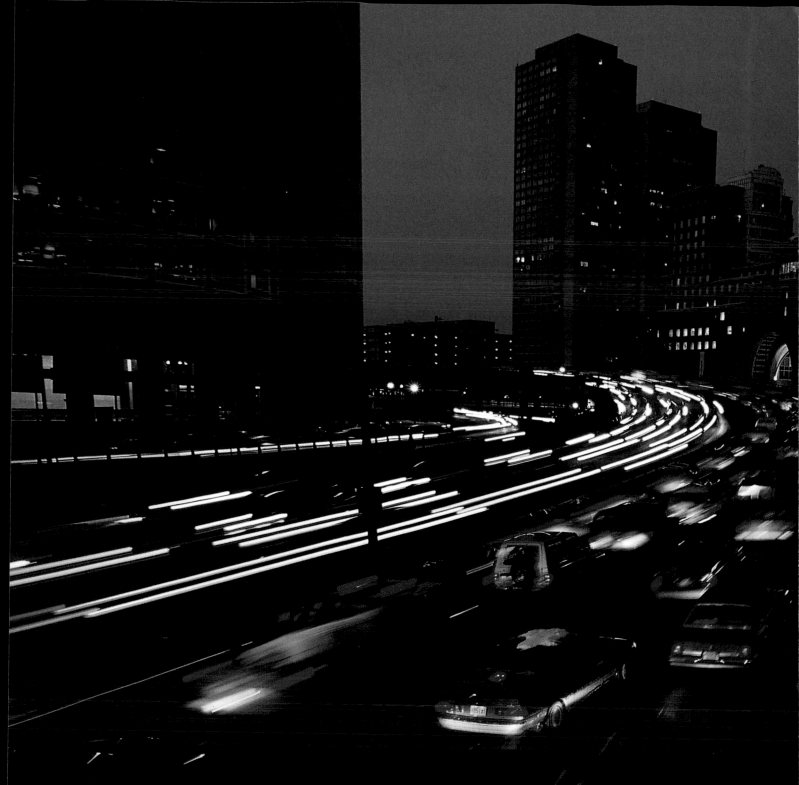

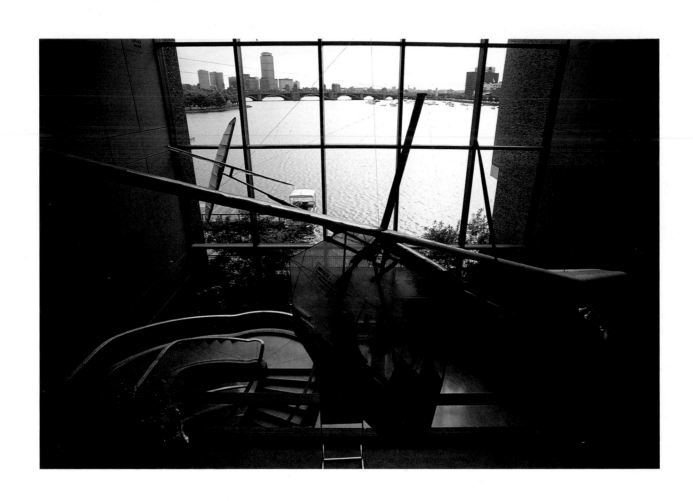

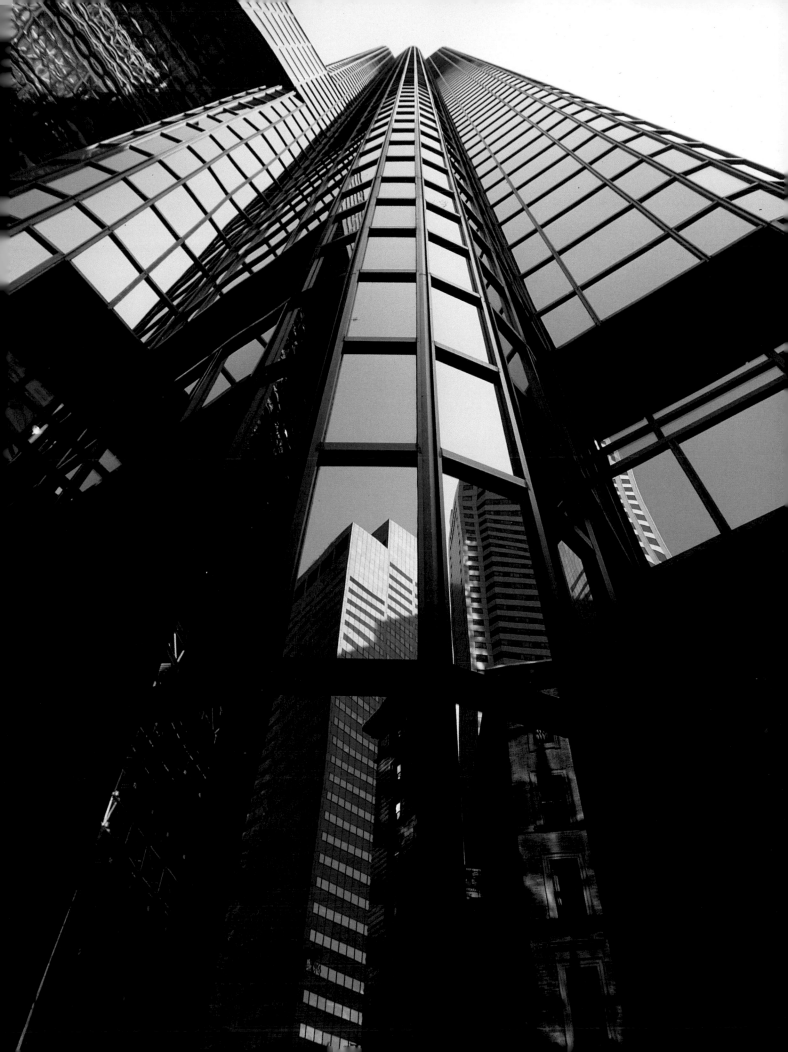

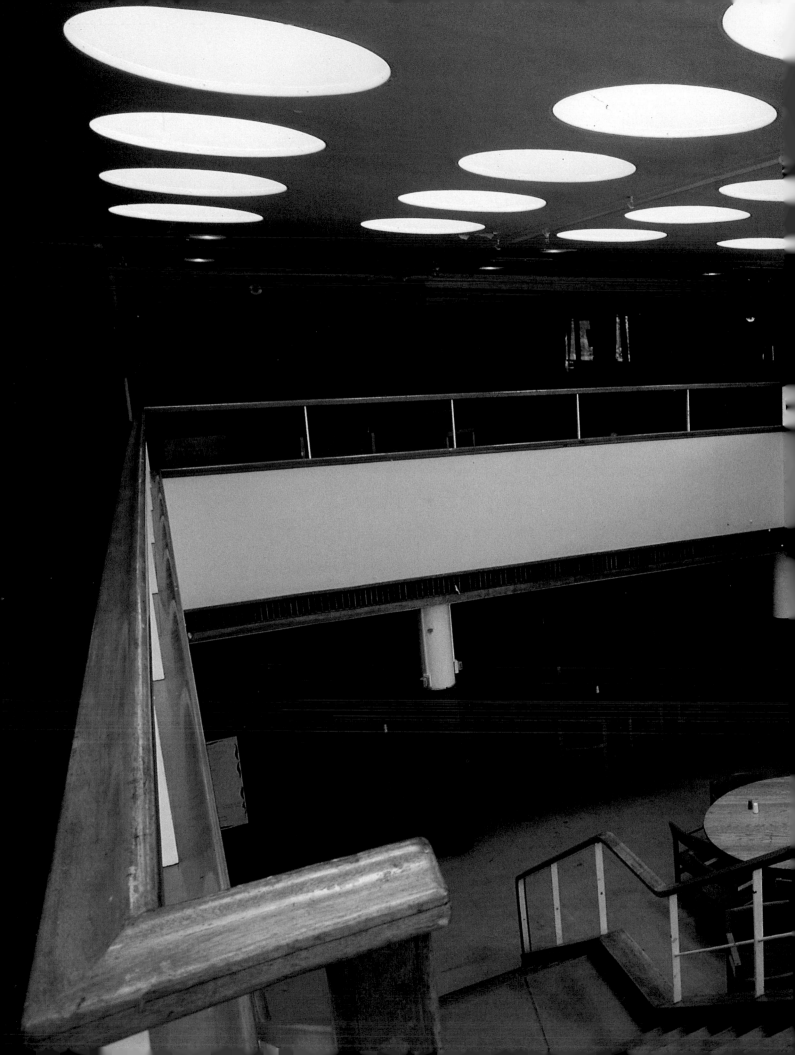

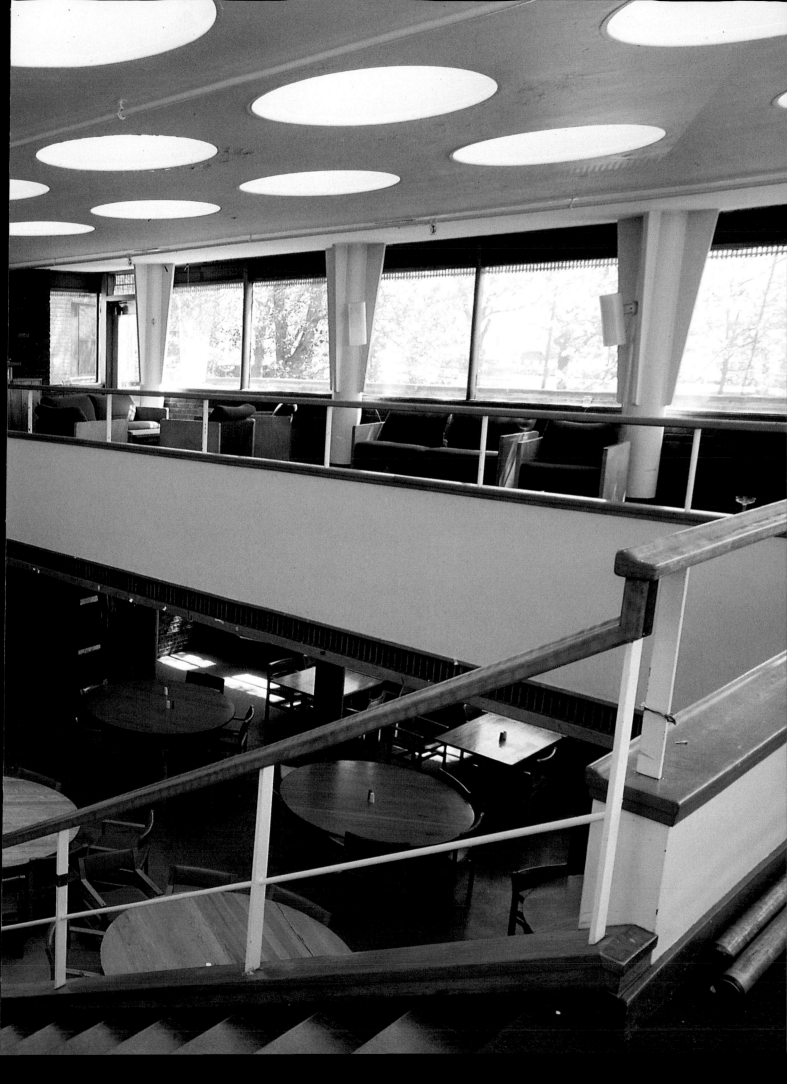

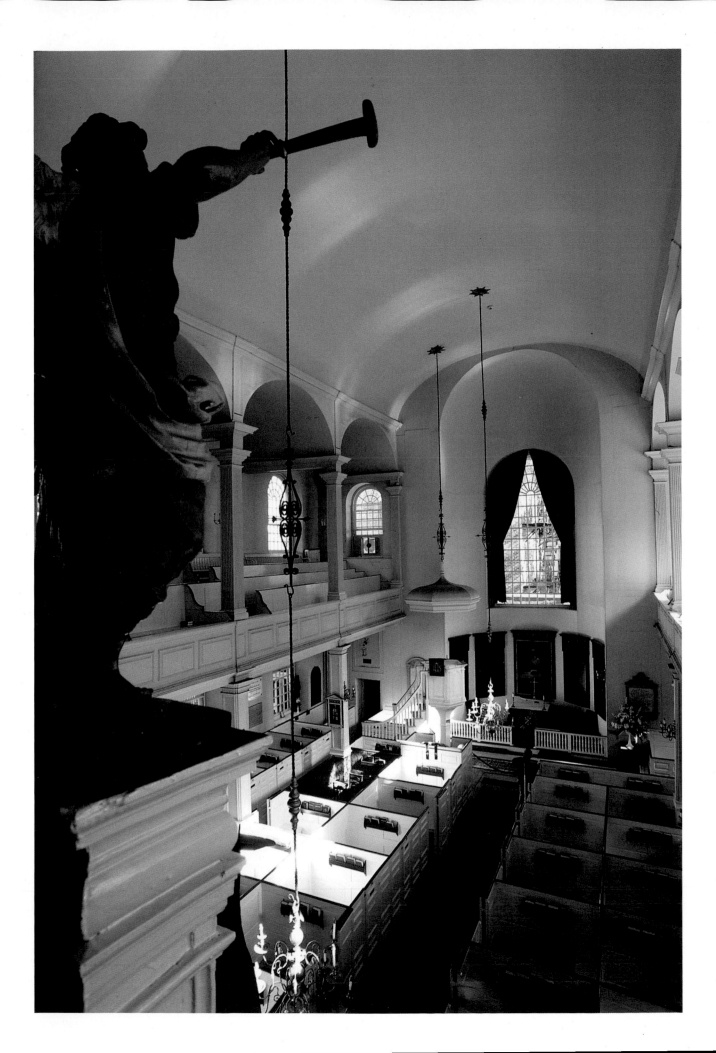

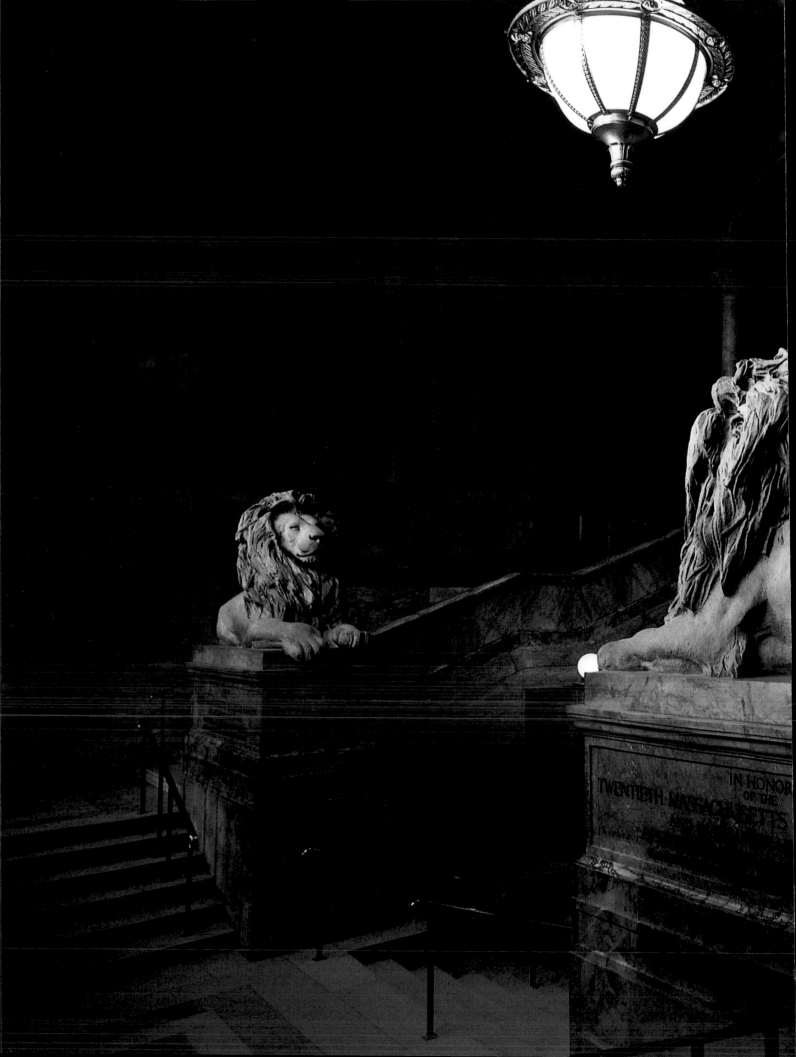

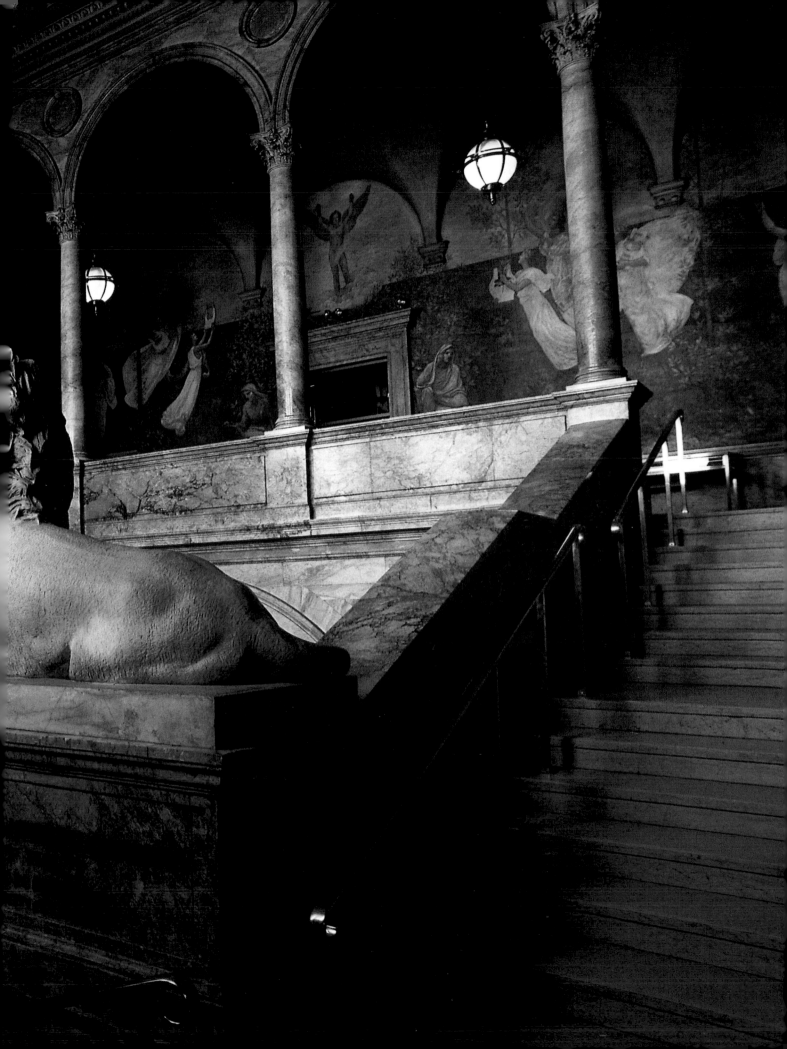

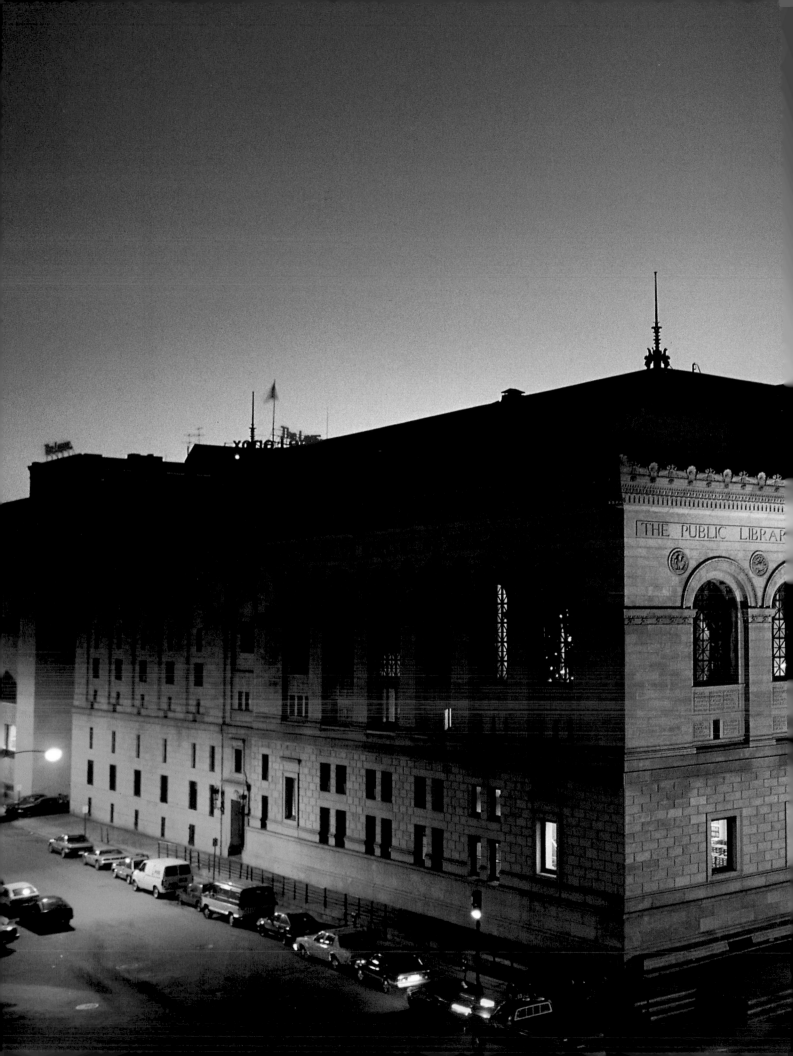

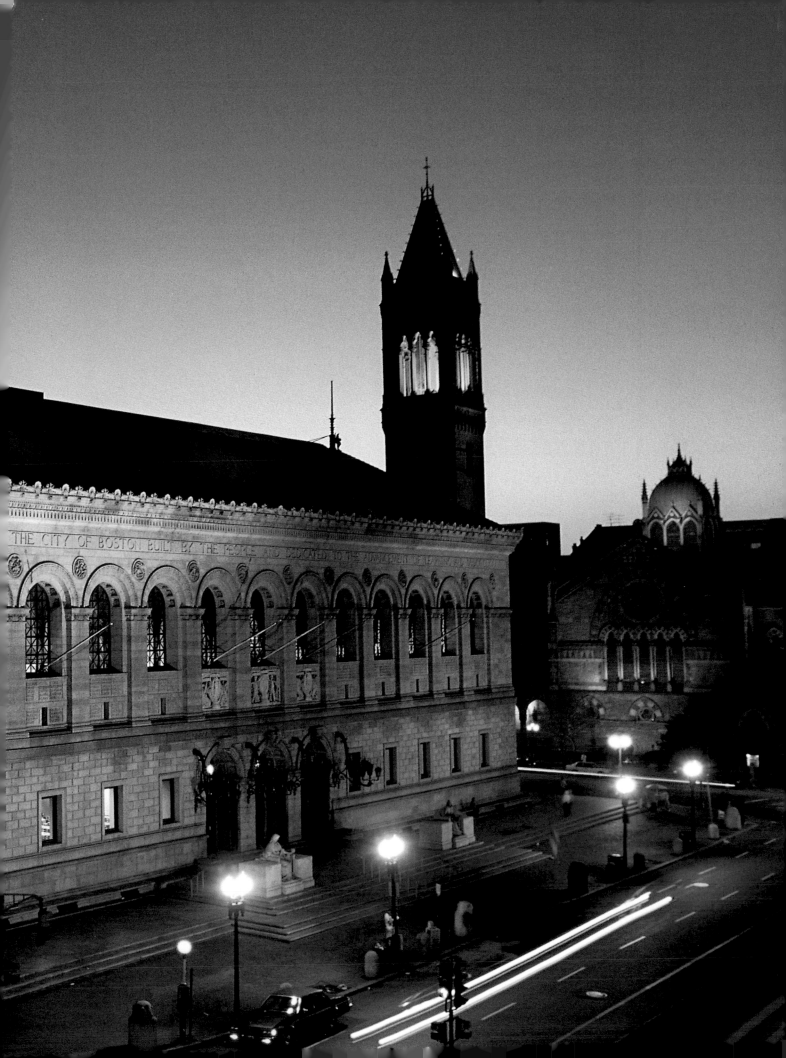

Page 72. Harvard Square subway station, Cambridge
Page 73. Decorated chimney pots, Cambridge

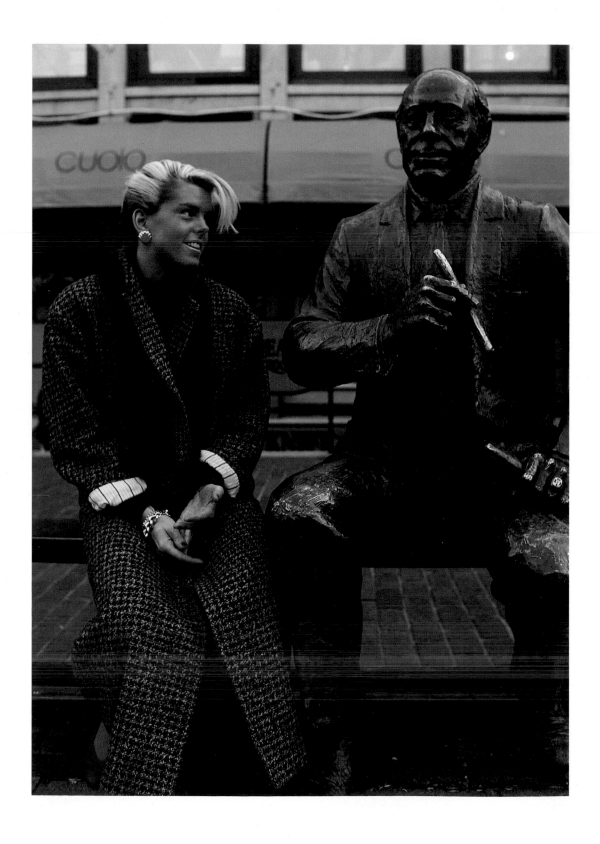

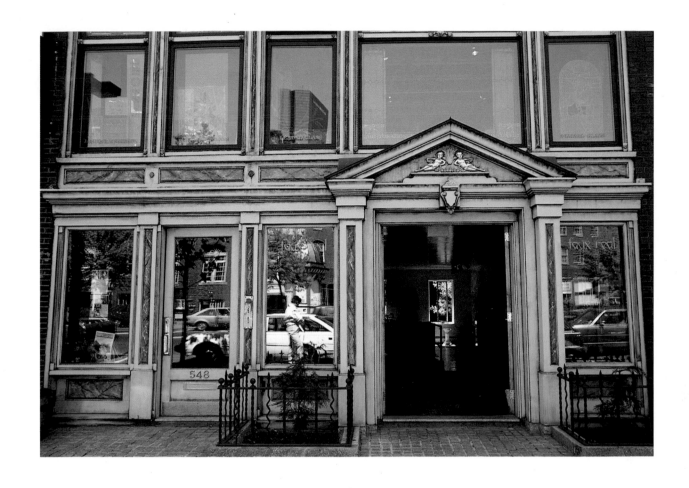

Page 74. Statue of Arnold "Red" Auerbach, president of the
Boston Celtics, by Lloyd Lillie, with an admiring companion
outside Faneuil Hall

Page 75. Faux Real, facade, Tremont Street

Pages 76–77. State House, interior

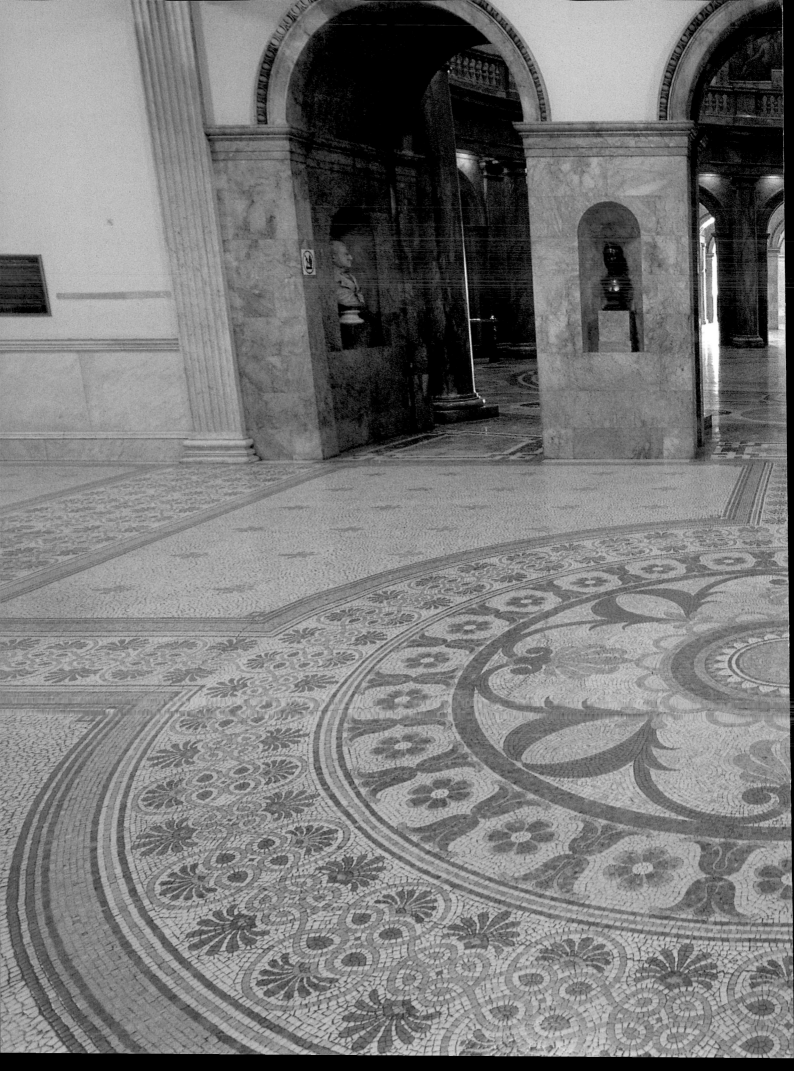

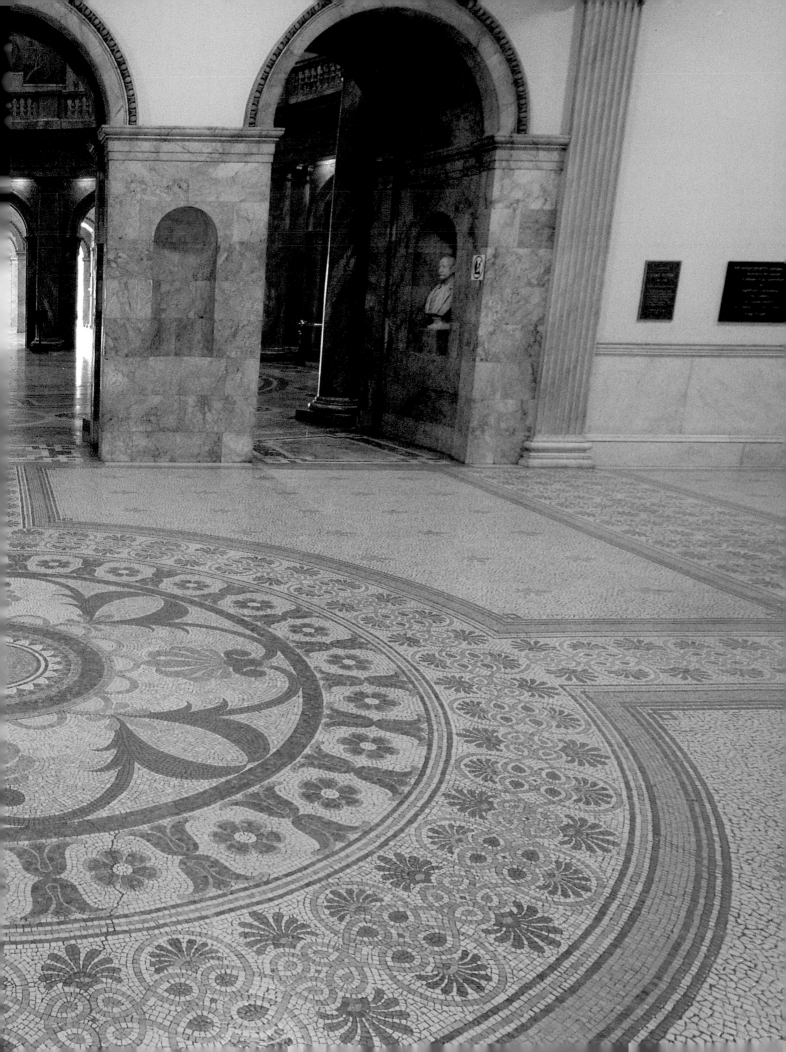

Page 79. King's Chapel

Pages 80–81. Gund Hall, Harvard University

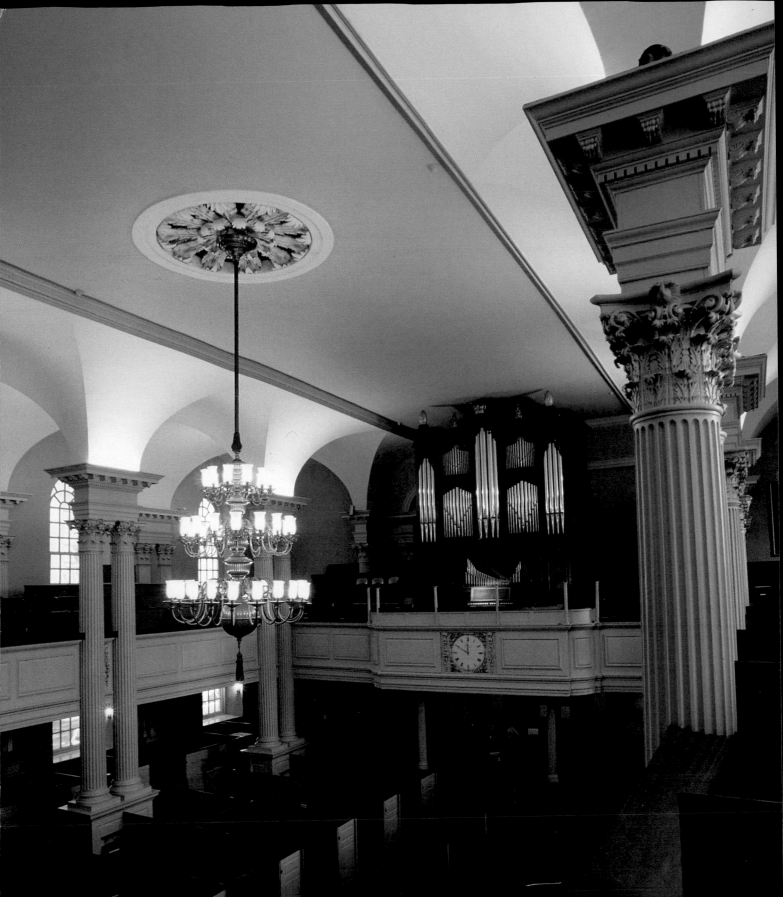

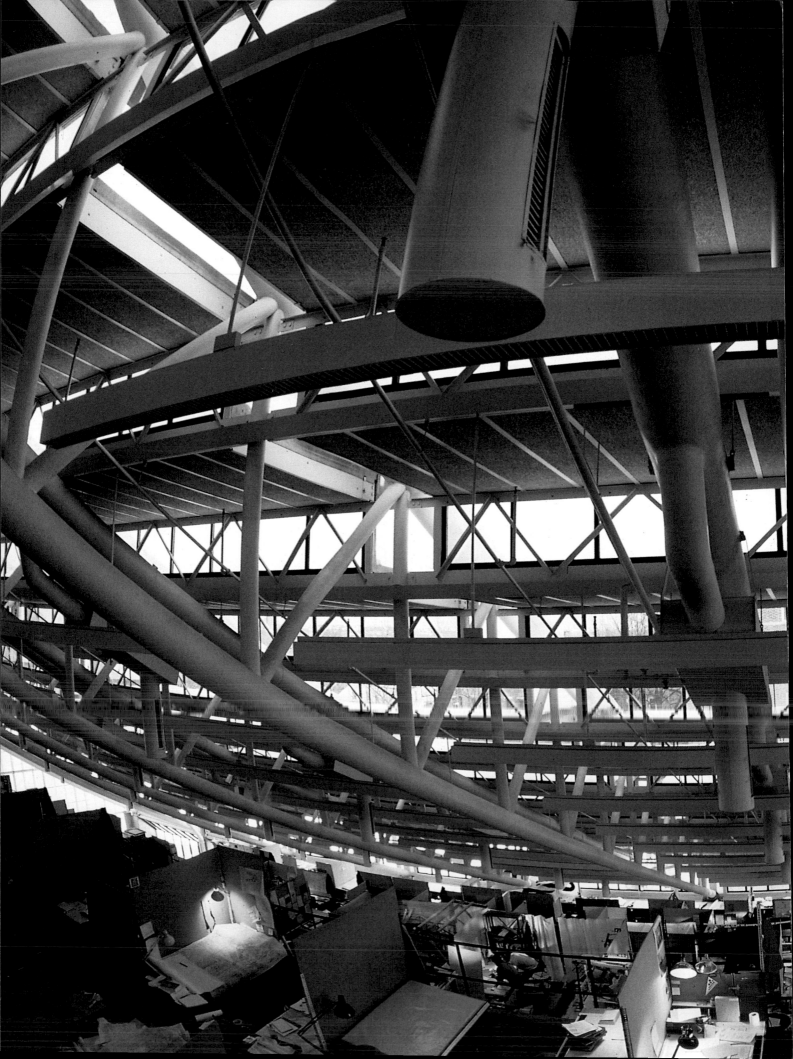

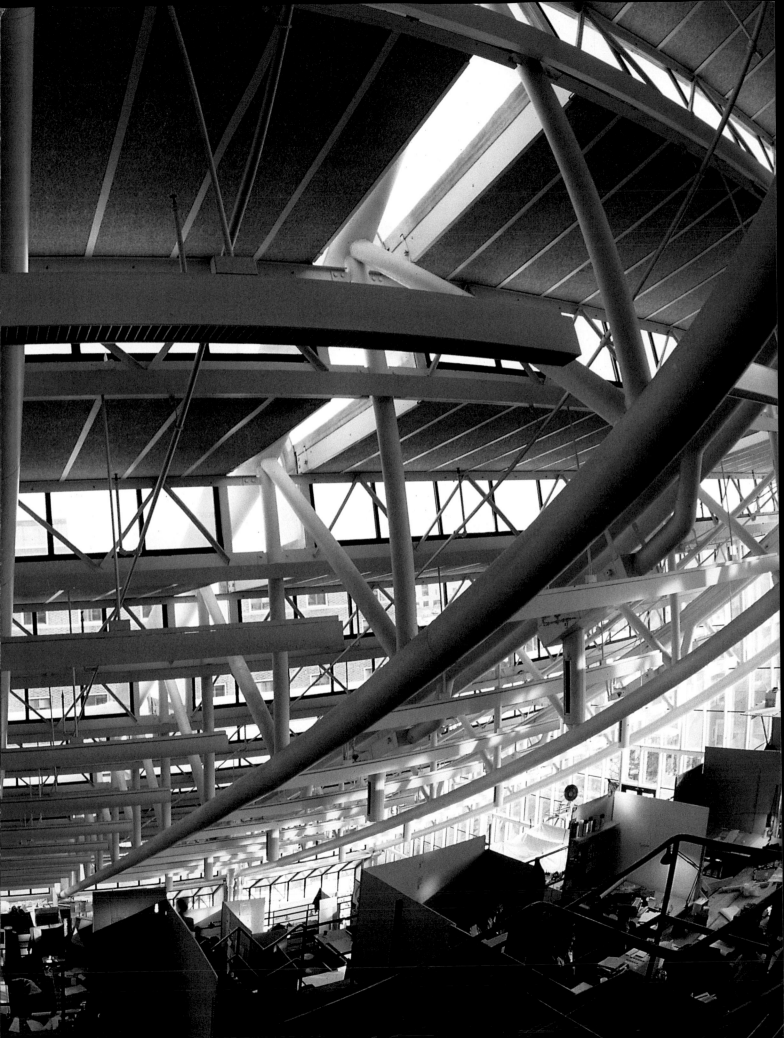

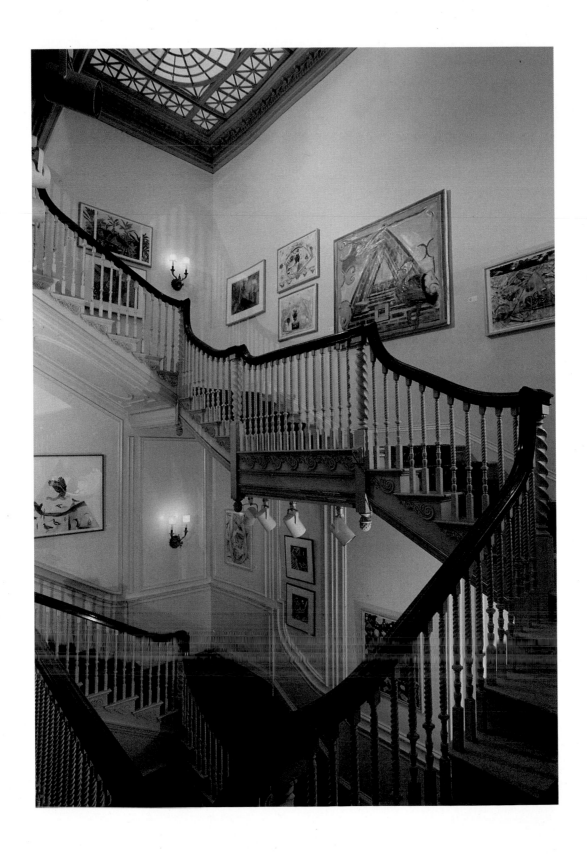

Page 82. St. Botolph Club, interior

Page 83. The Arthur M. Sackler Museum, staircase, by James Stirling

Pages 84–85. Walker Memorial, Massachusetts Institute of Technology

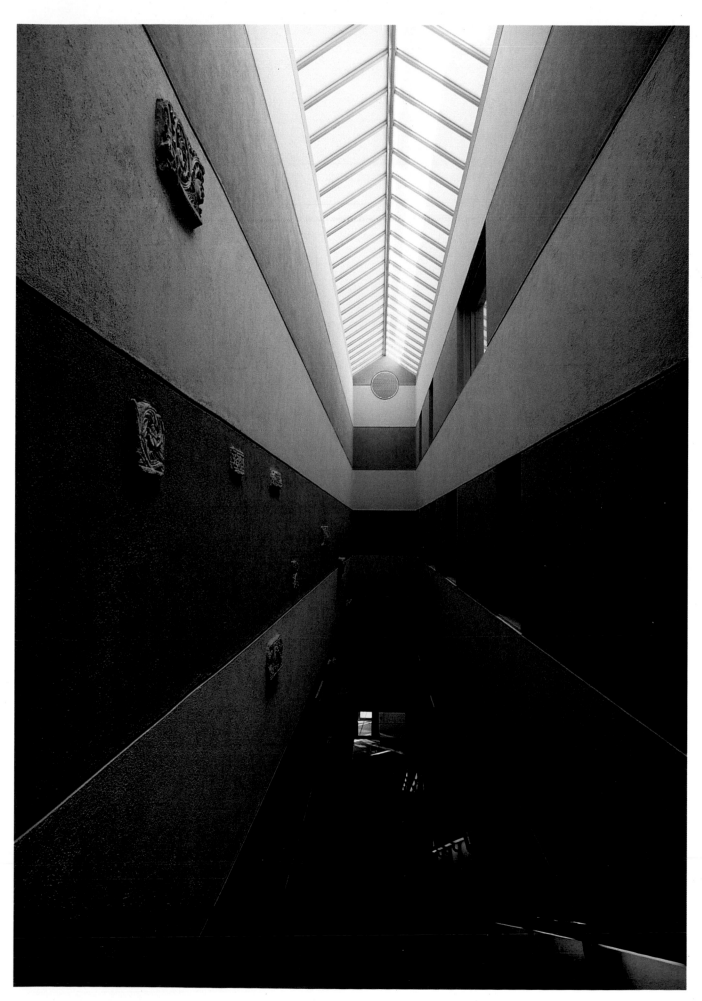

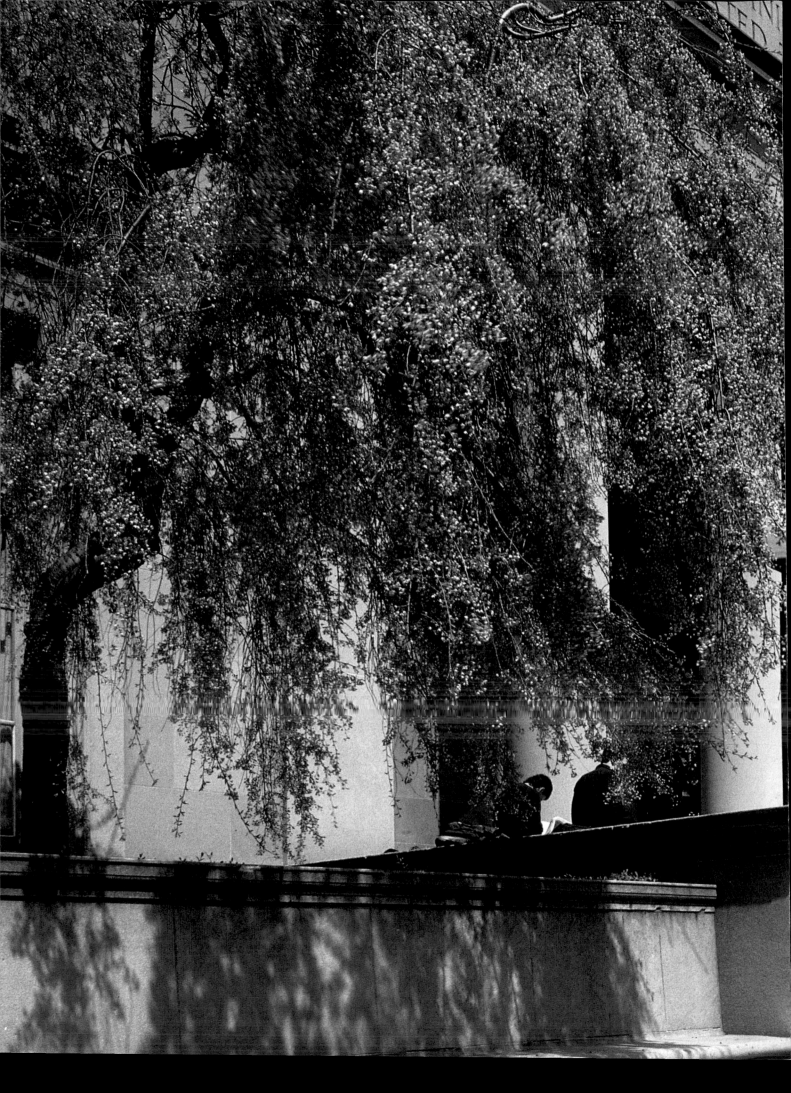

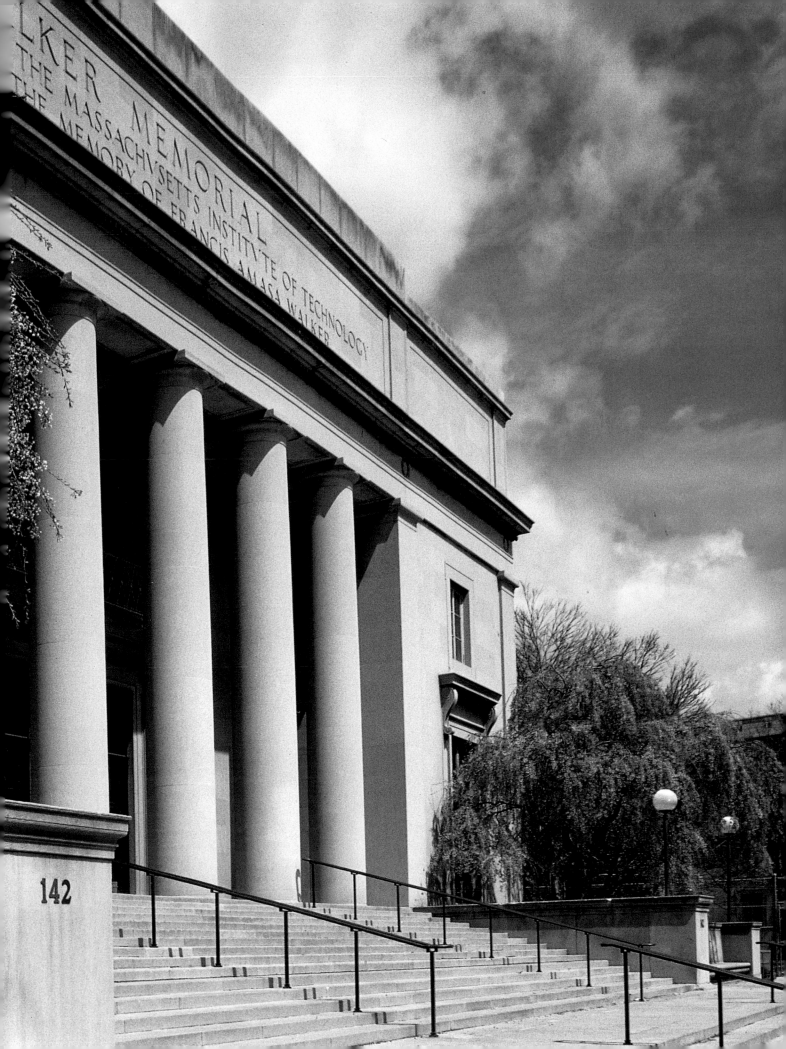

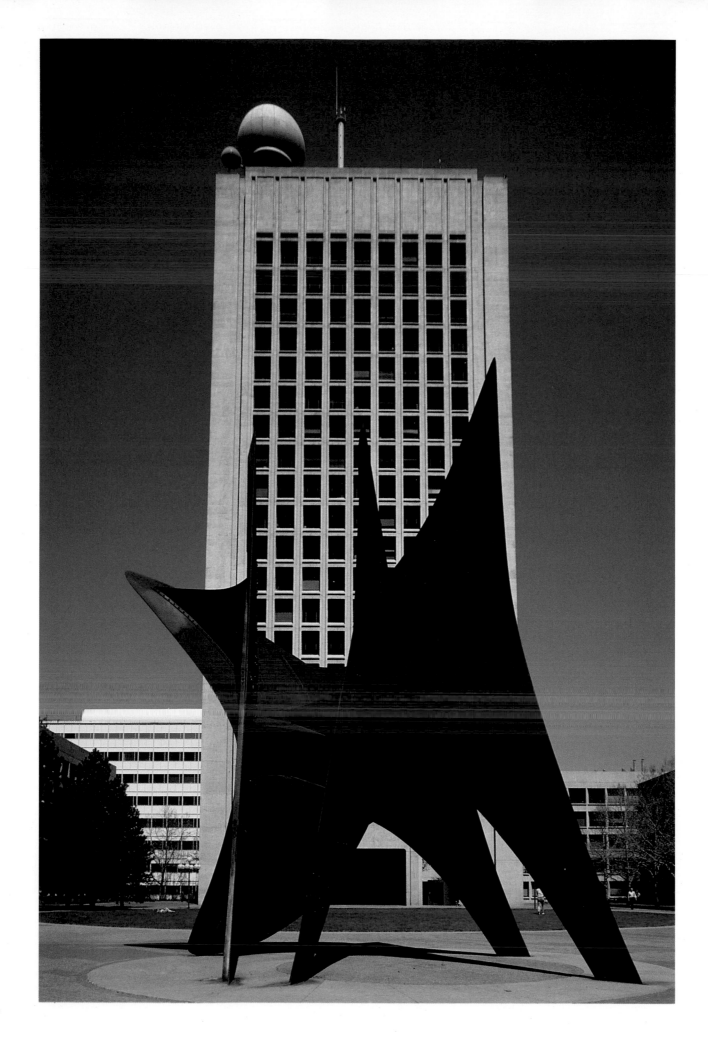

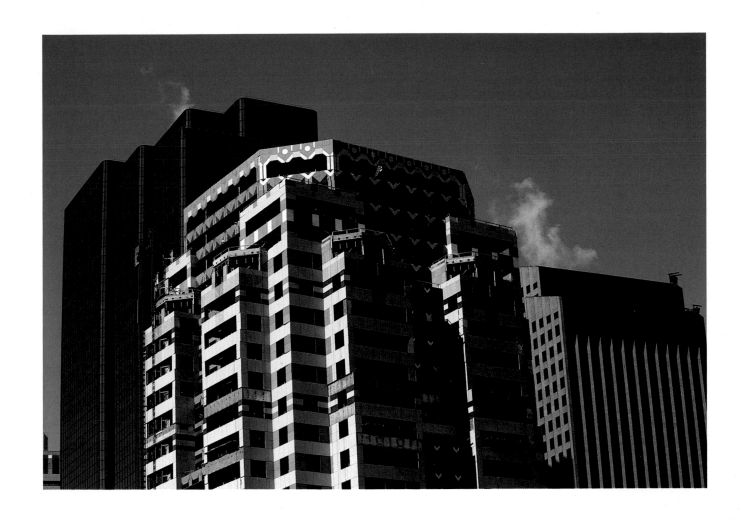

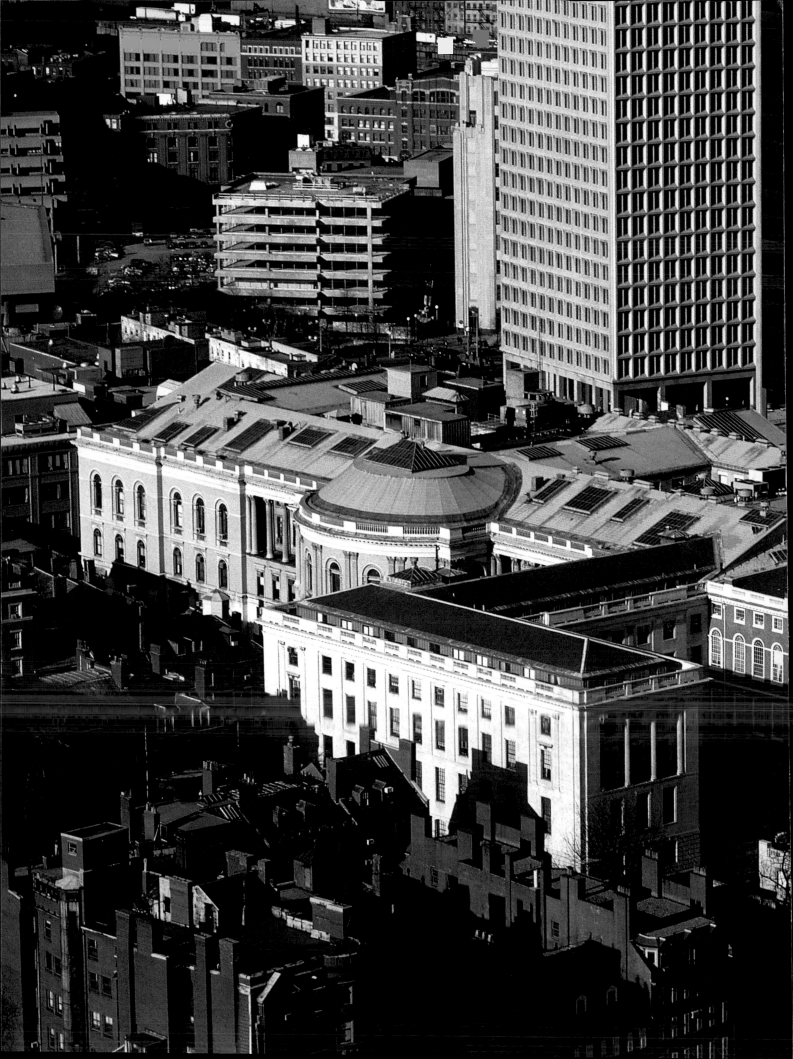

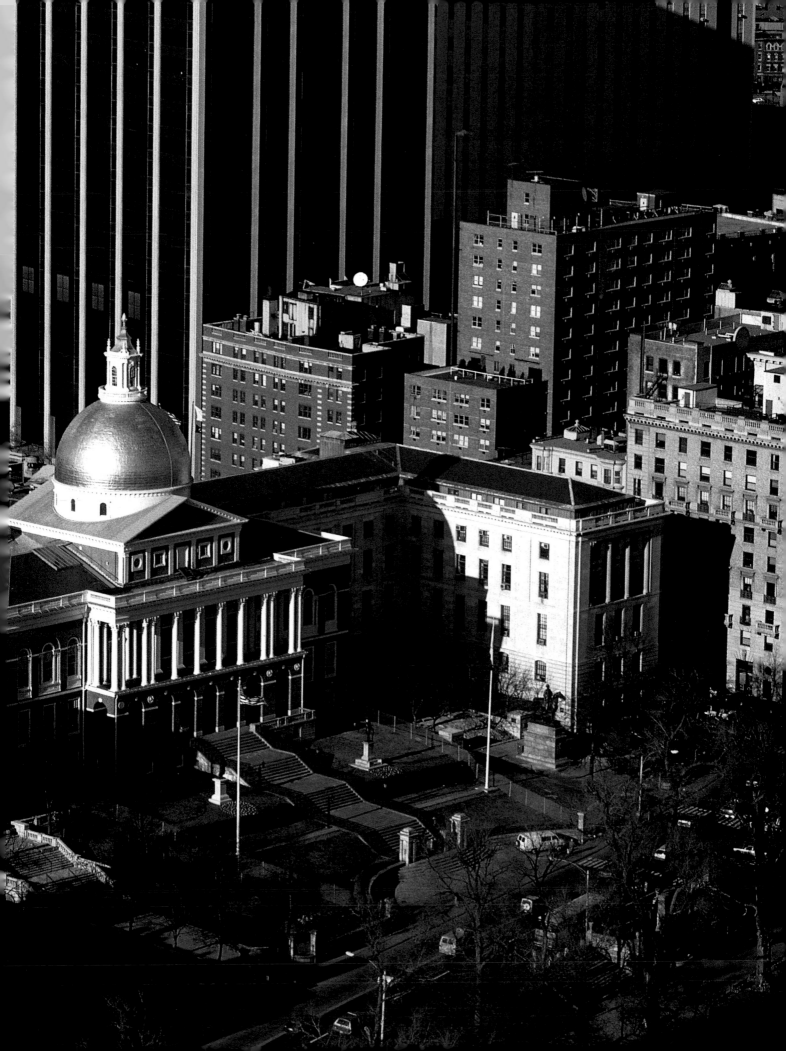

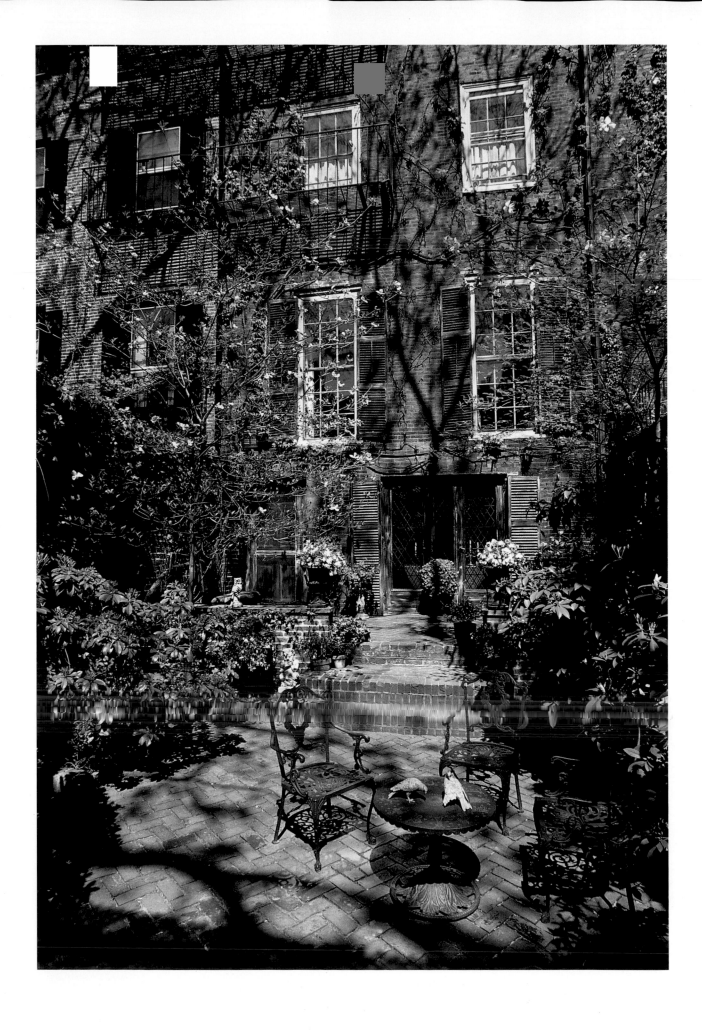

90

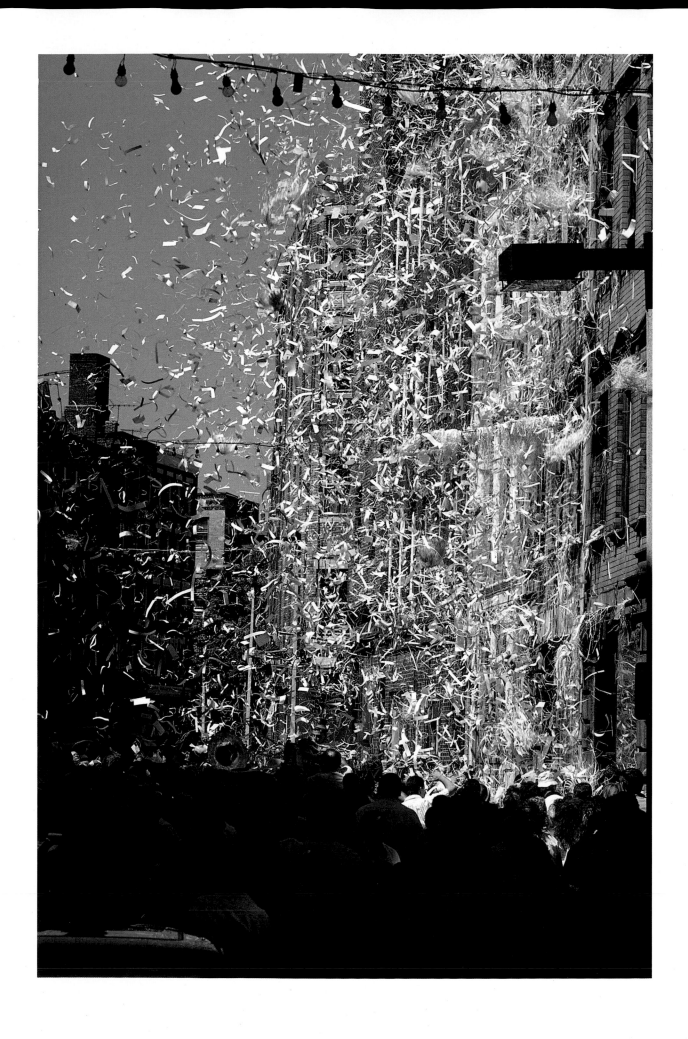

Page 93. Ames Building, One Court Street
Pages 94–95. Boston City Hall

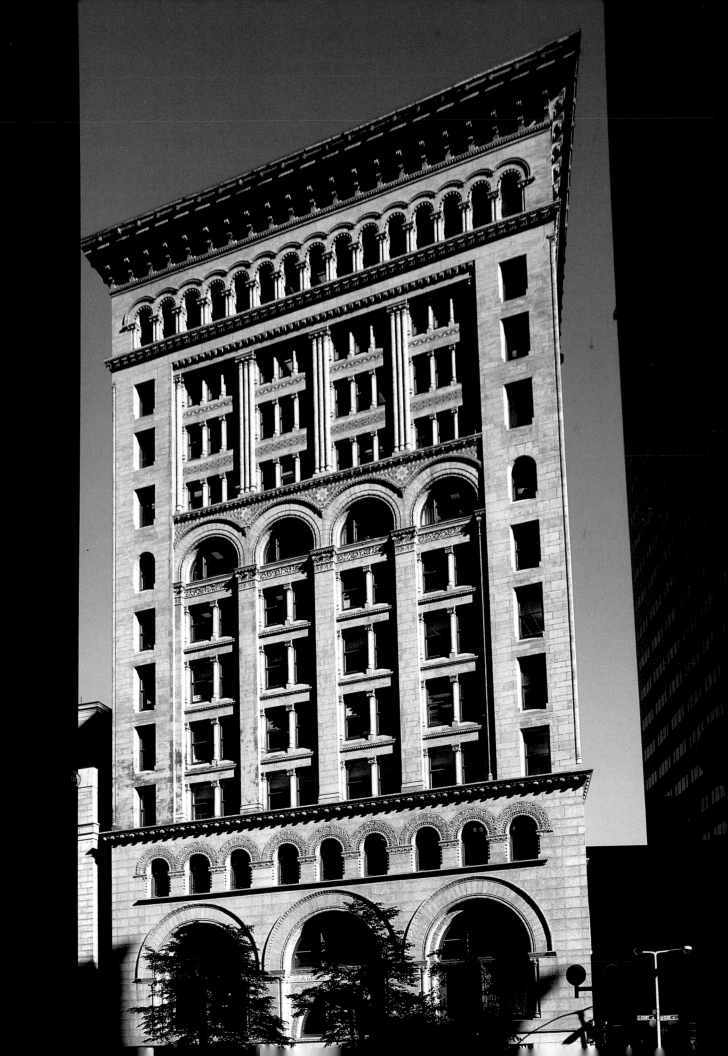

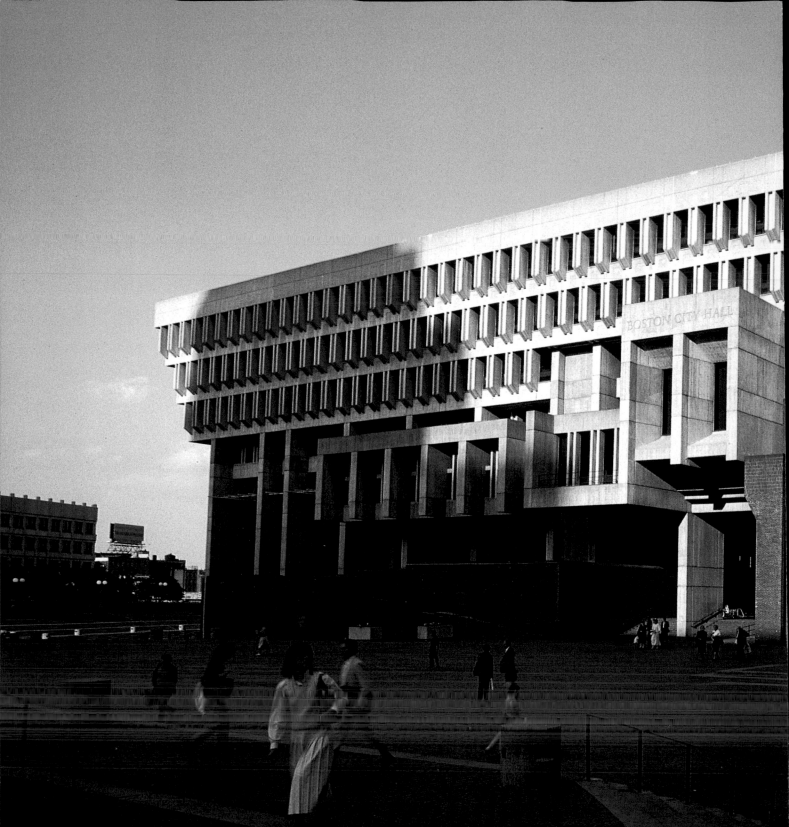

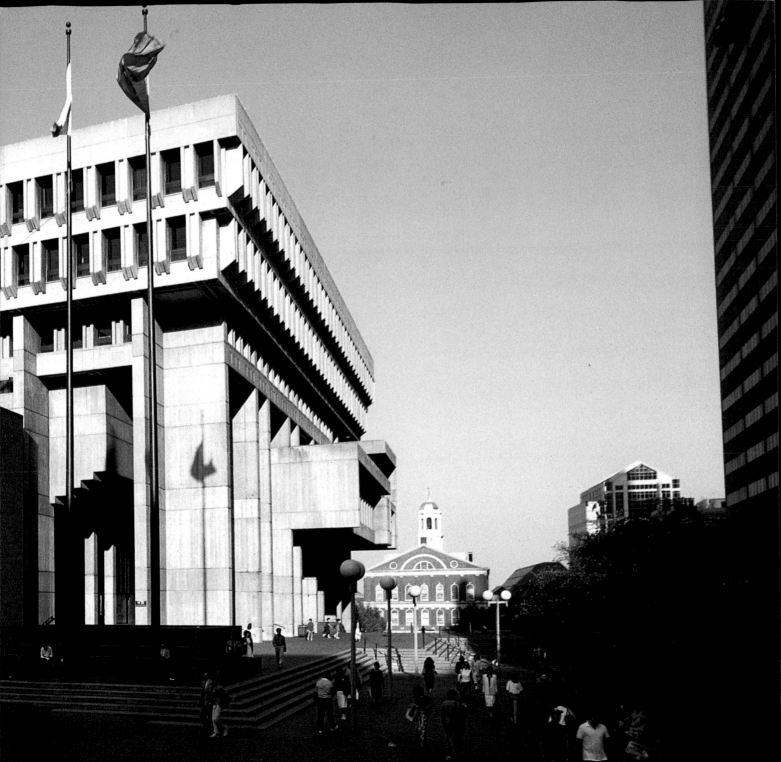

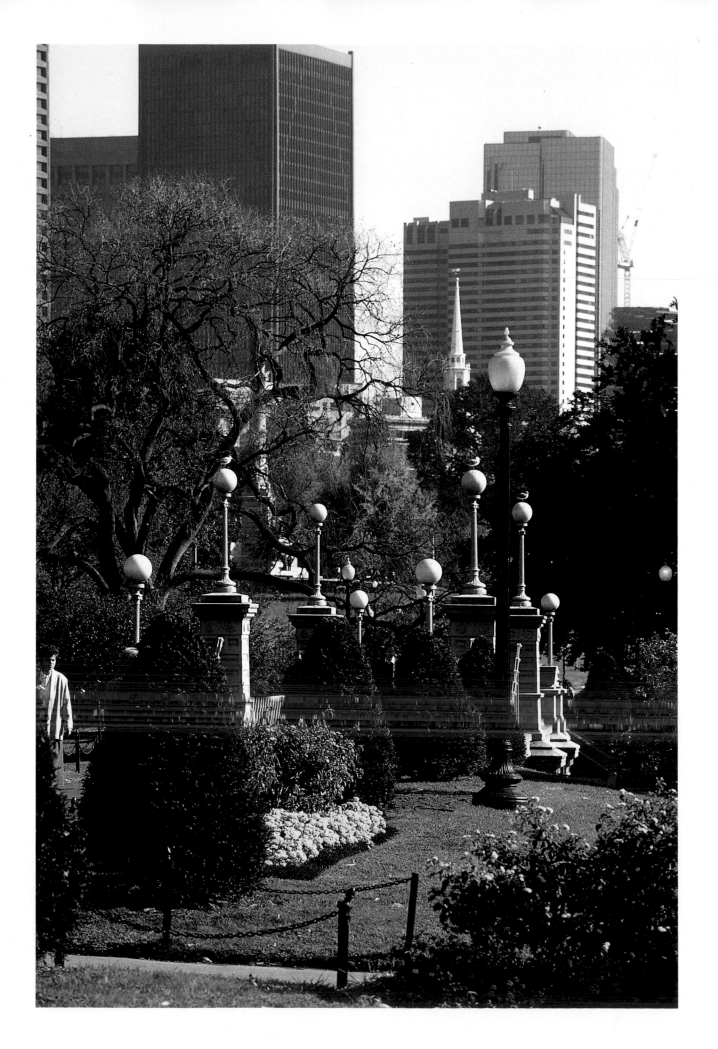

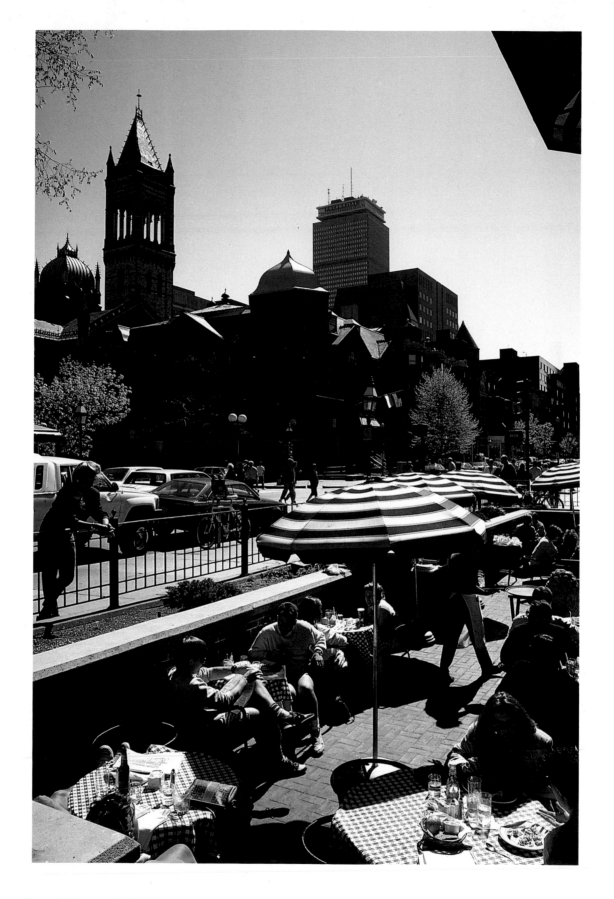

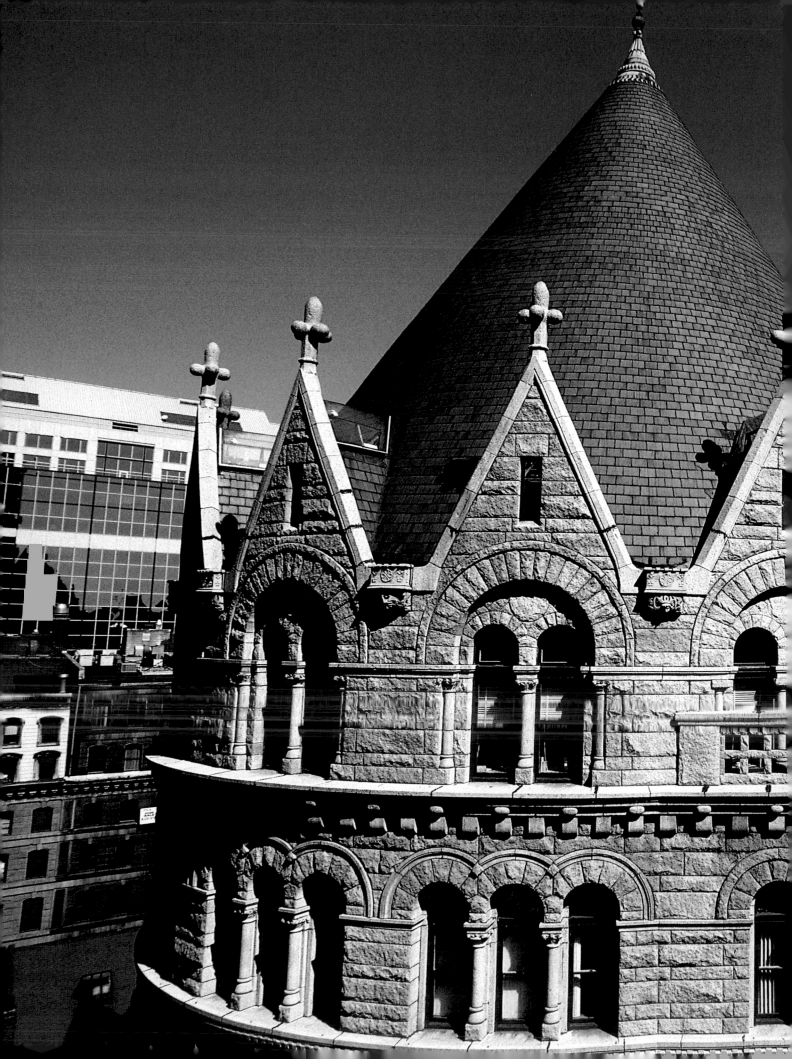

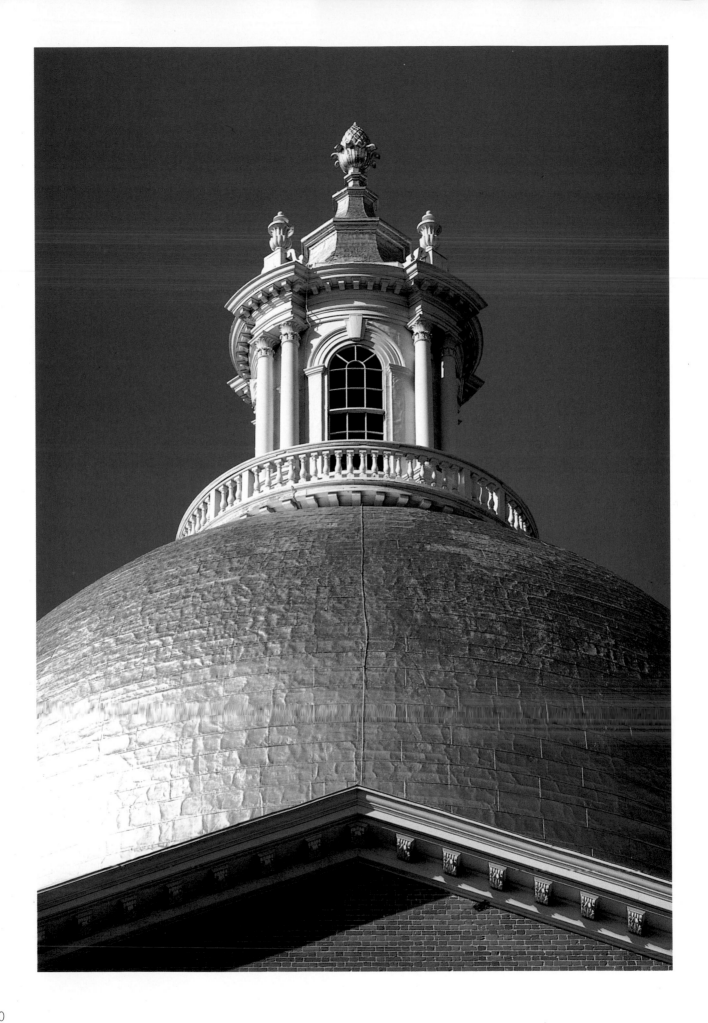

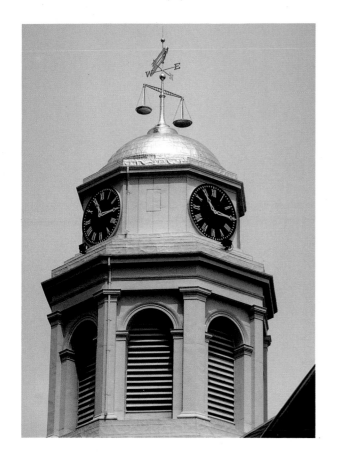
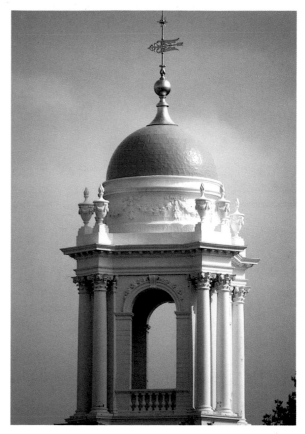
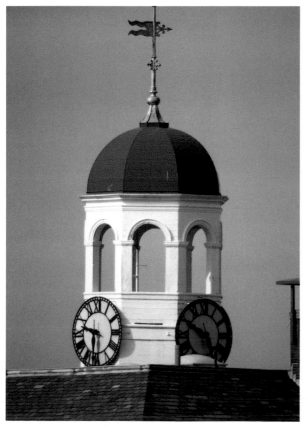
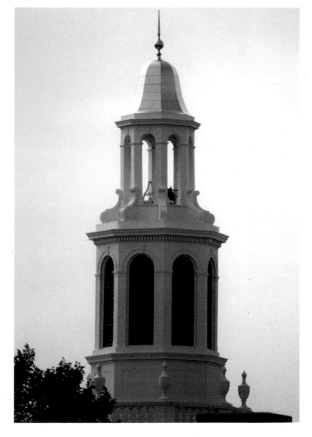

Page 100. The golden dome of the State House

Page 101. Cambridge towers and cupolas

Pages 102–3. Custom House Tower with Logan Airport at rear

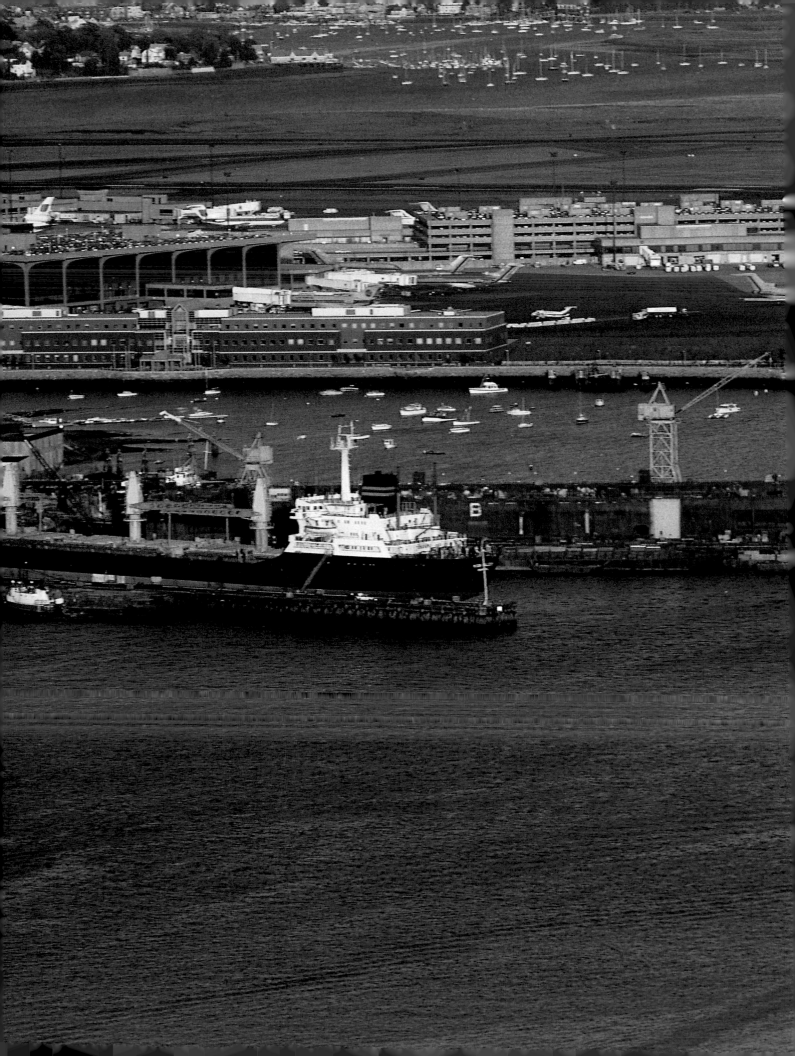

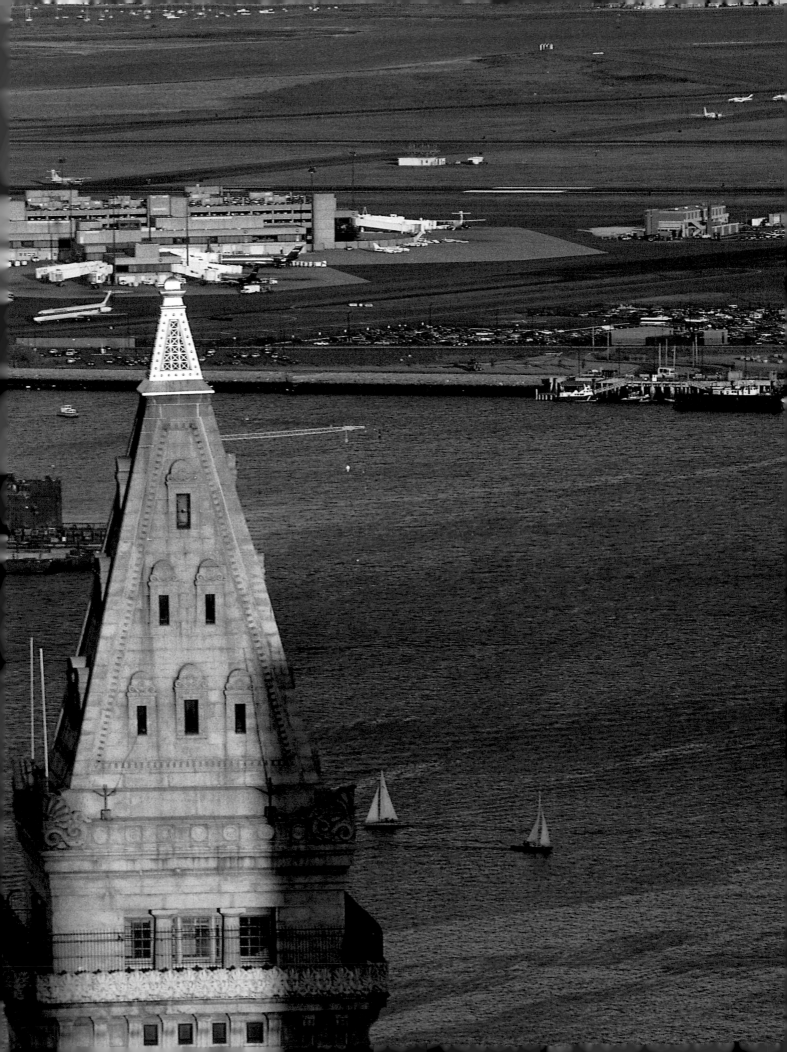

Page 105. Old State House

Pages 106–7. Boston Common, *Soldiers and Sailors Monument*, by Martin Milmore

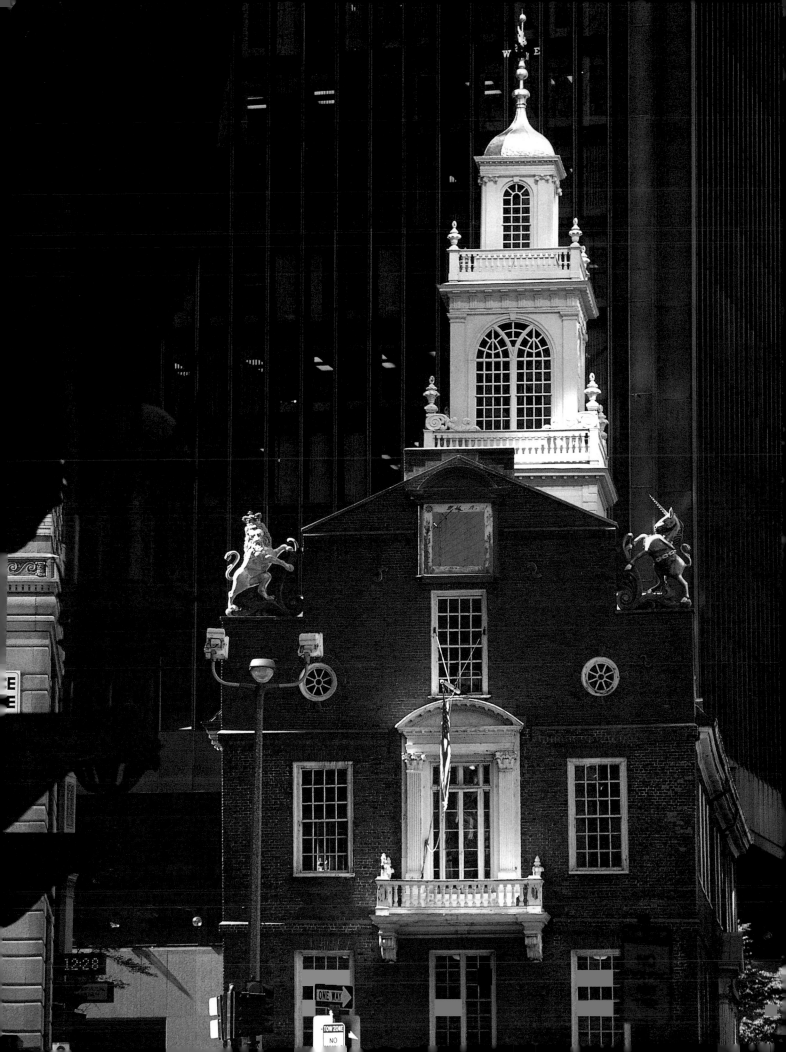

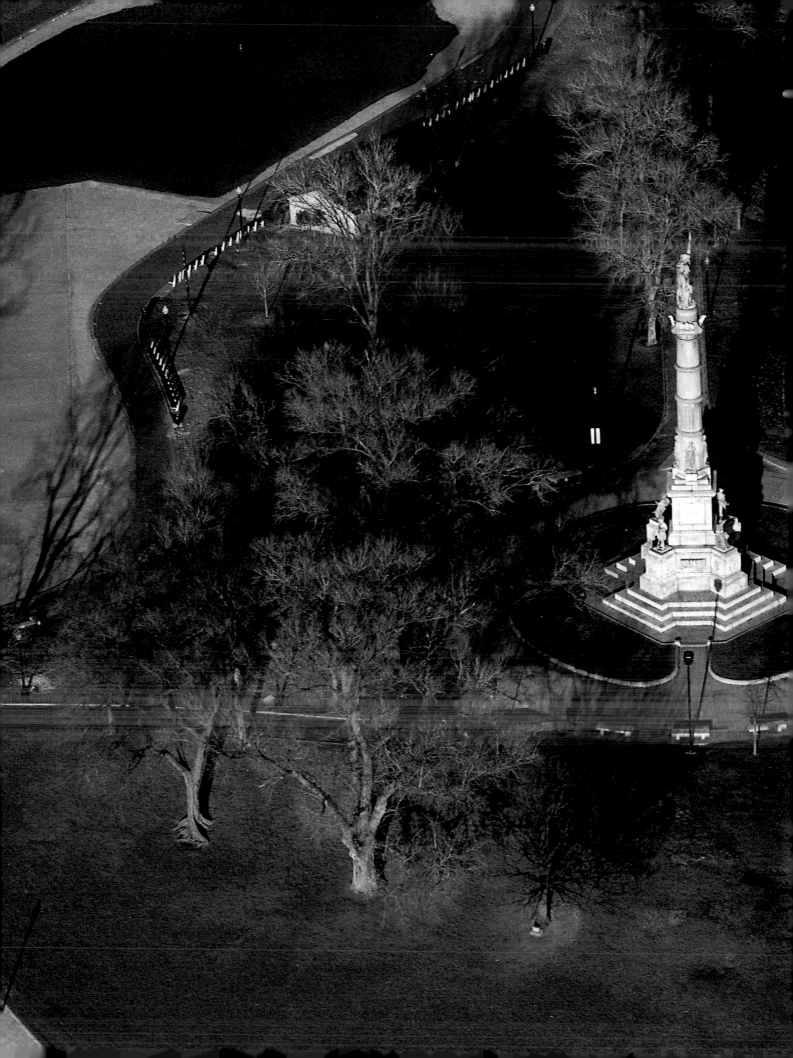

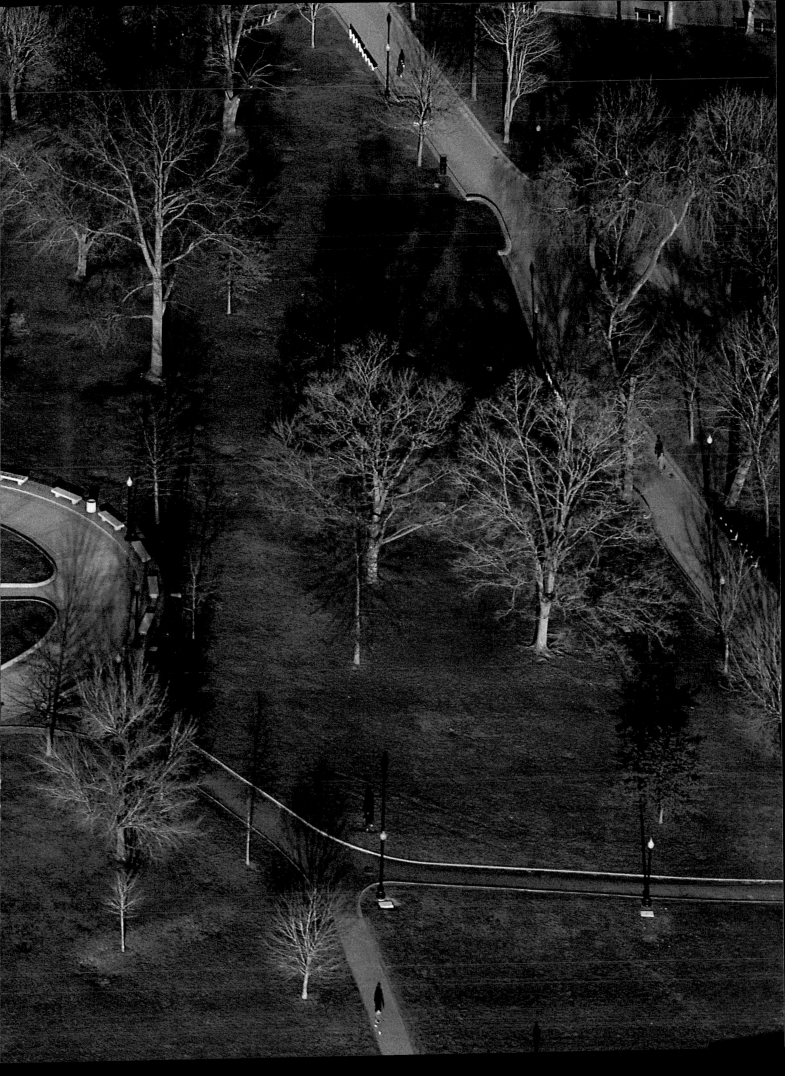

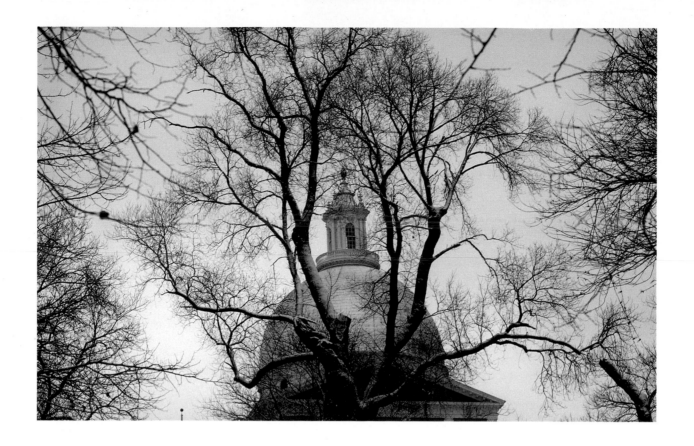

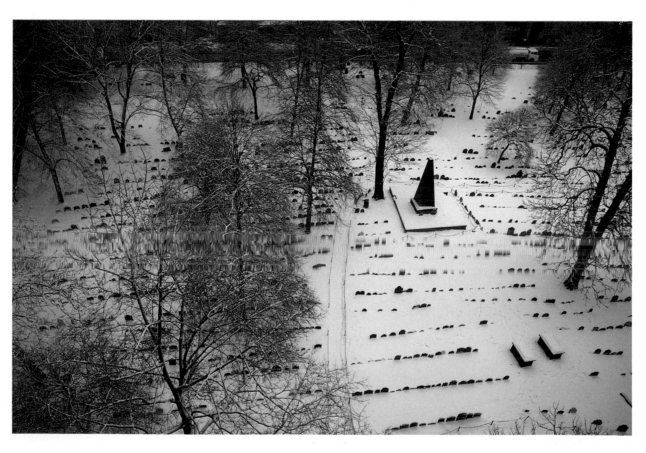

Top. The State House dome

Bottom. Old Granary Burying Ground

Christmas tree on the State House grounds

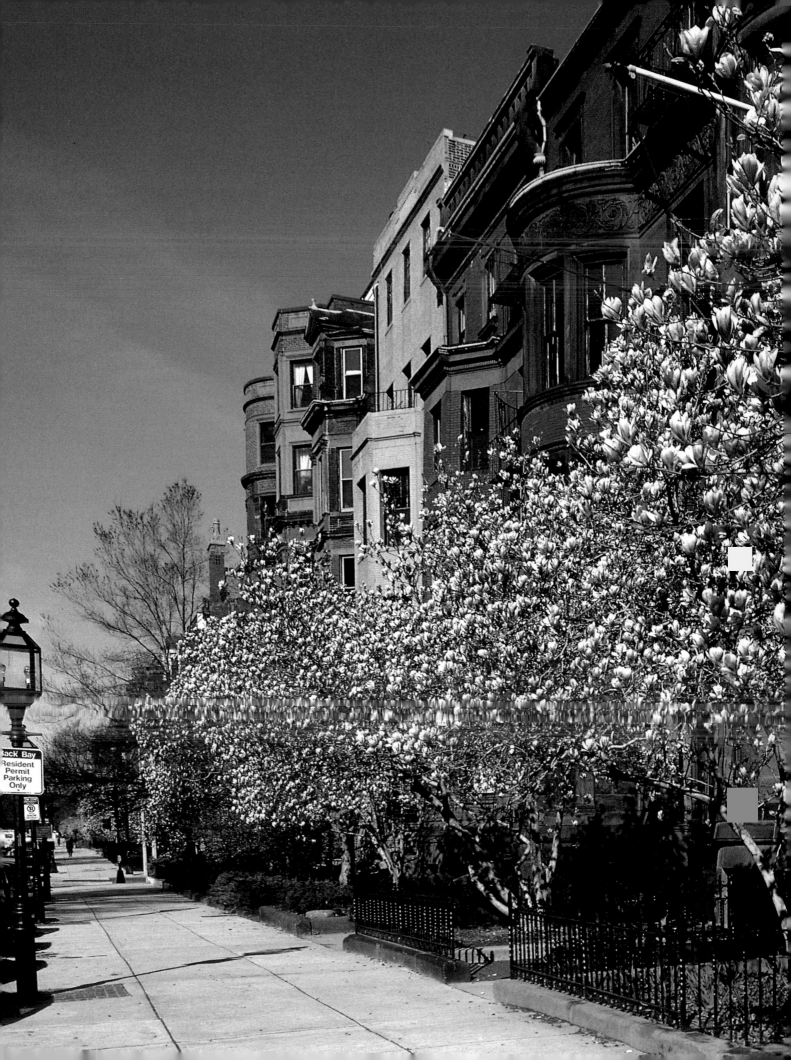

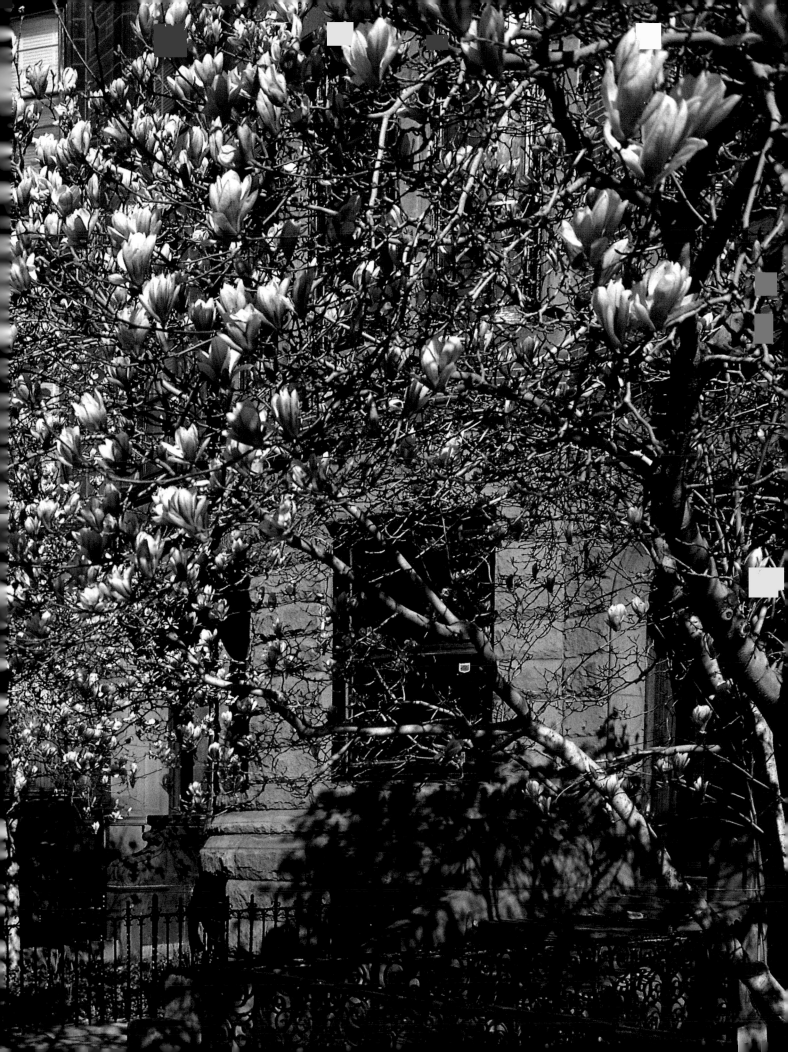

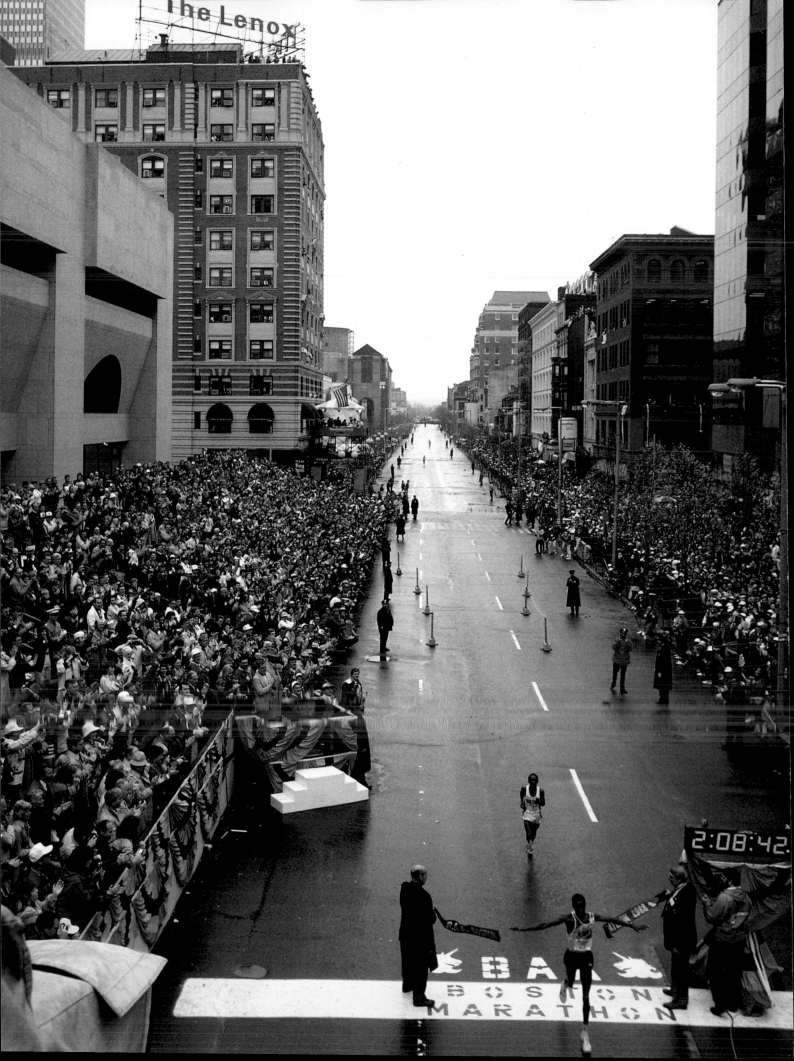

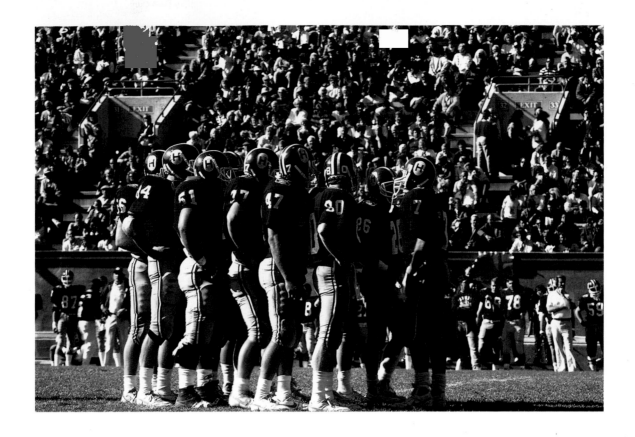

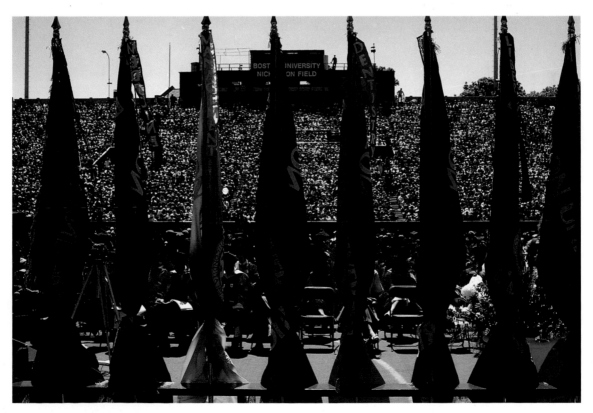

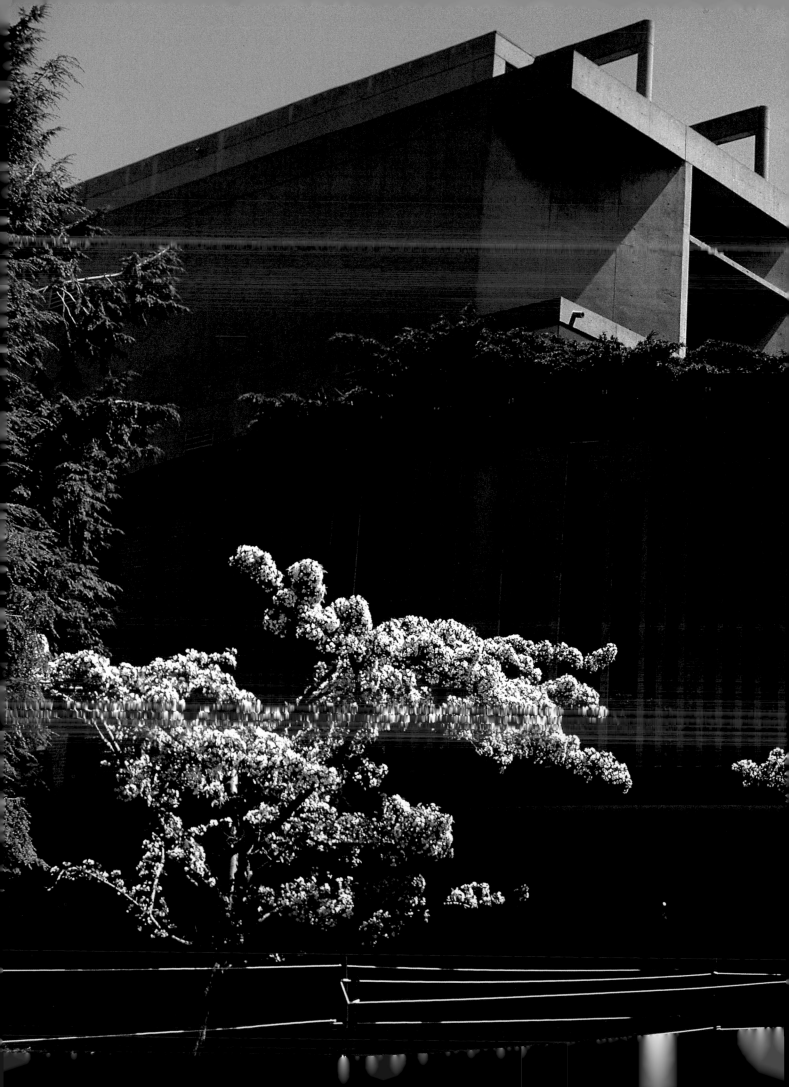

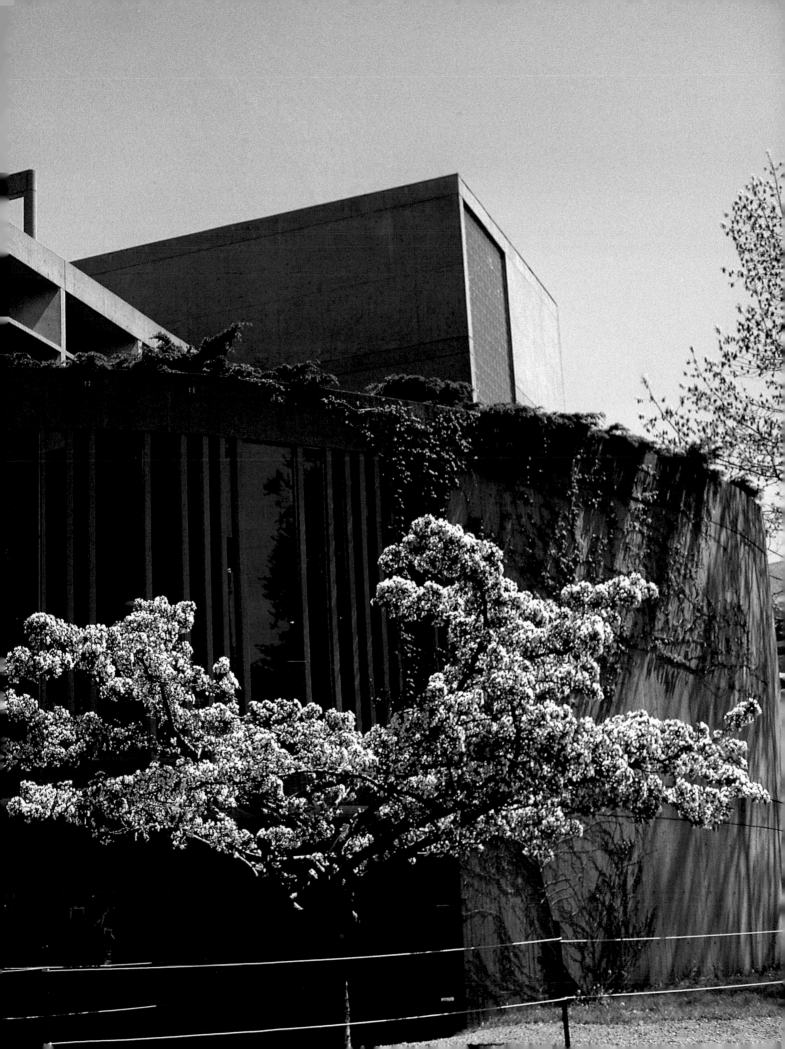

The Prudential Center

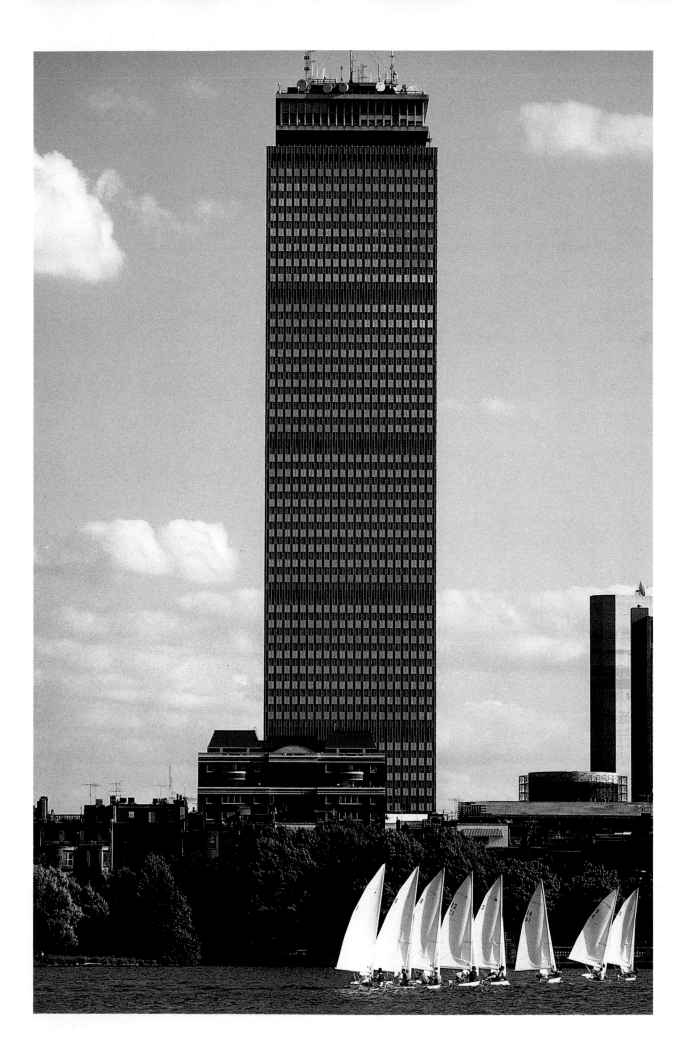

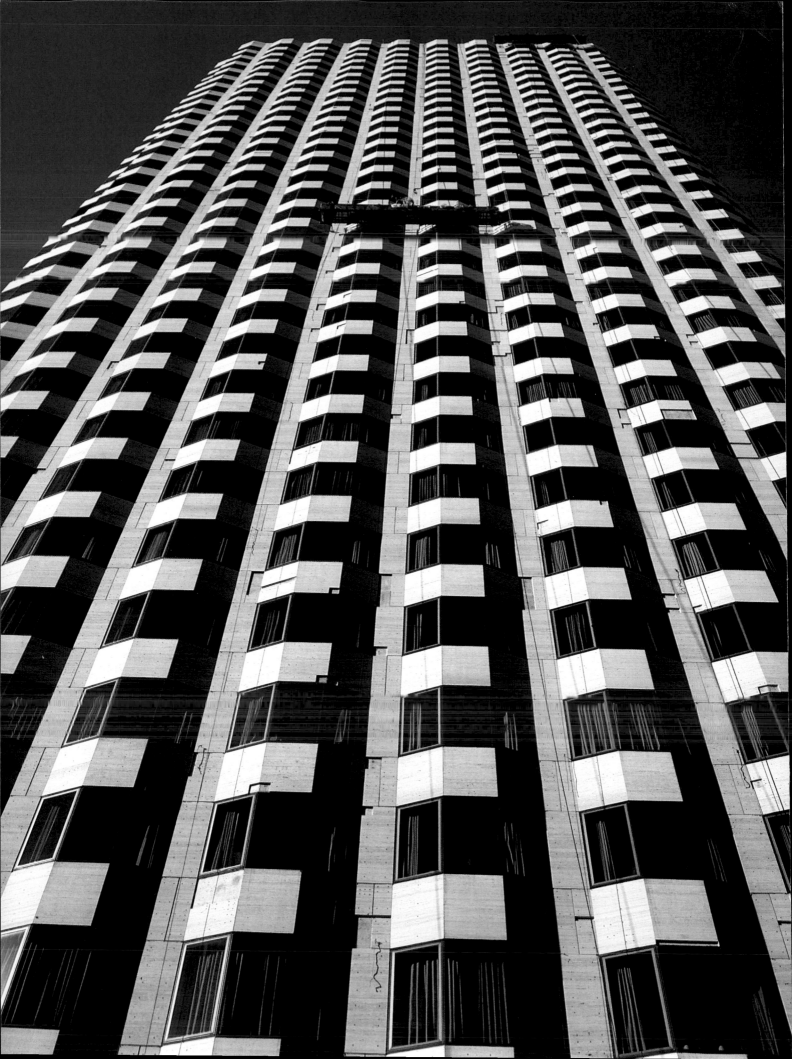

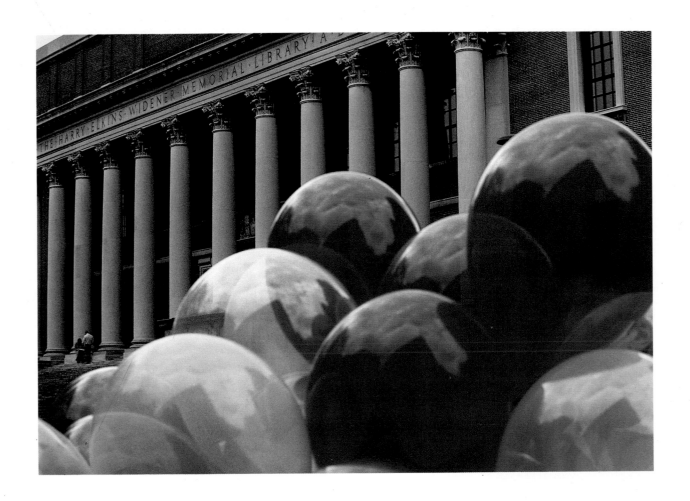

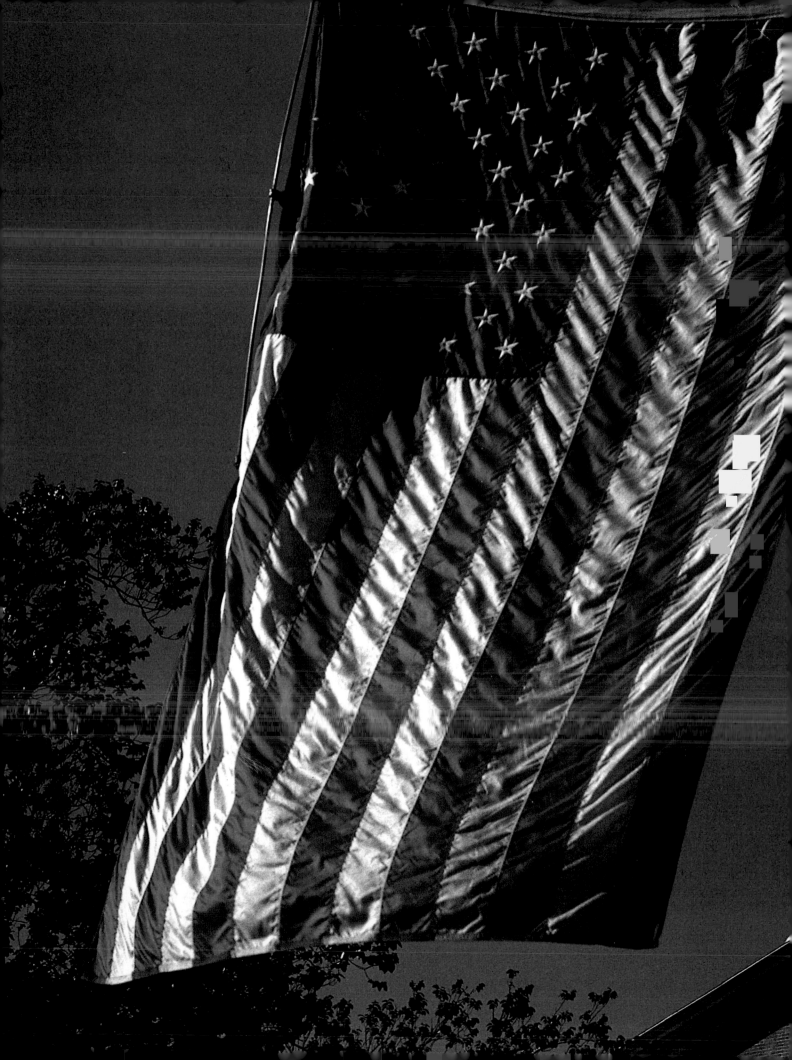

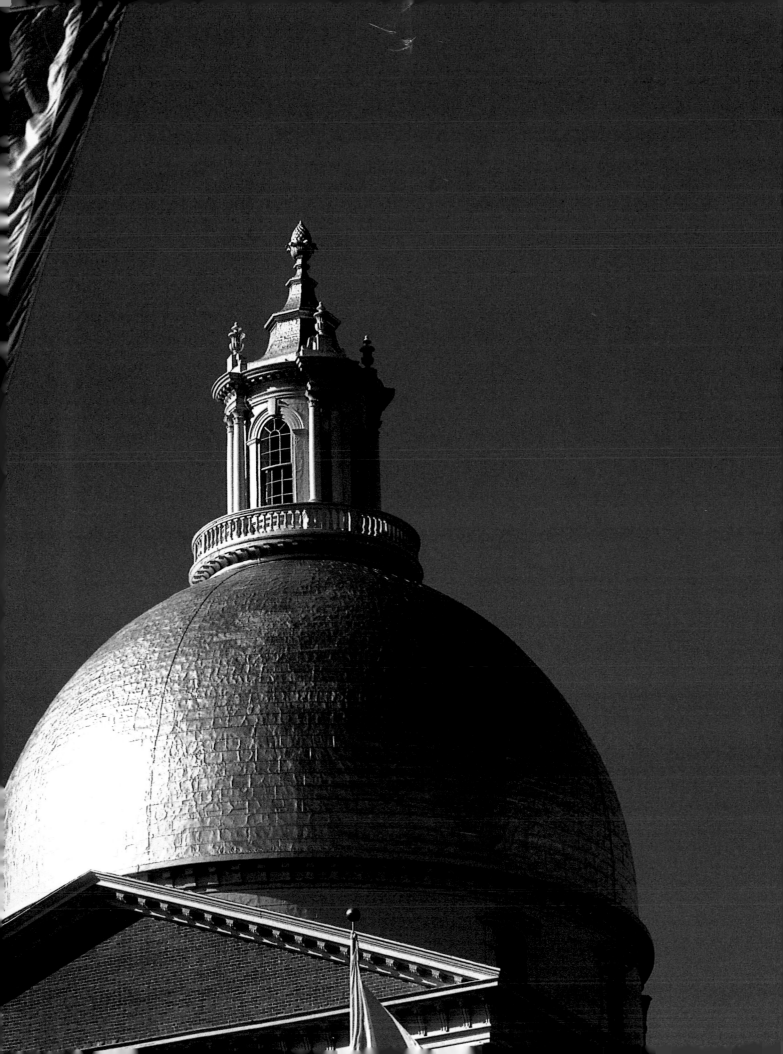

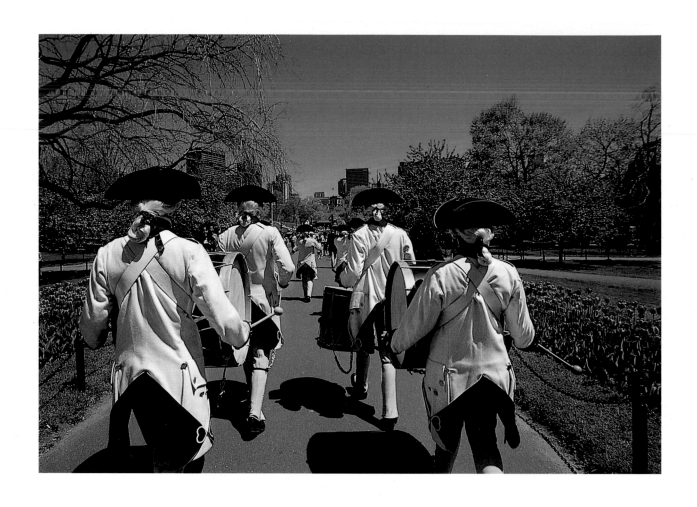

Pages 122, 123. Mother's Day in Boston Public Garden
Pages 124–25. Boston Public Garden

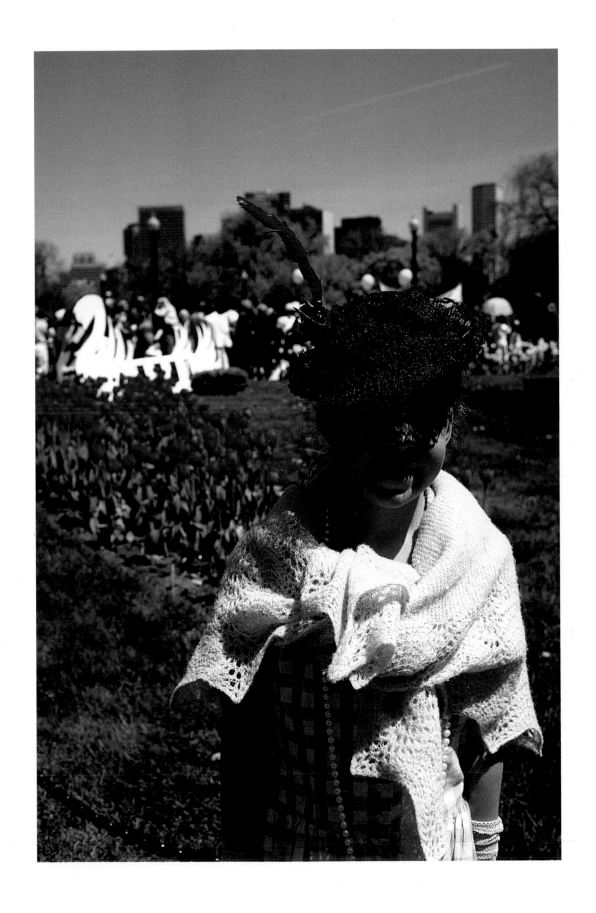

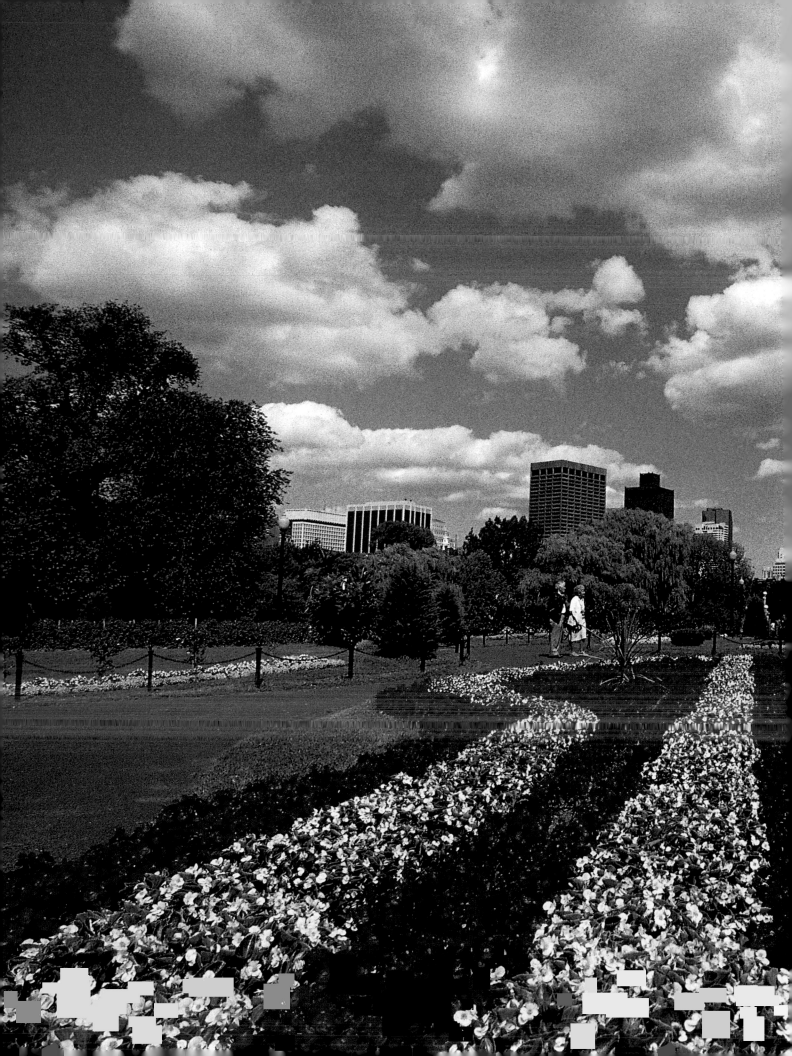

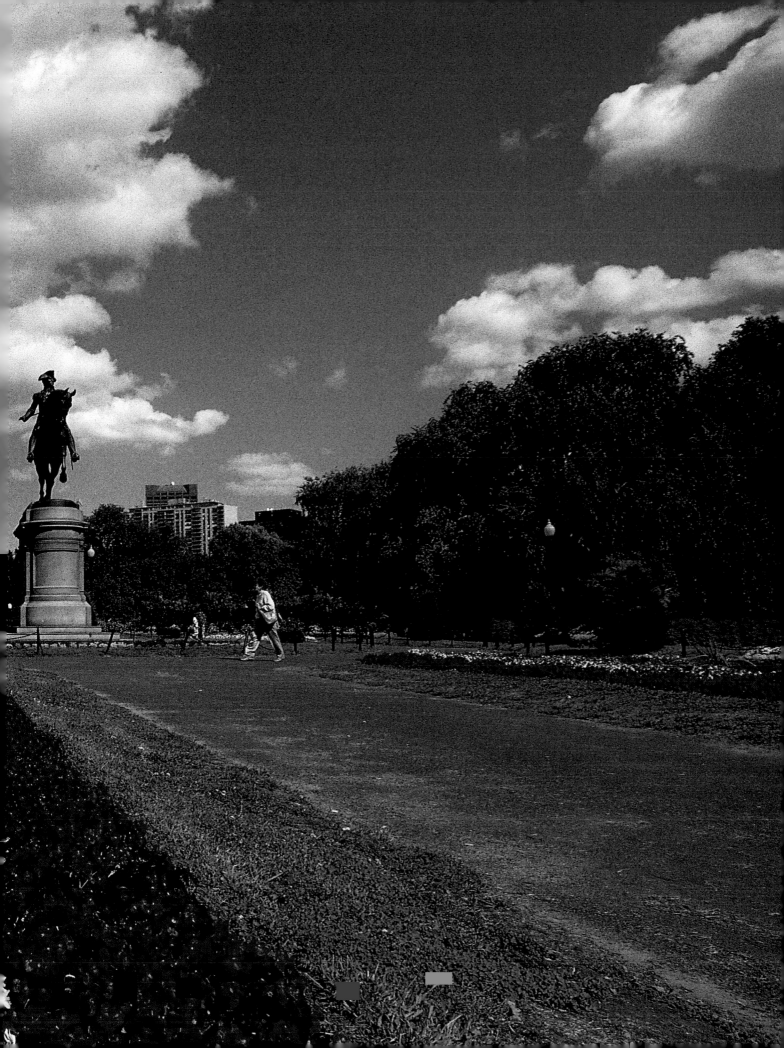

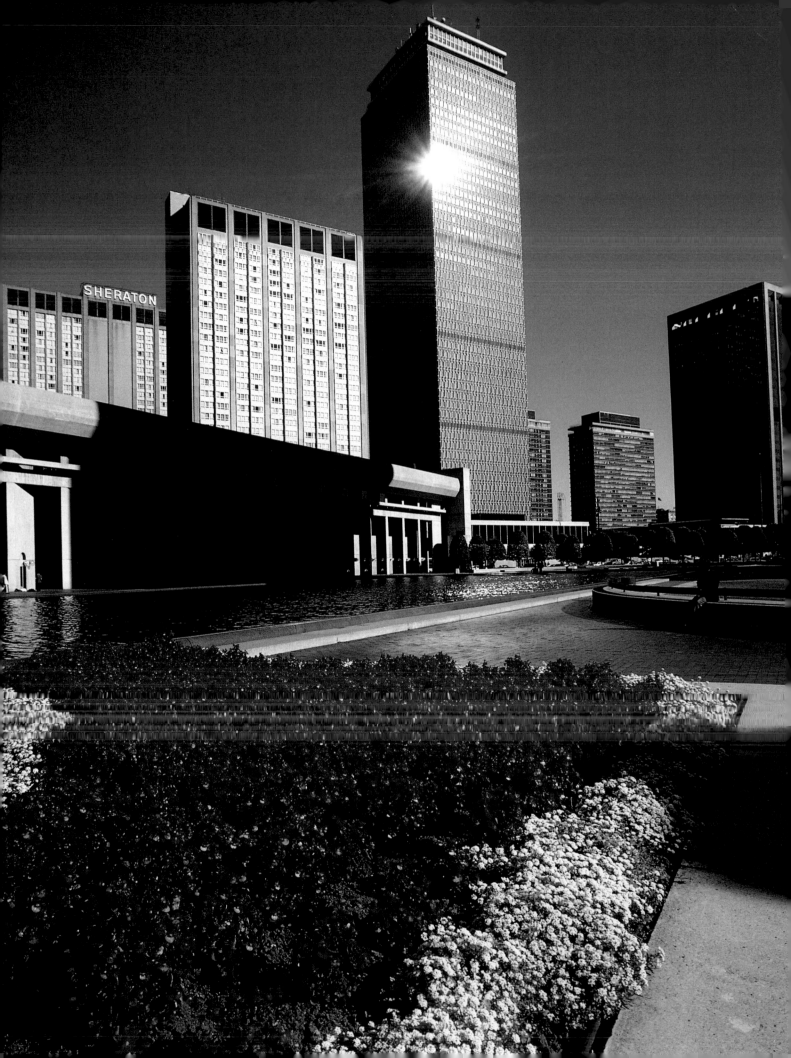

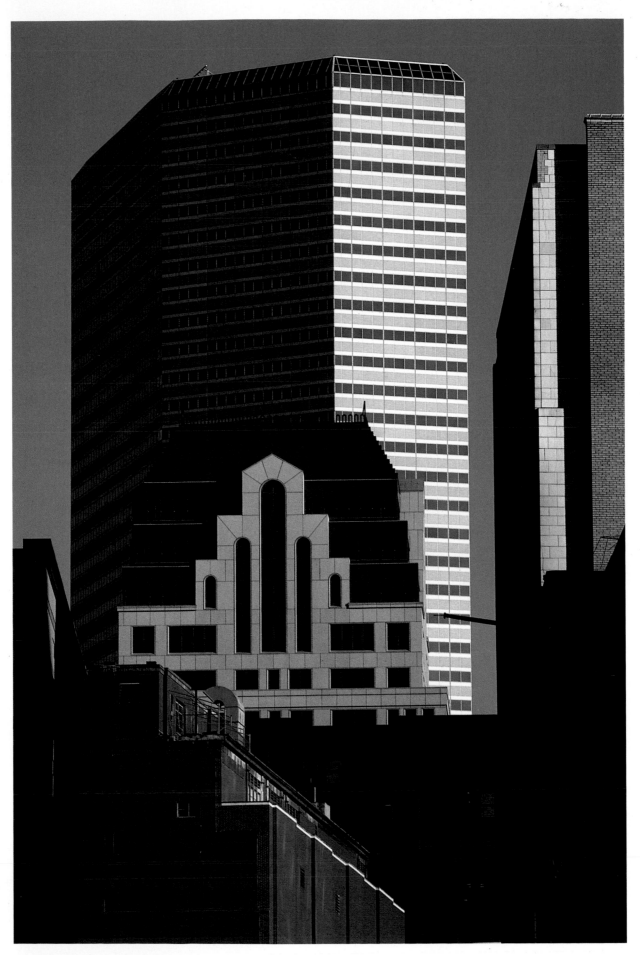

Page 126. The Prudential Center

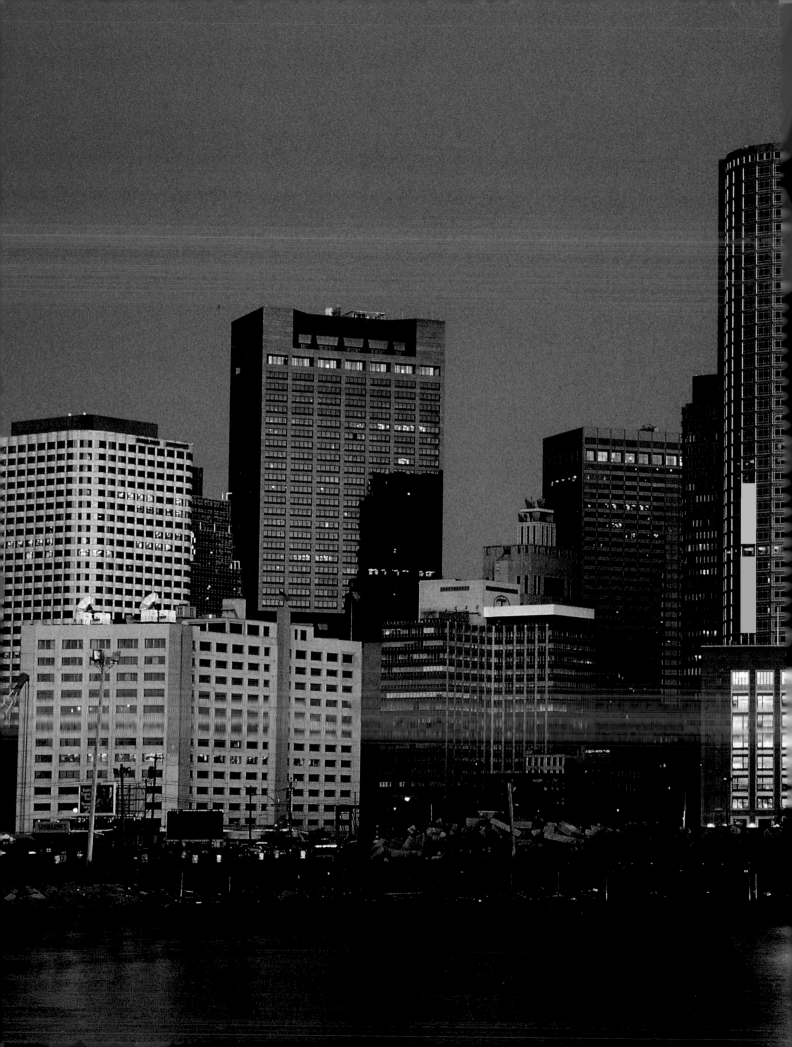

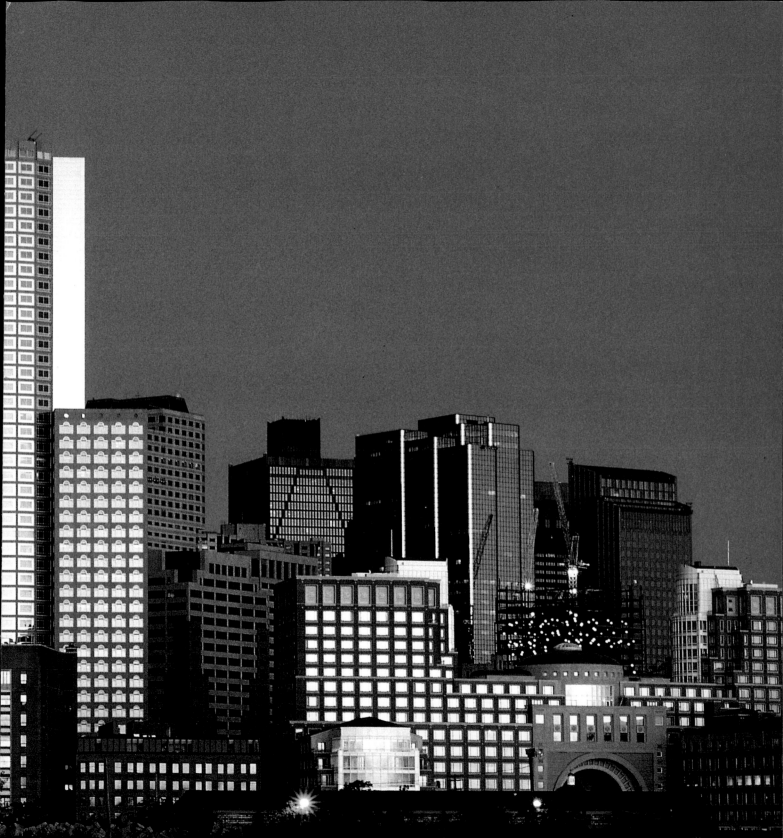

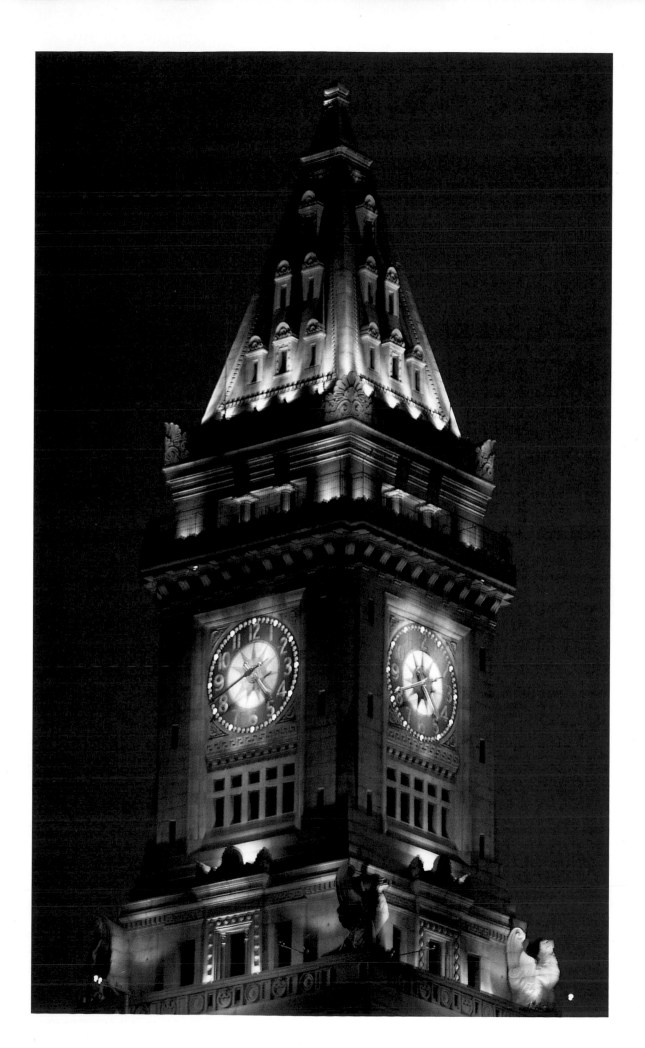

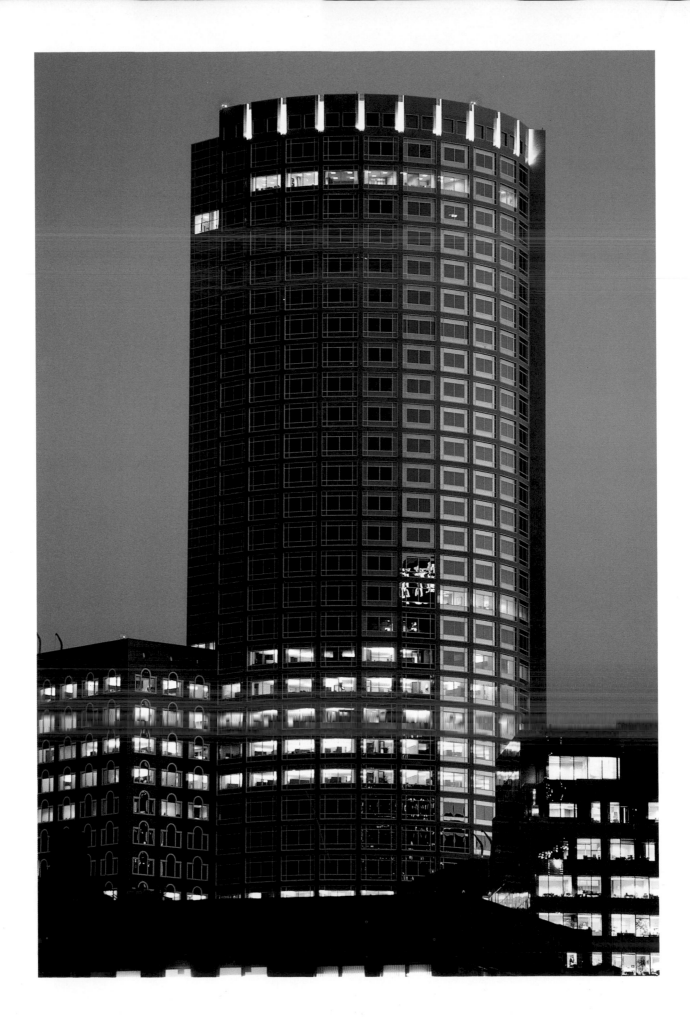

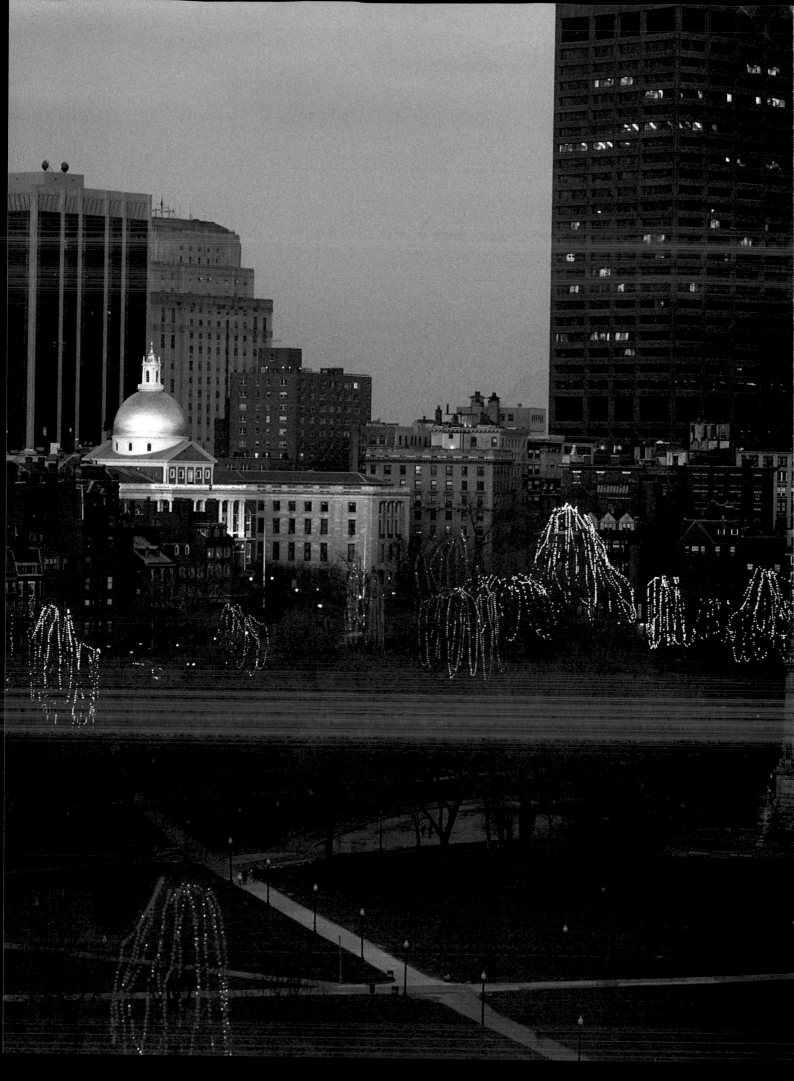

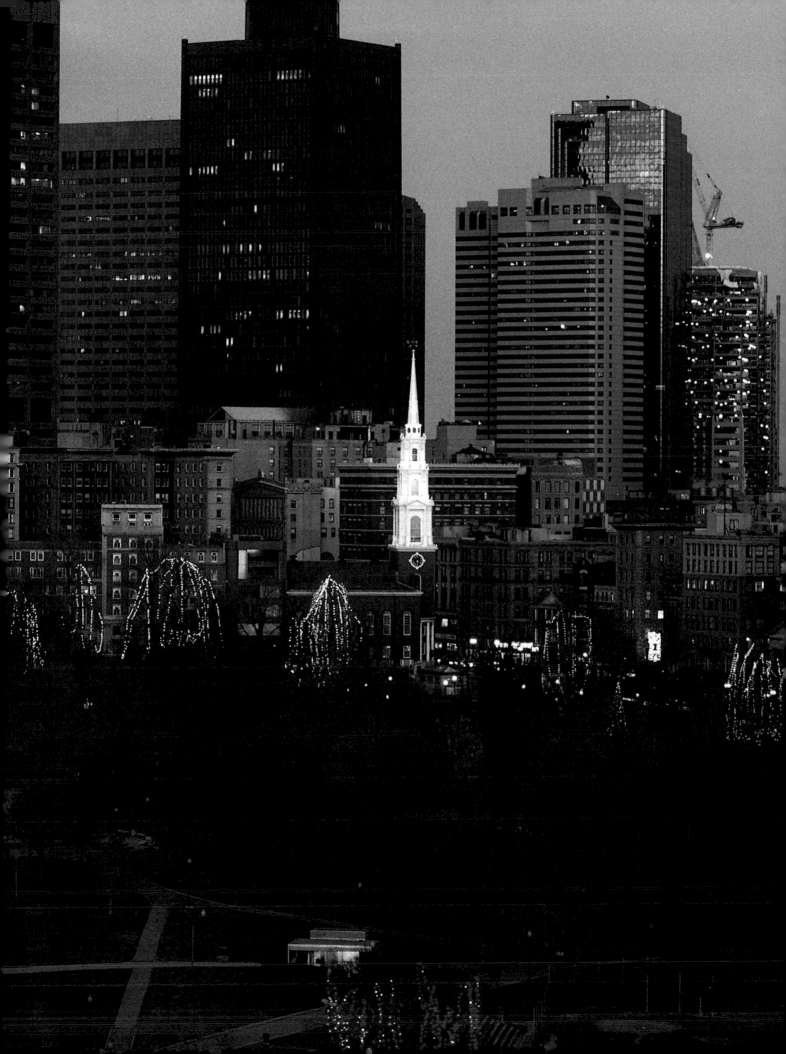

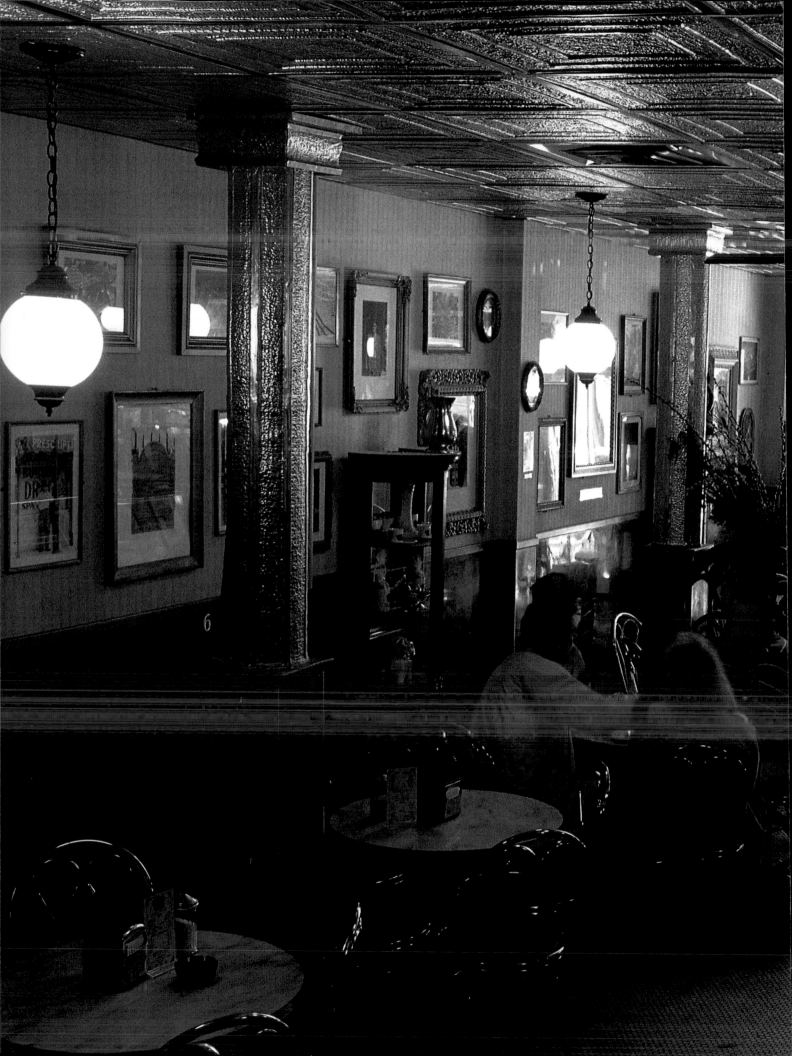

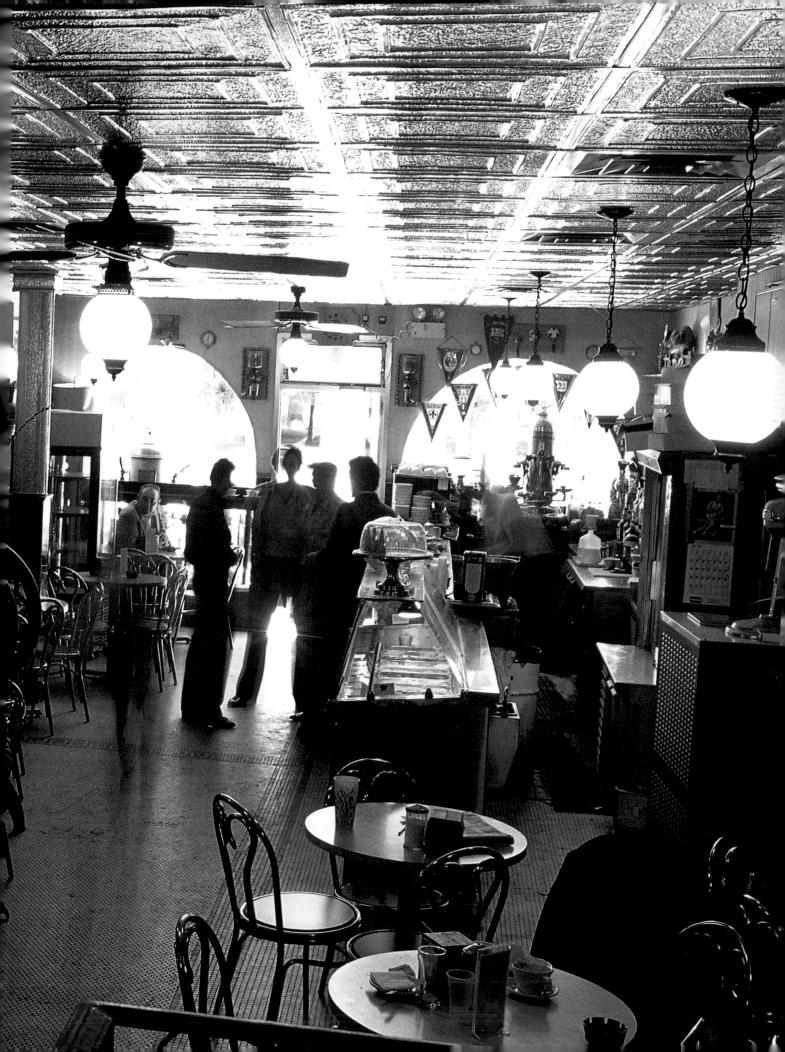

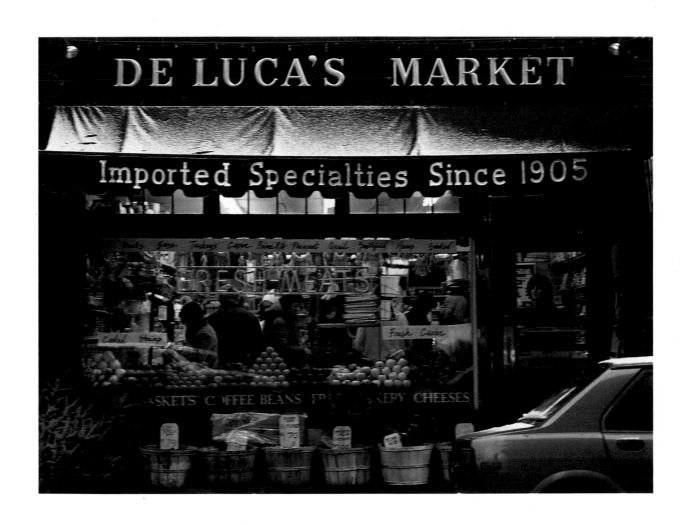

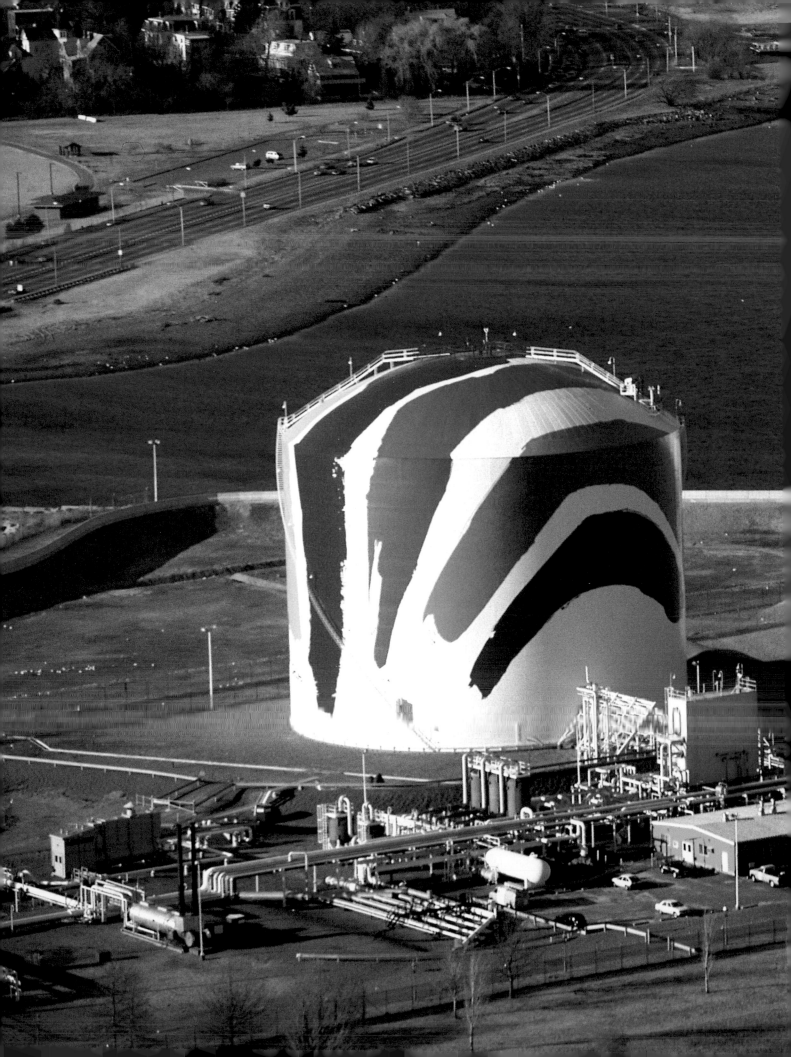

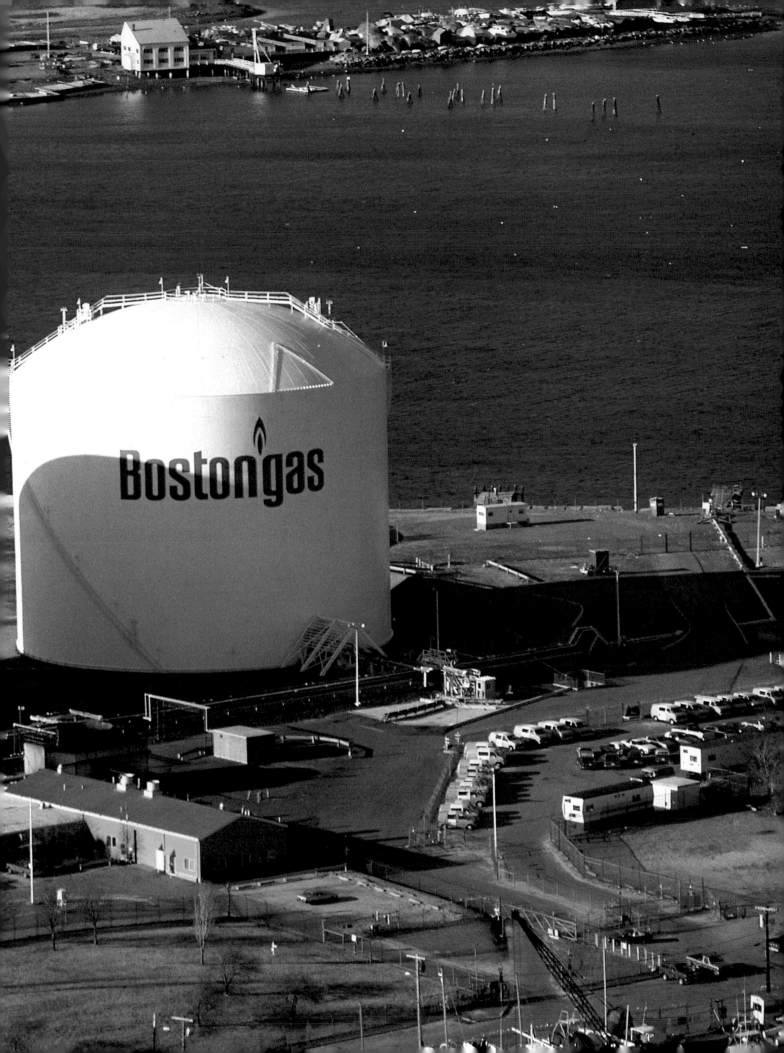

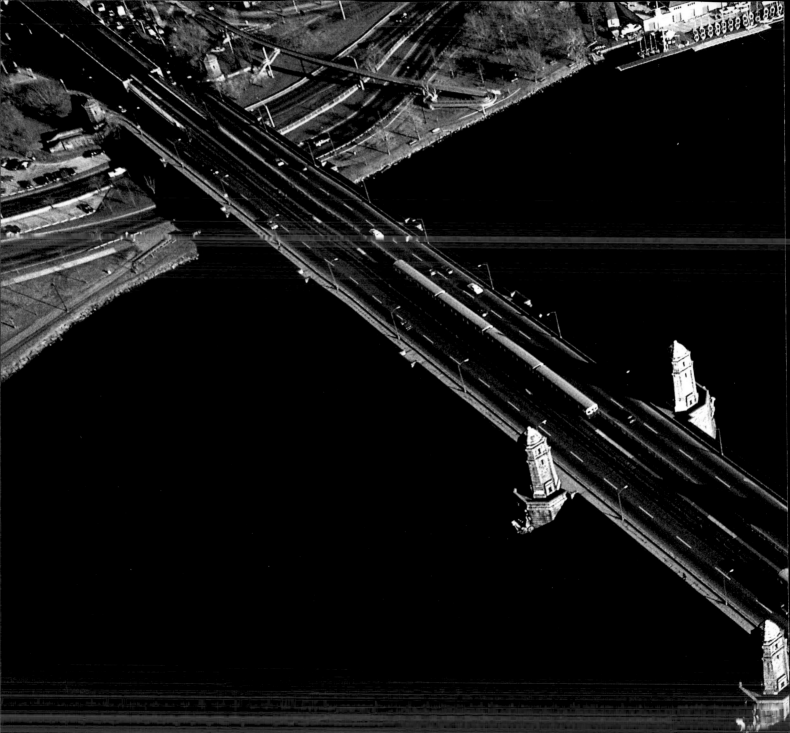

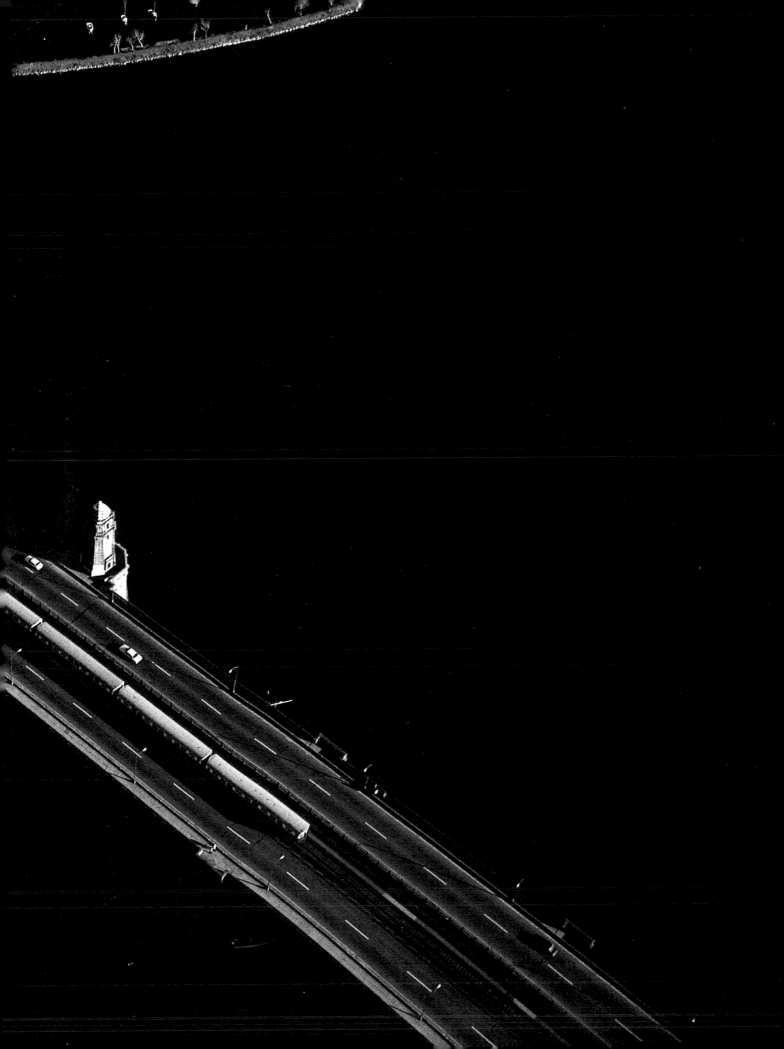

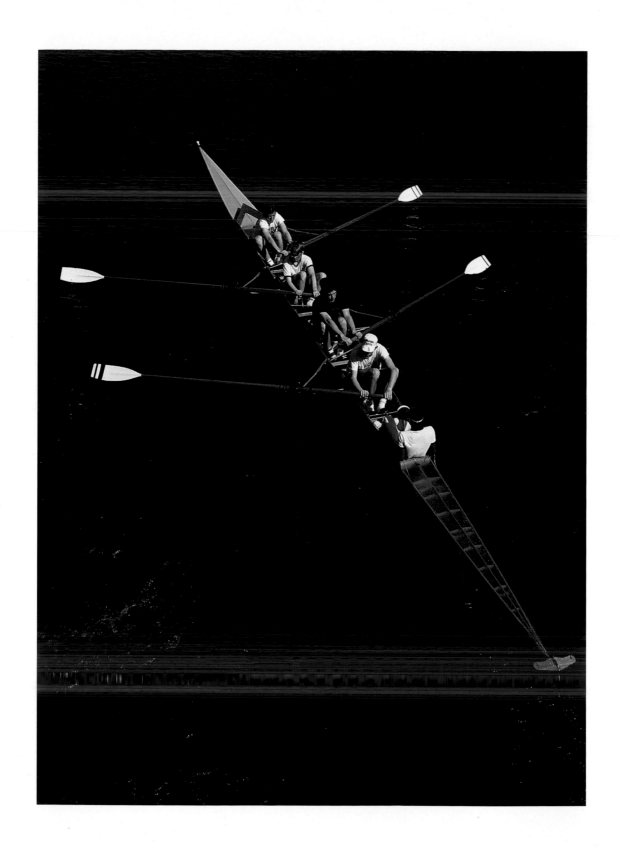

Page 144. Sculling on Charles River
Page 145. Swan boat in Boston Public Garden

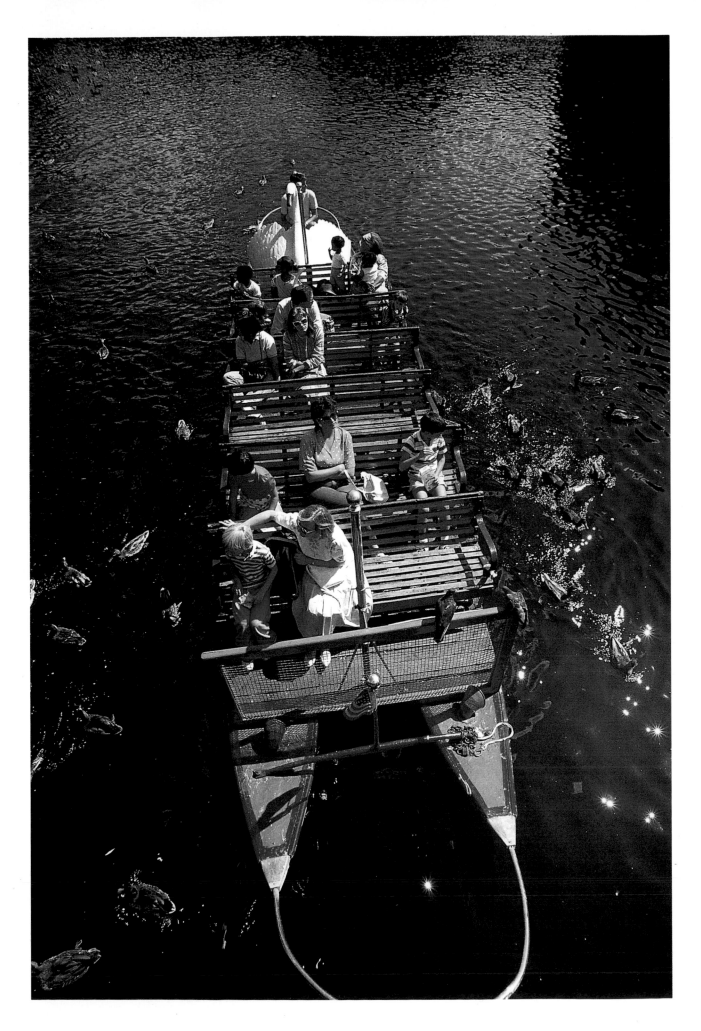

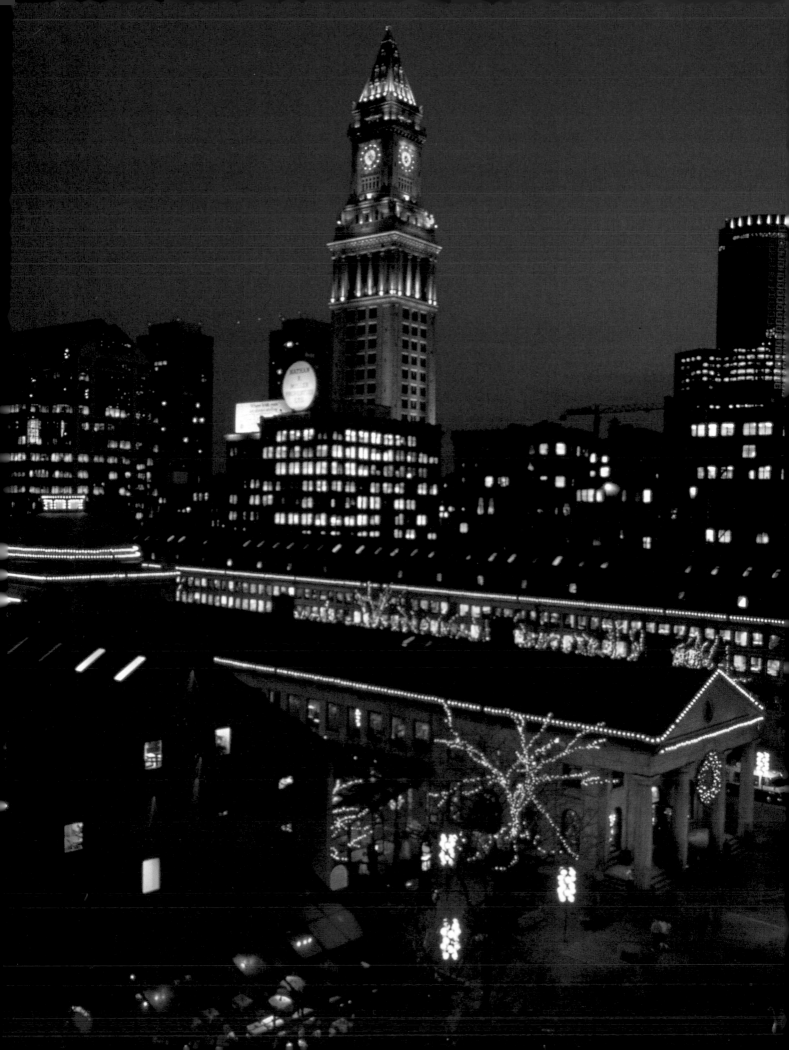

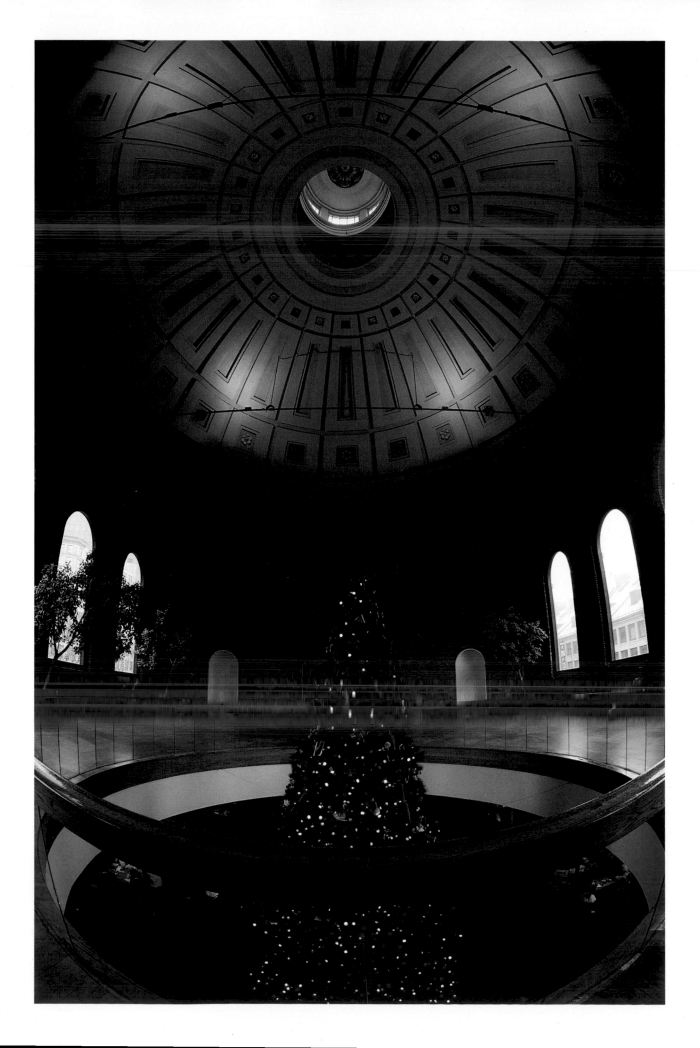

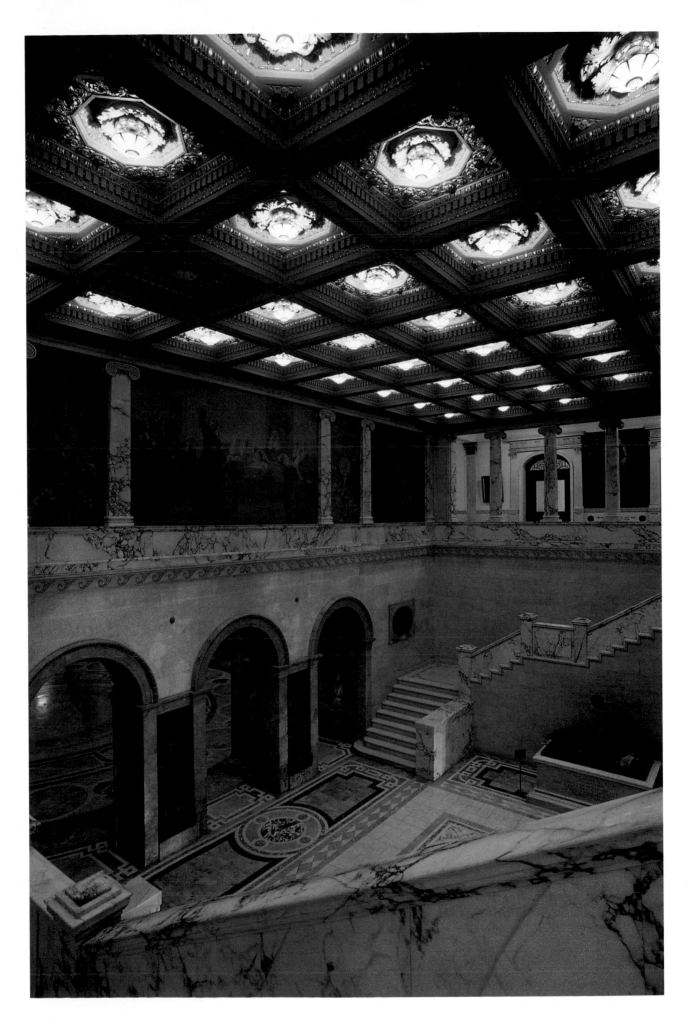

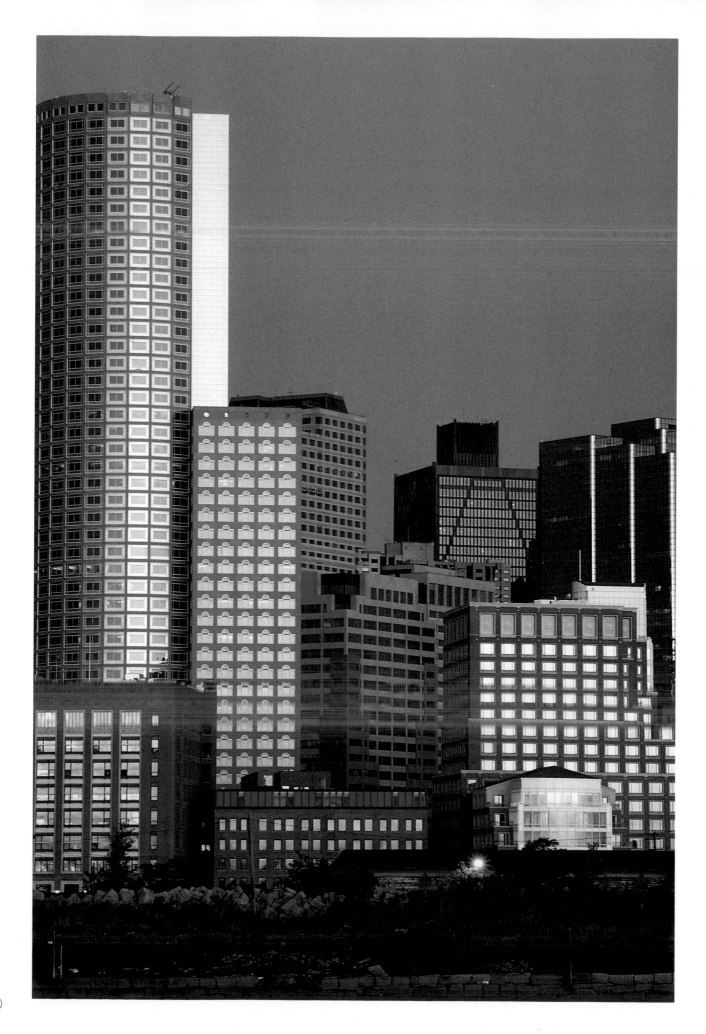

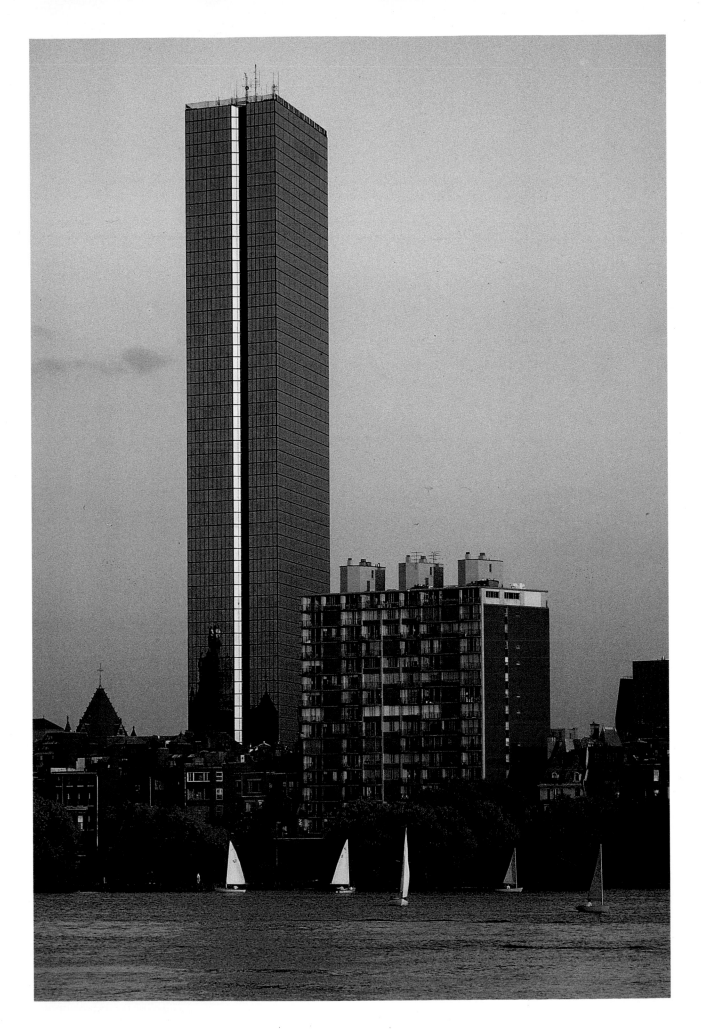

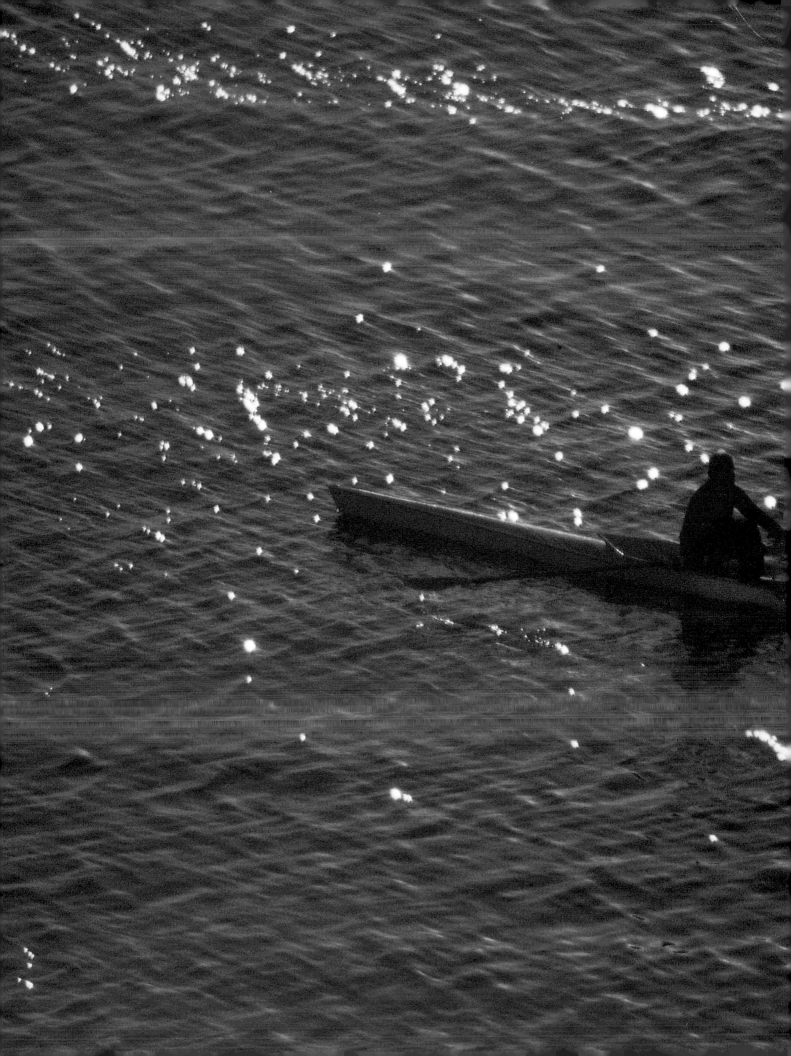

Pages 152–53. Boston Harbor, sculling at sunrise

Page 154. *Arthur Fiedler,* by Ralph Helmick

Page 155: Swan boat in Boston Public Garden, in front of the old and new Hancock towers

Pages 156–57. Tanner Fountain, by SWA Group, with Memorial Hall at rear, Harvard University

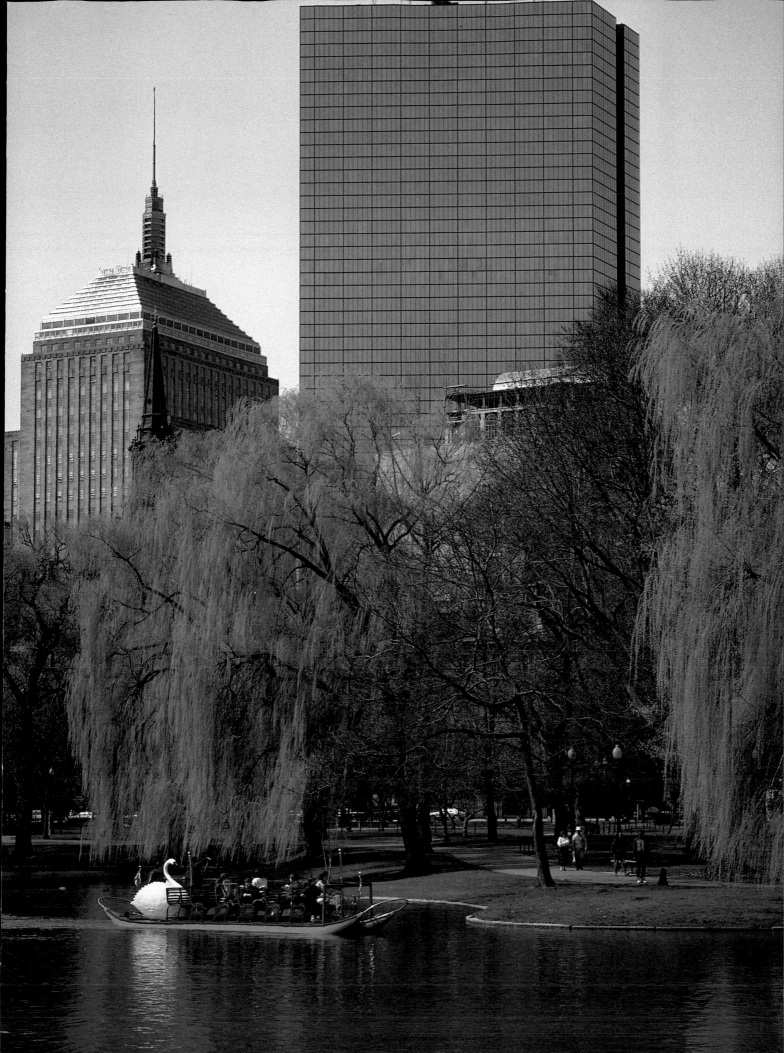

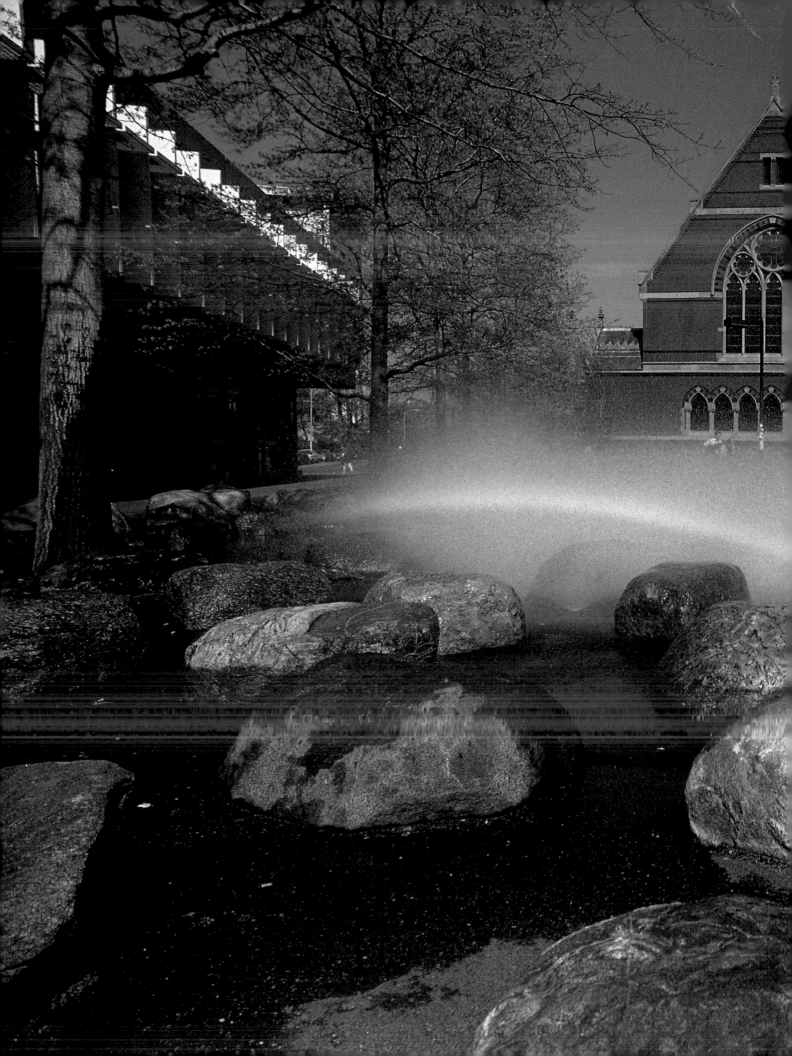

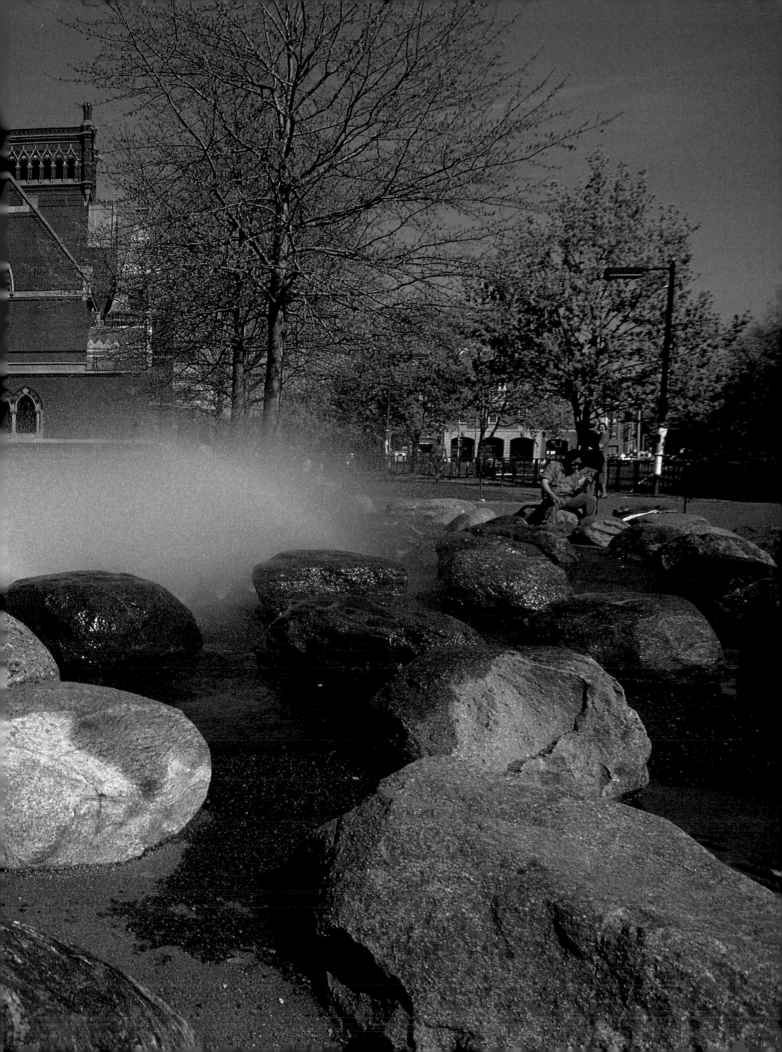

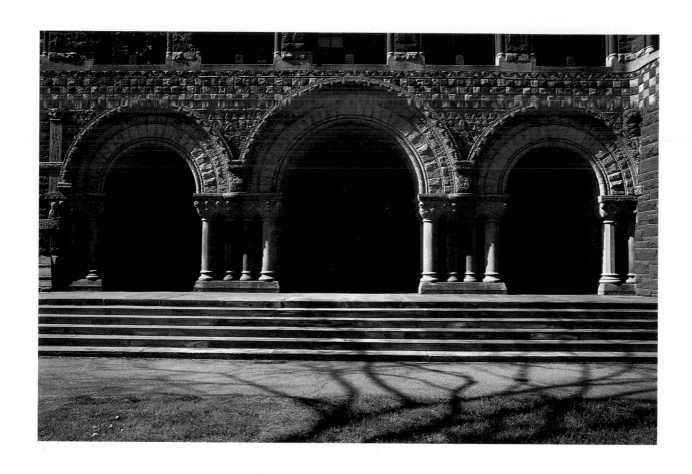

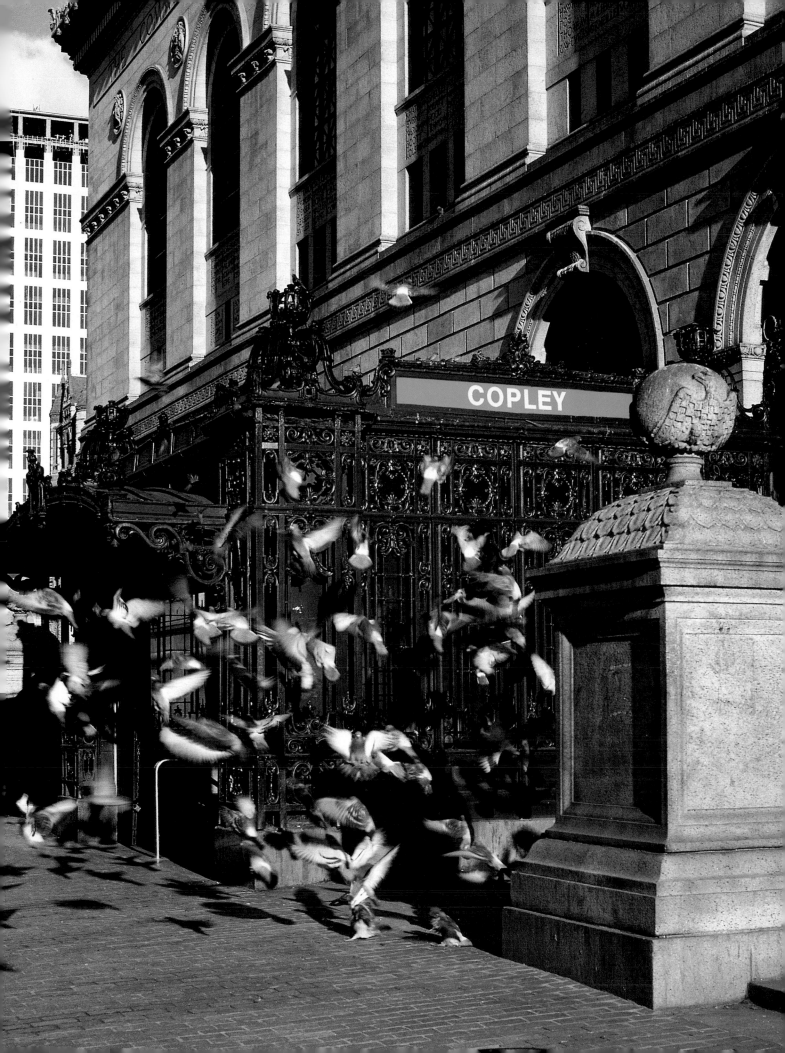

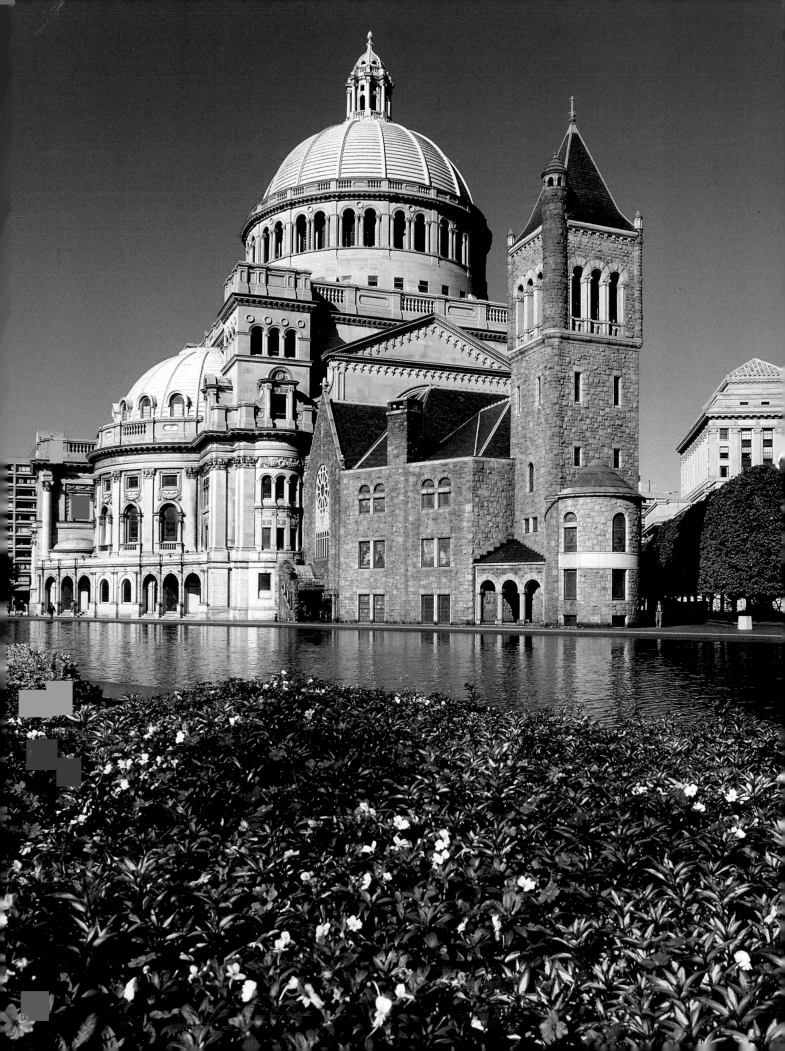

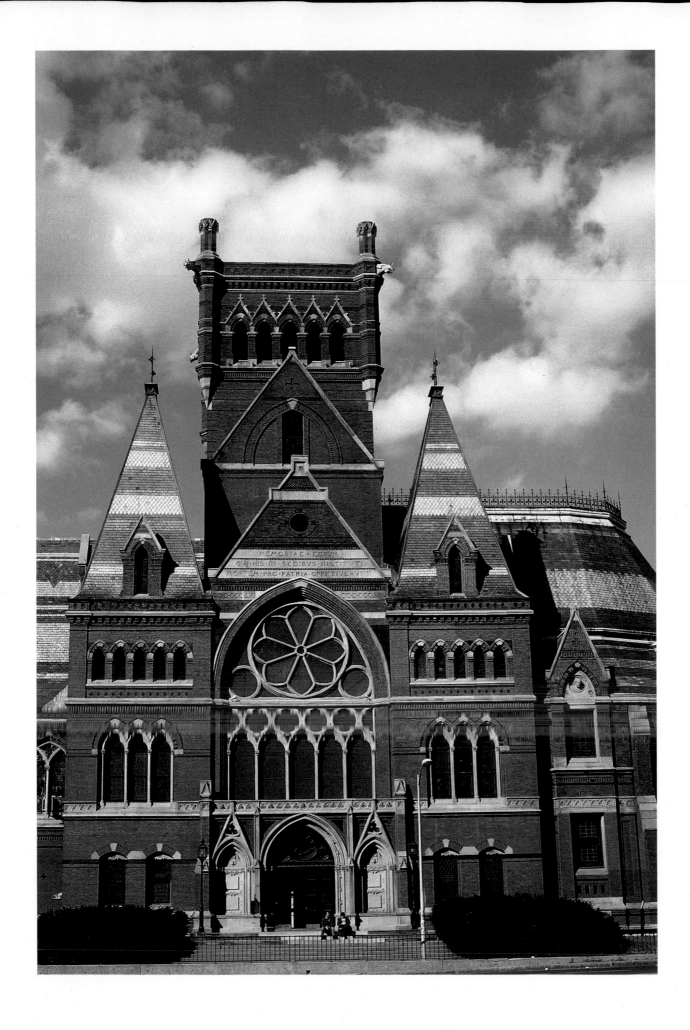

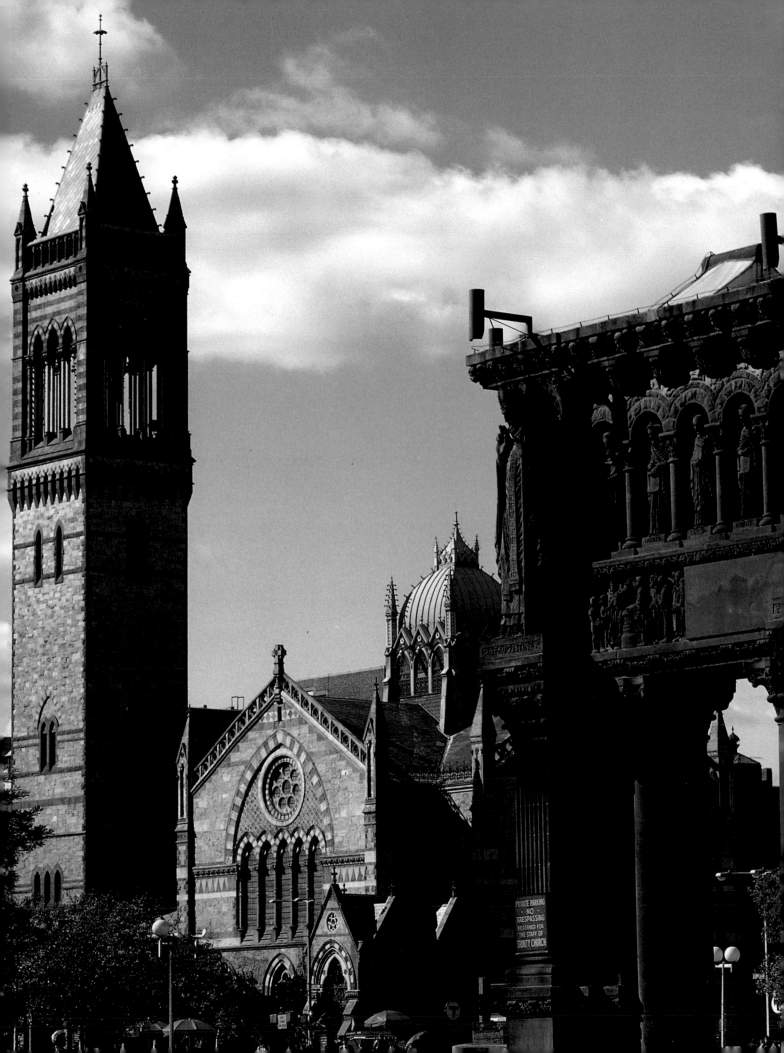

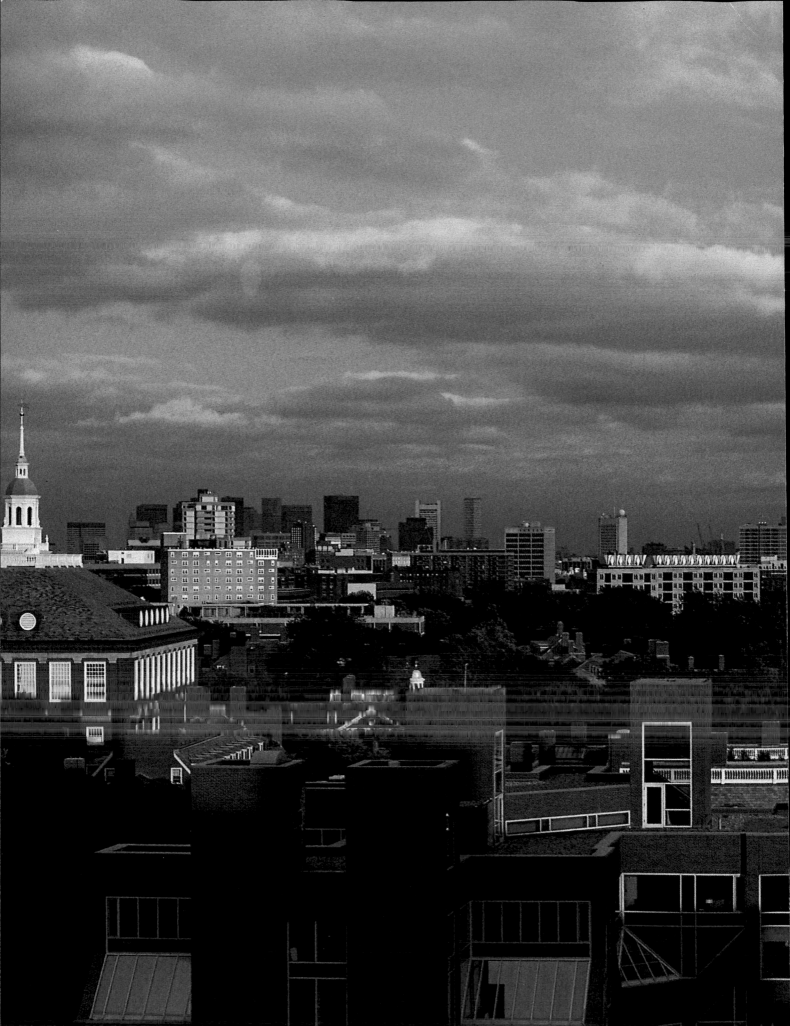

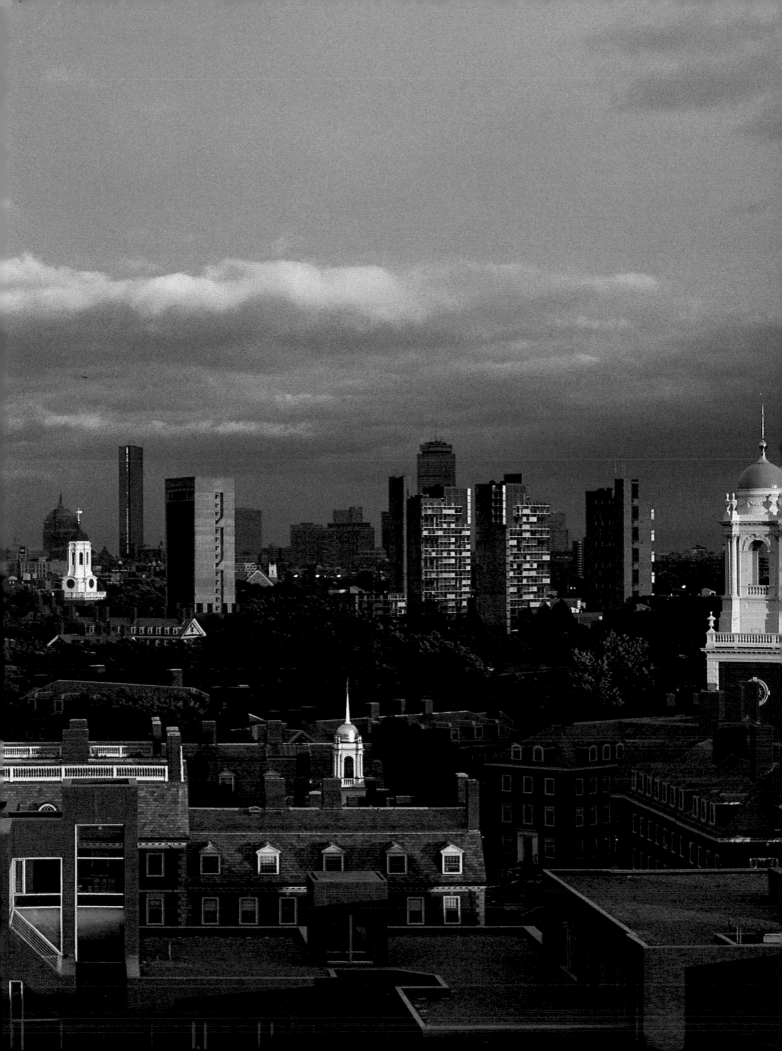

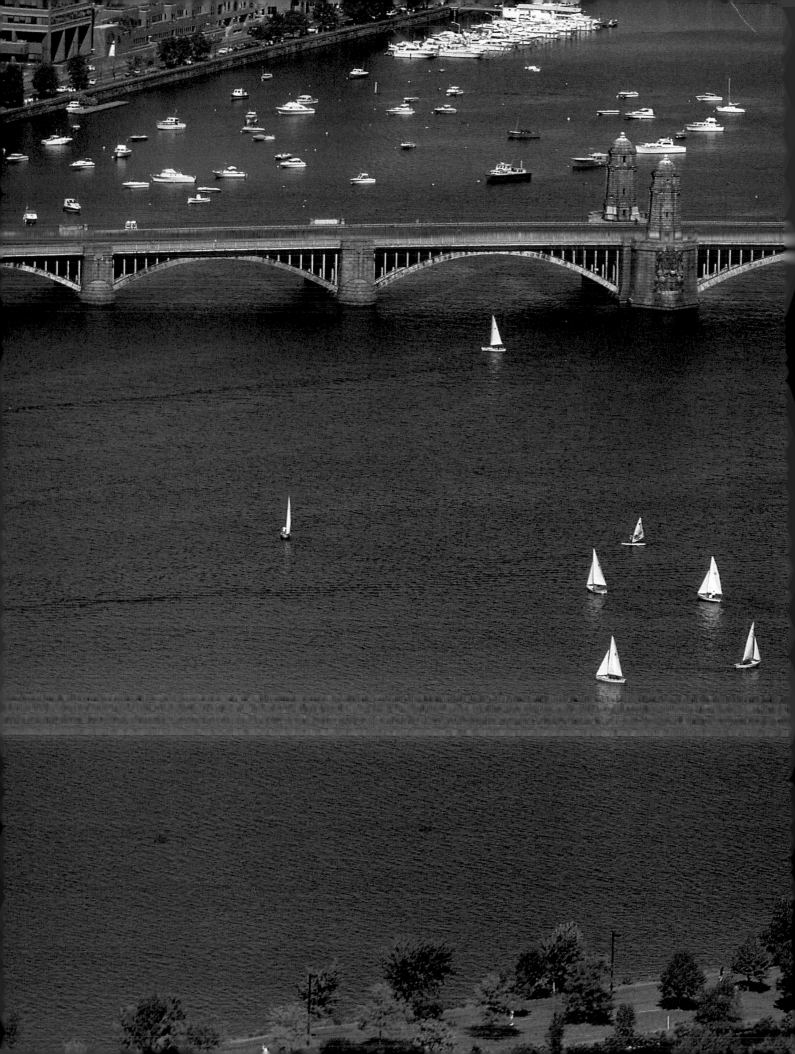

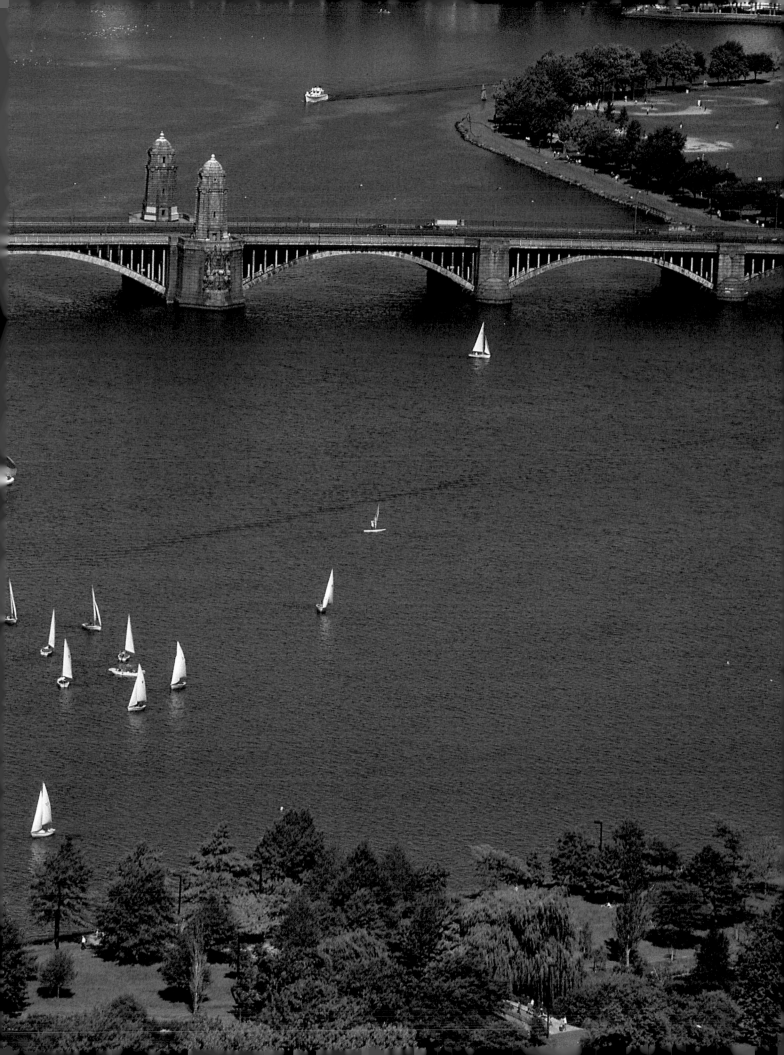

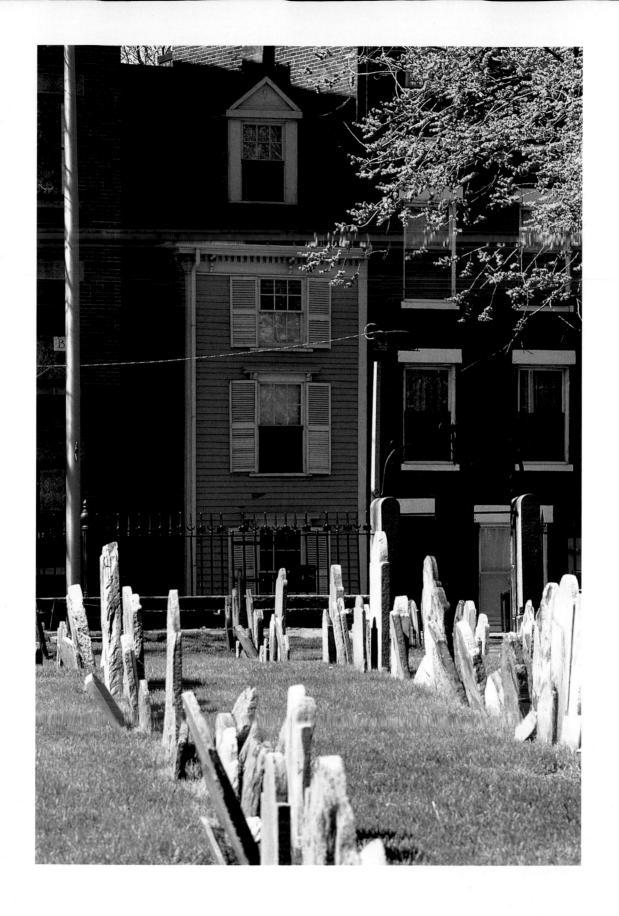

Page 168. Copp's Hill Burial Ground
Page 169. Acorn Street, Beacon Hill

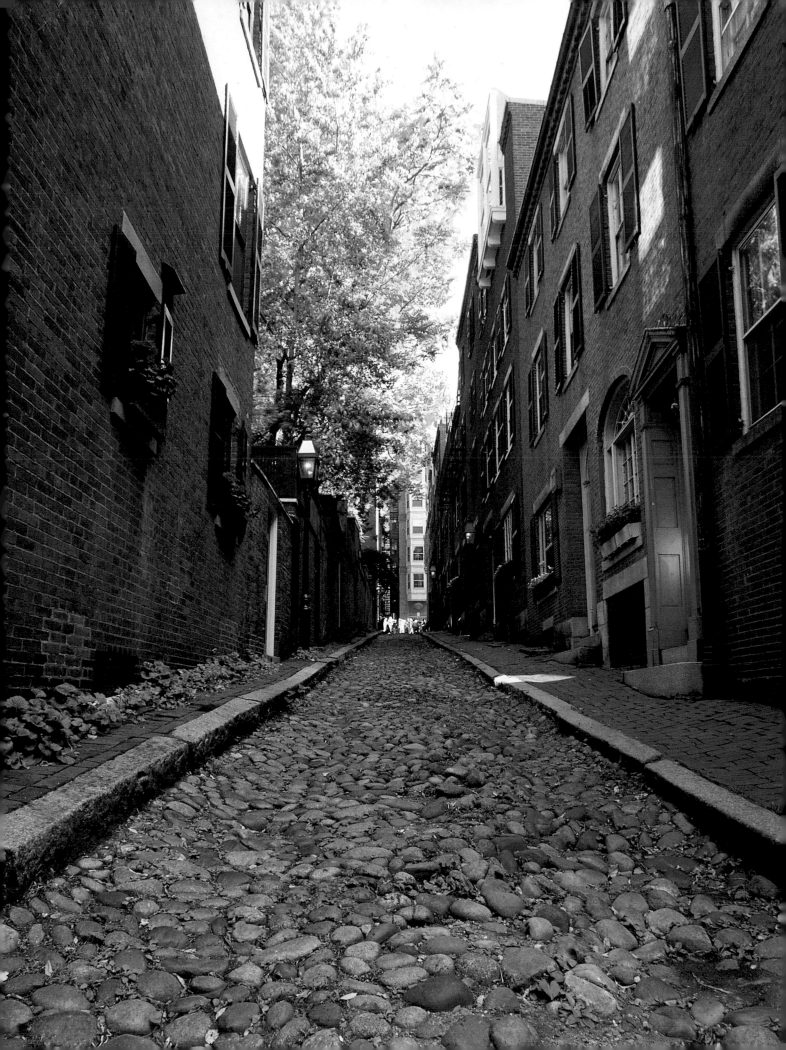

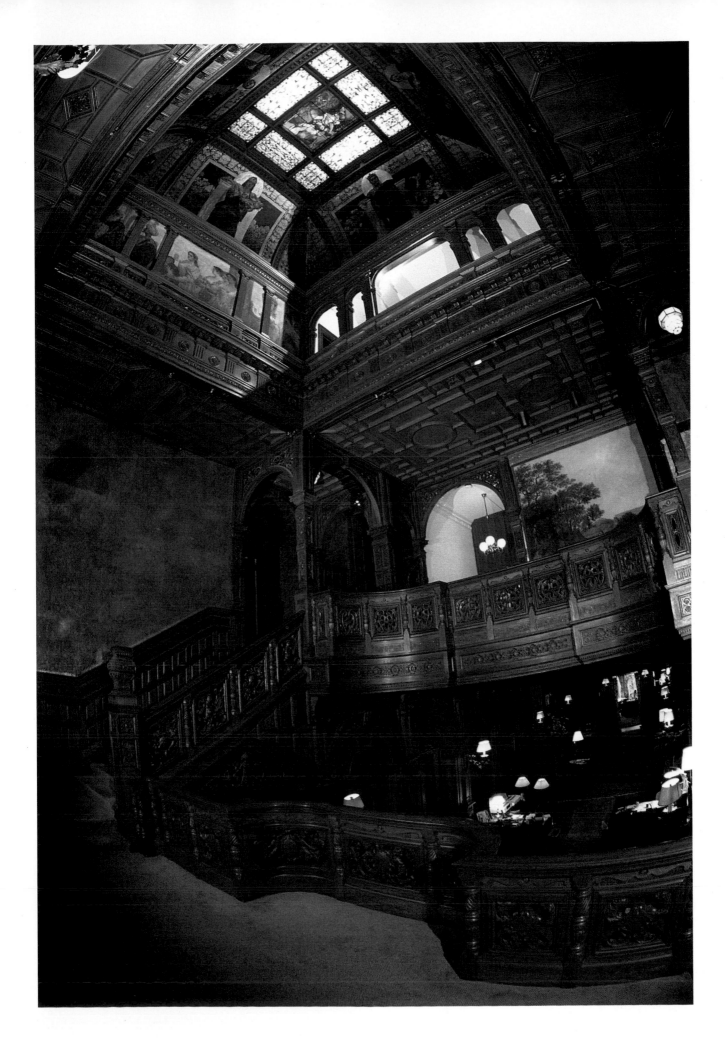

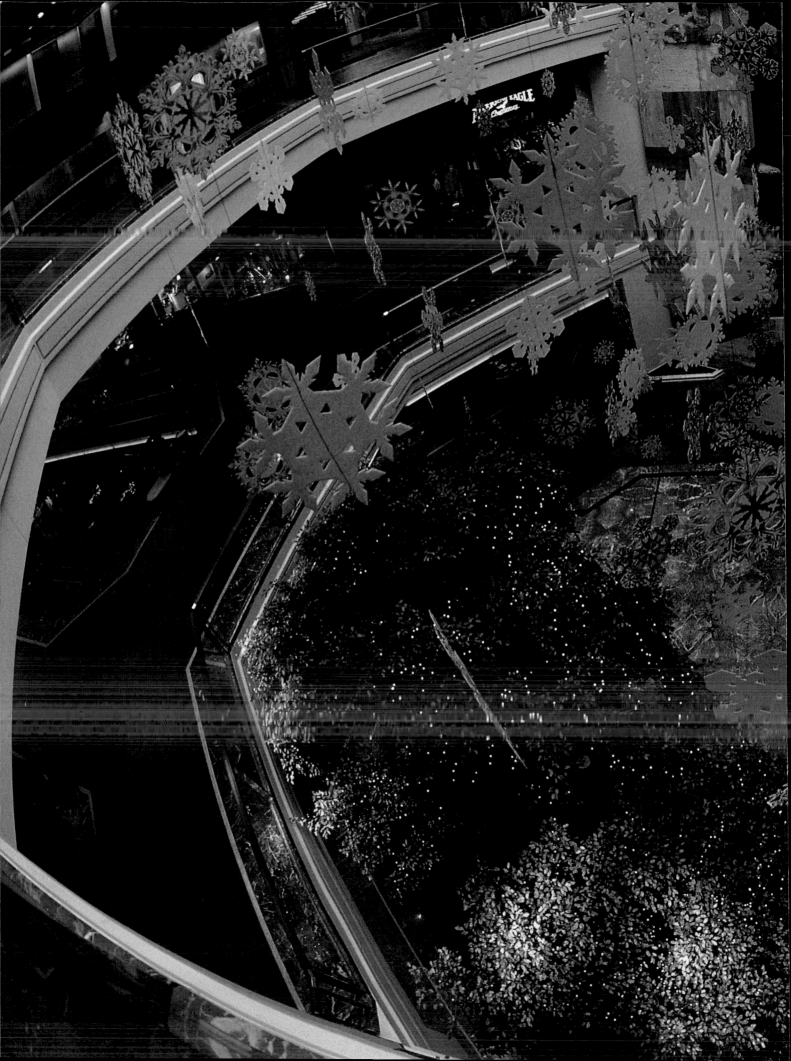

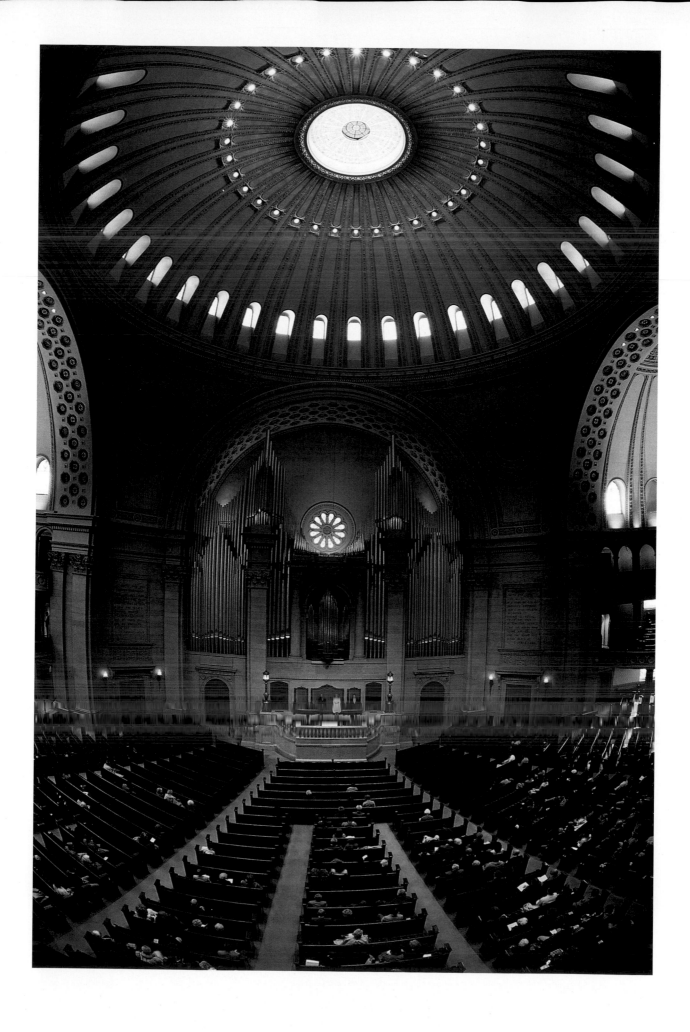

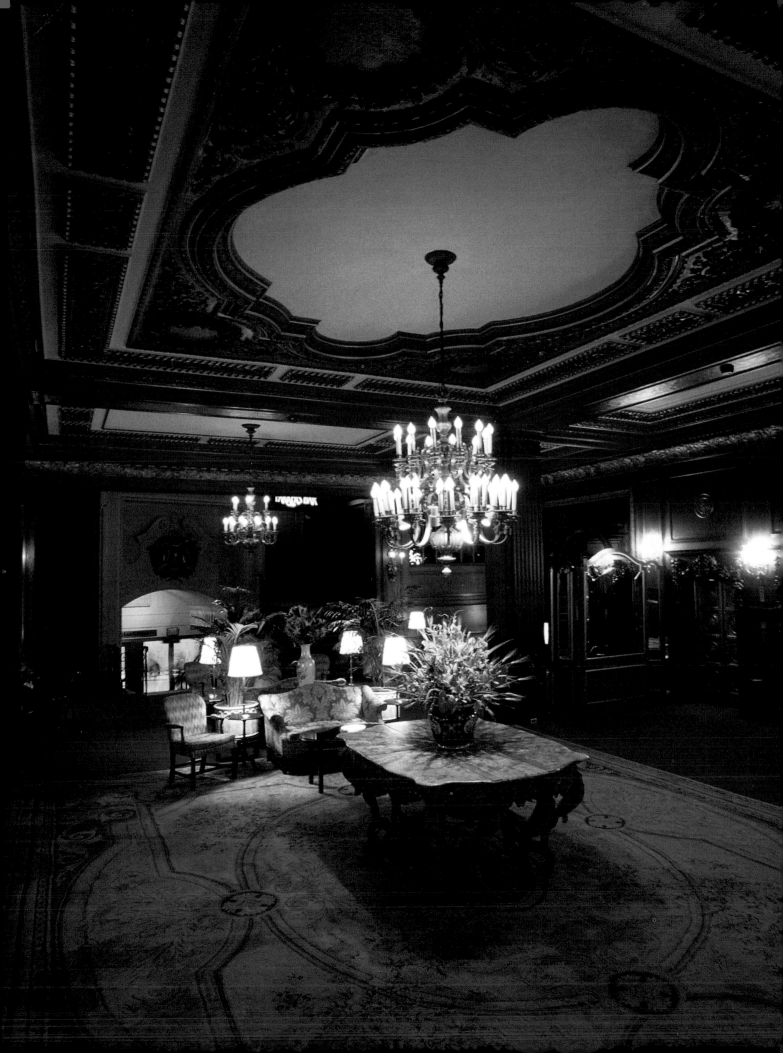

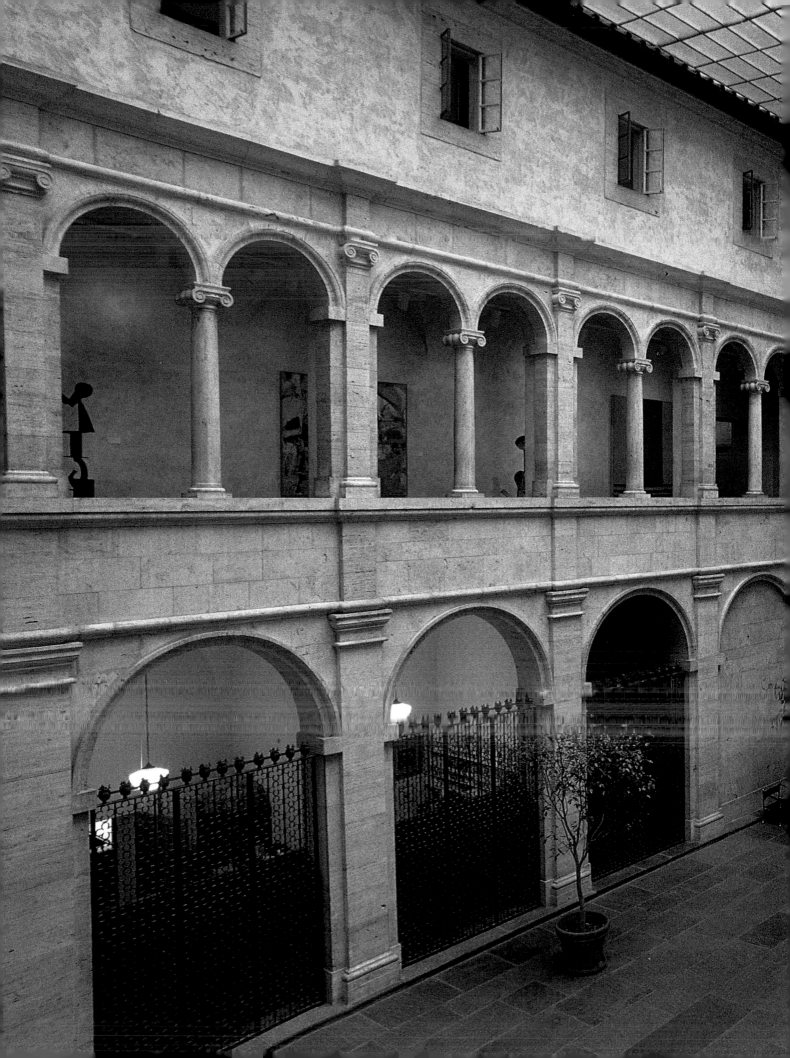

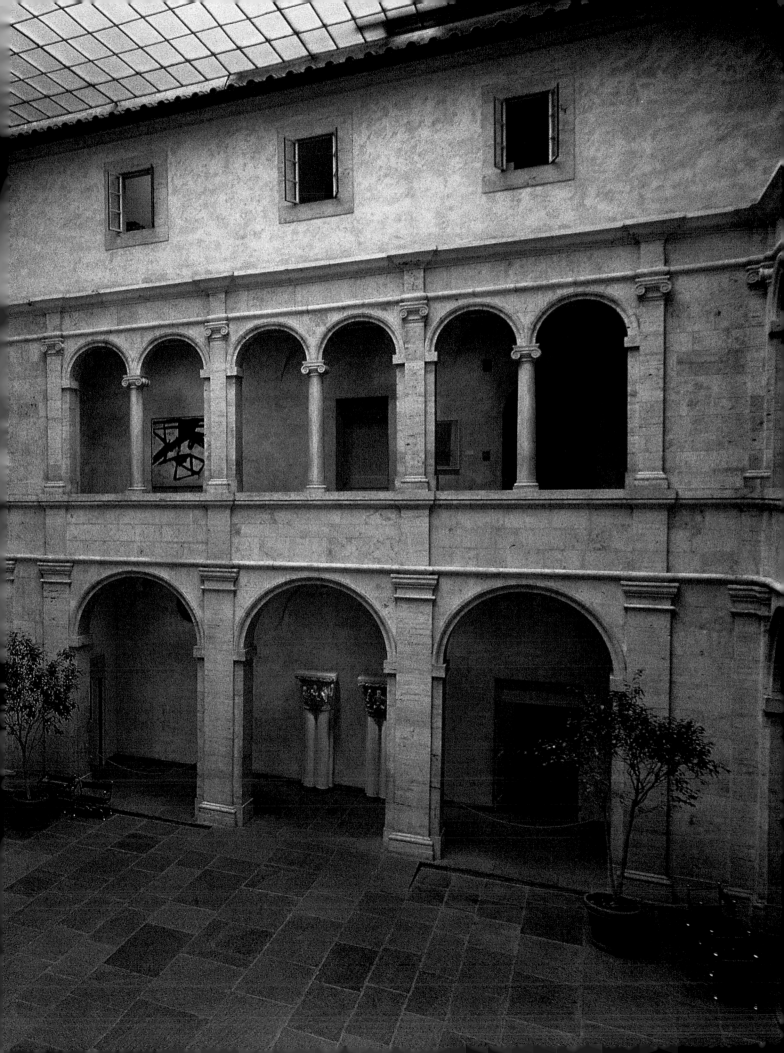

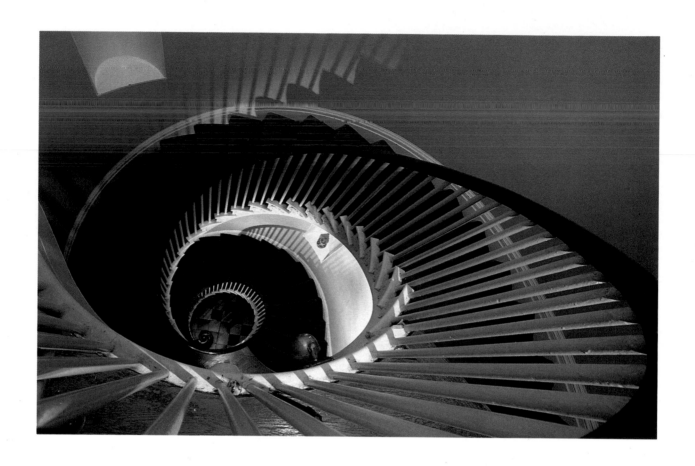

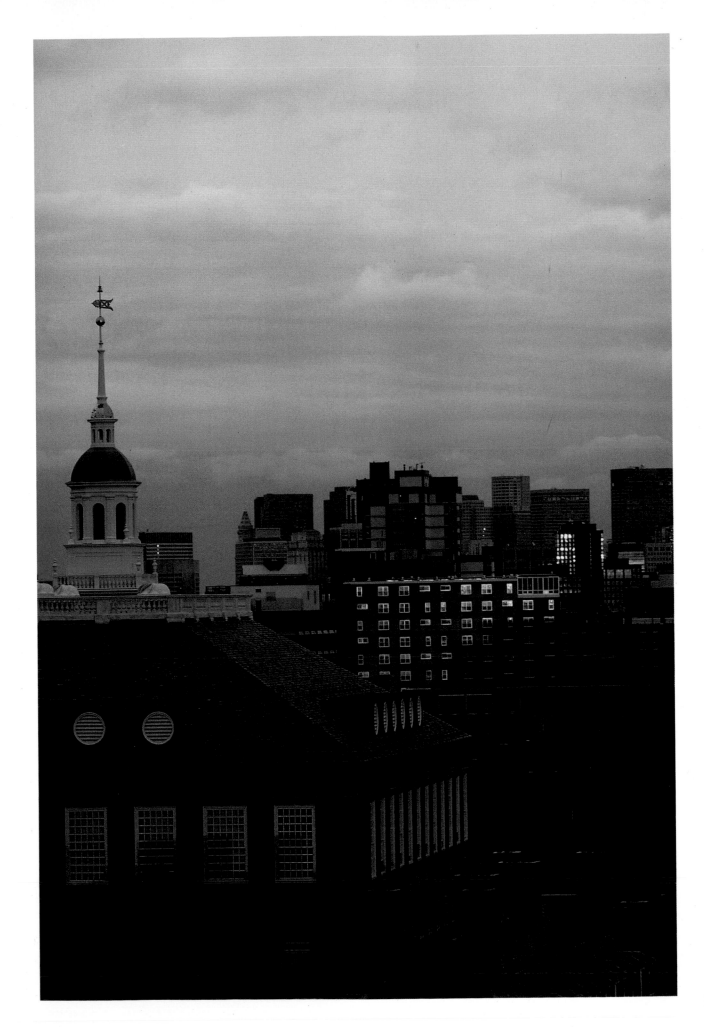

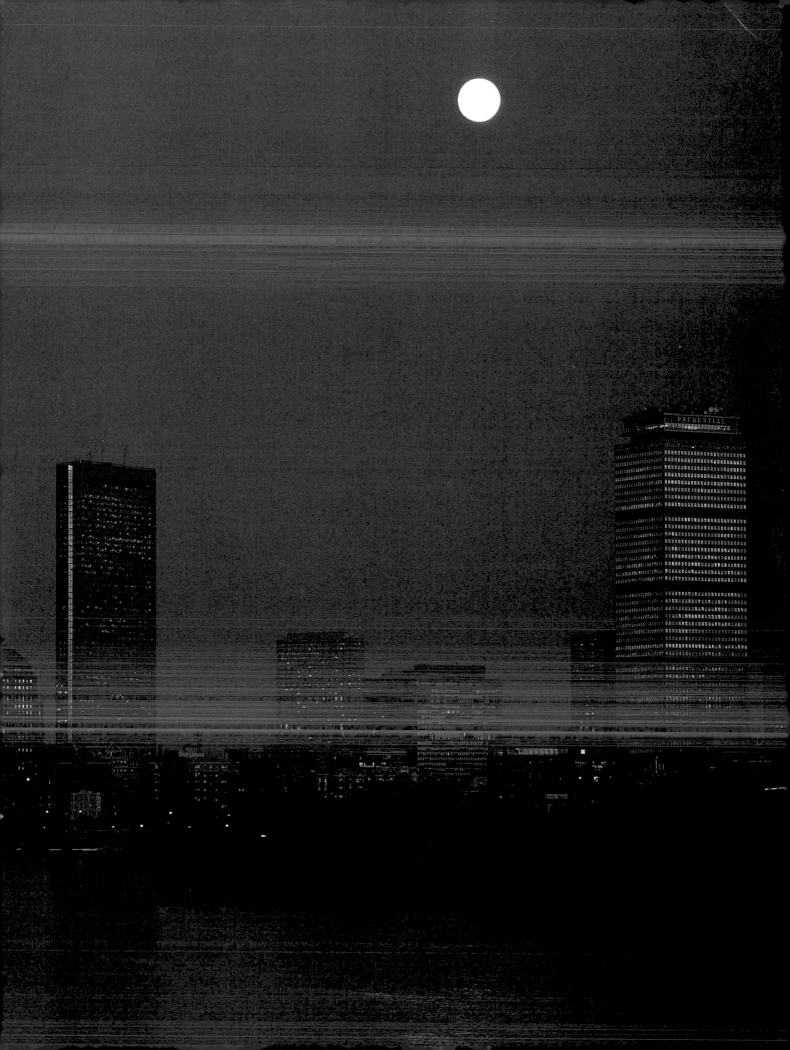

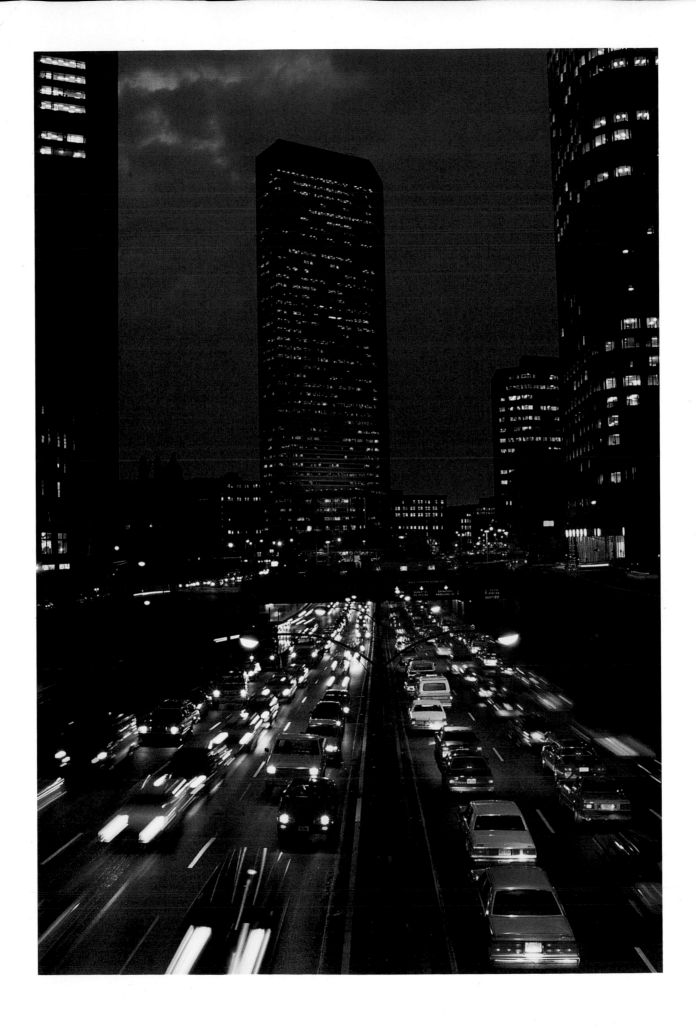

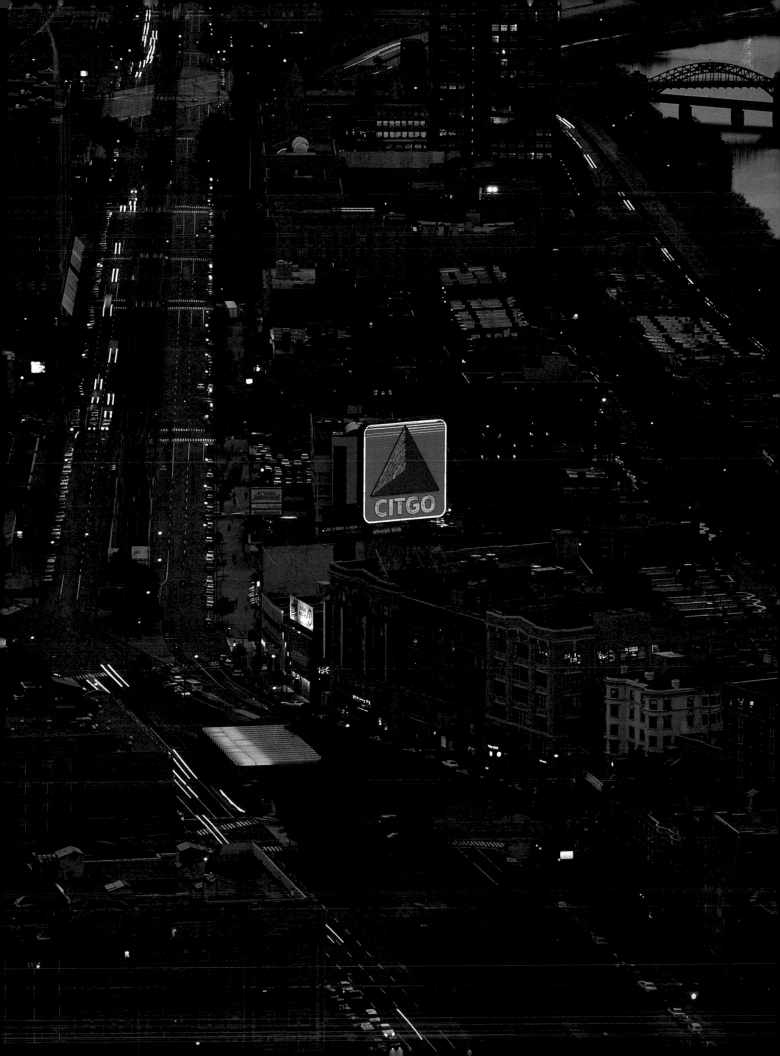

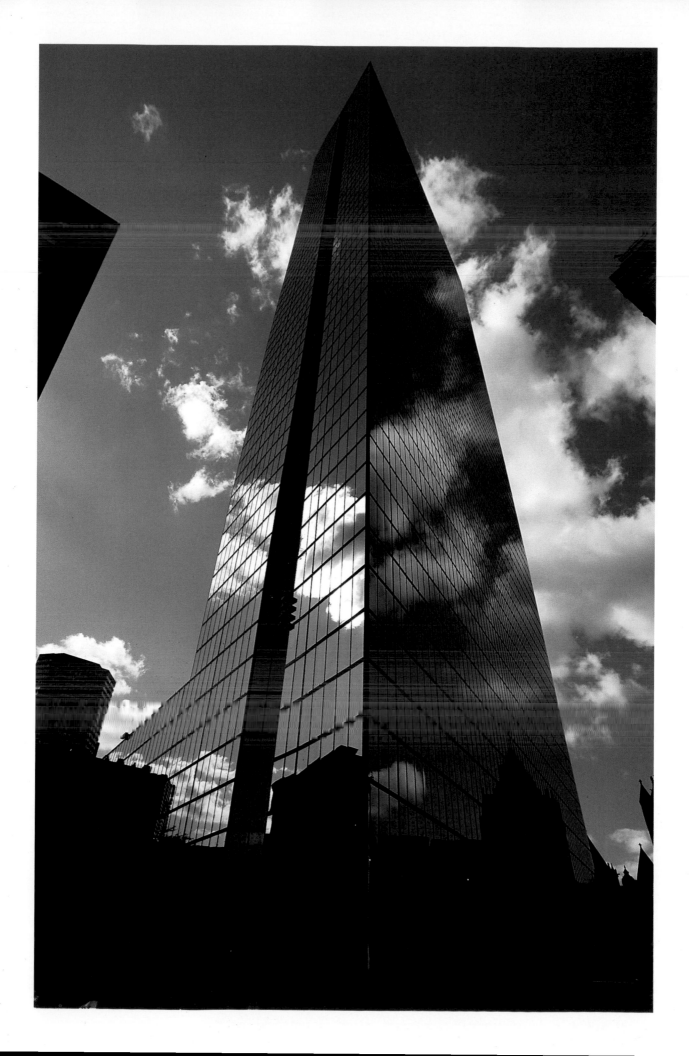

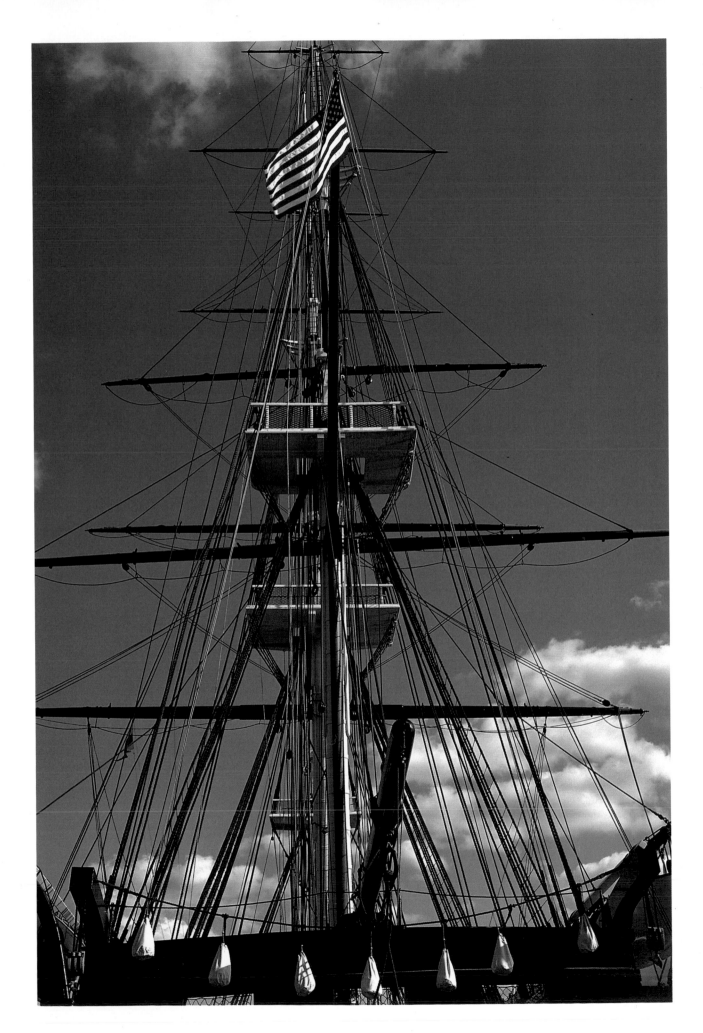

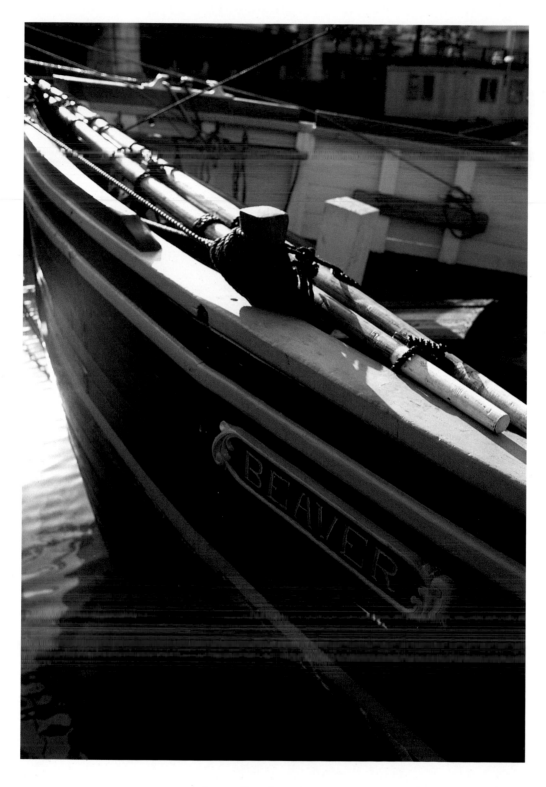

Beaver II, replica of the ship involved in the Boston Tea Party

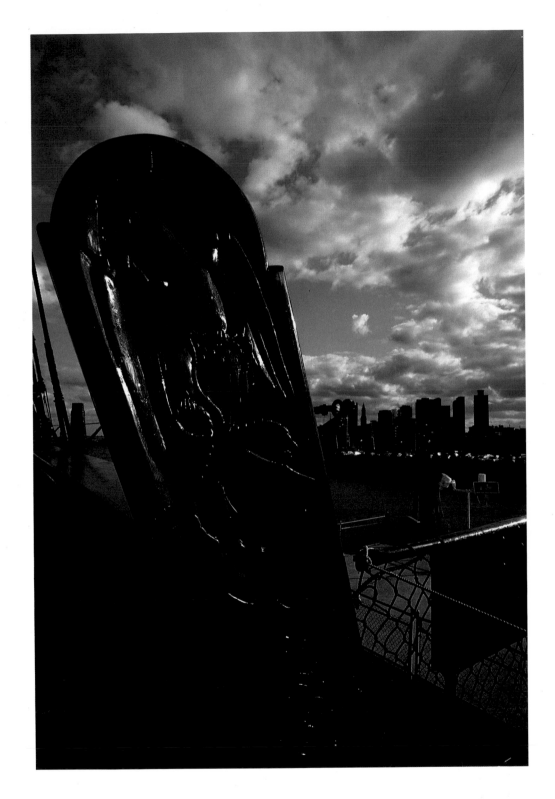

From the deck of the U.S.S. *Constitution*

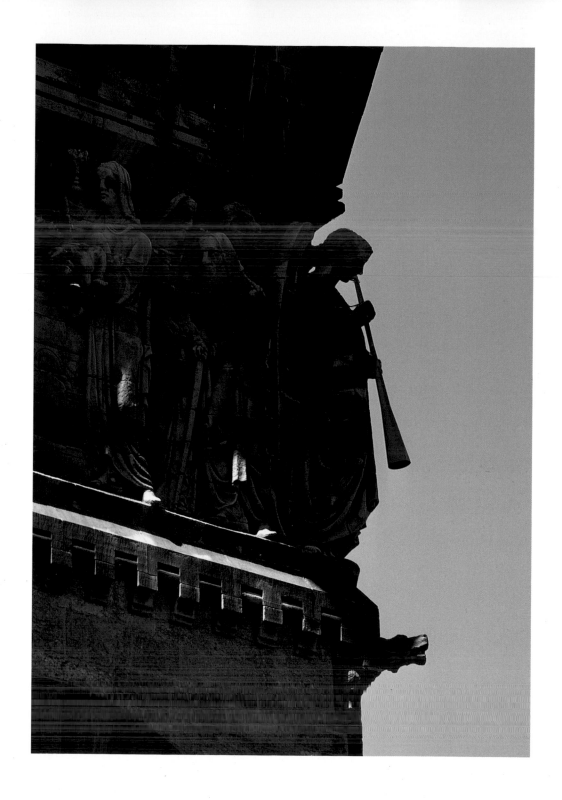

Page 188. First Baptist Church tower, detail
Page 189. First Church of Christ Scientist
Pages 190–91. Leaving Boston on the water shuttle

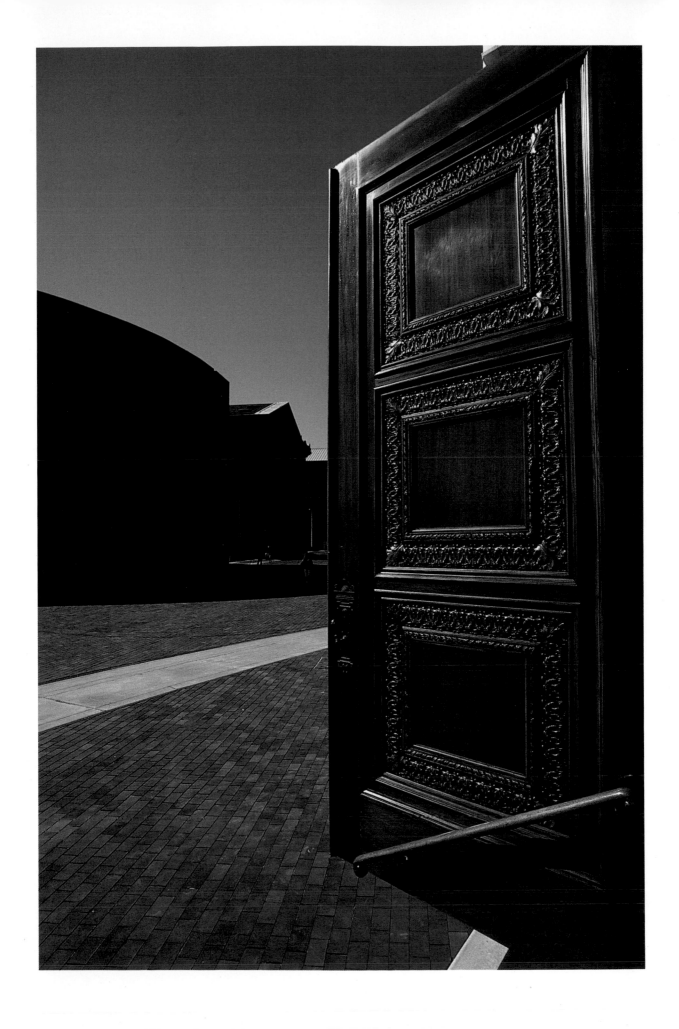

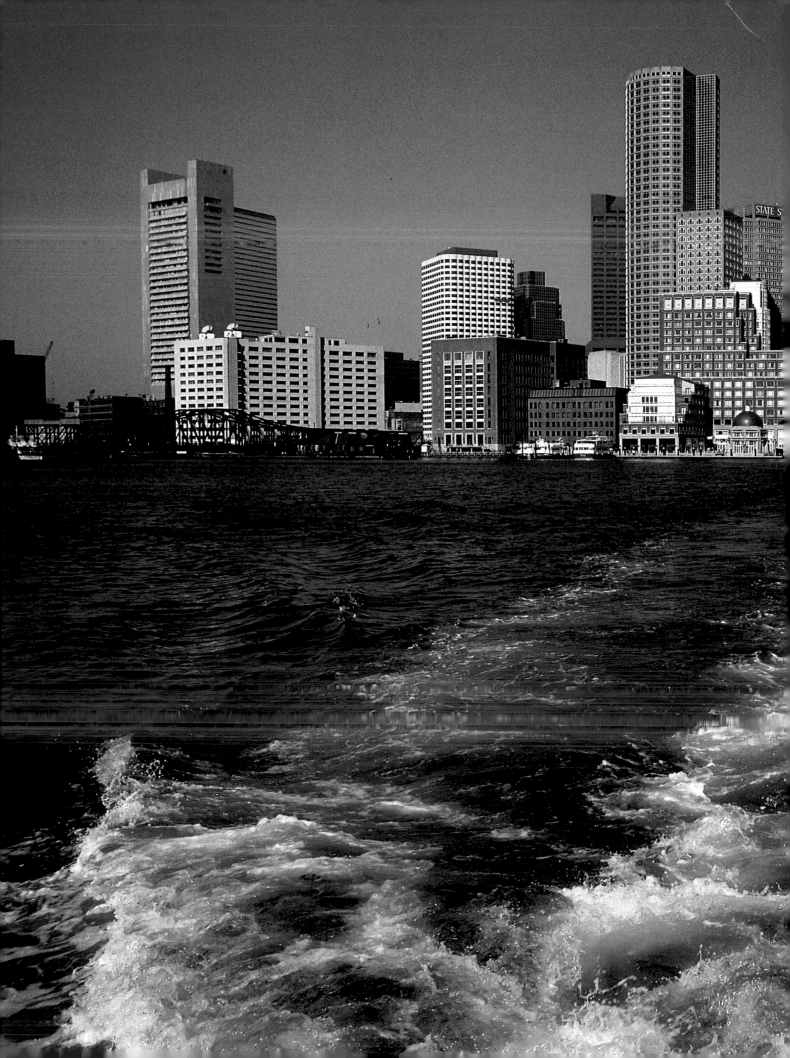

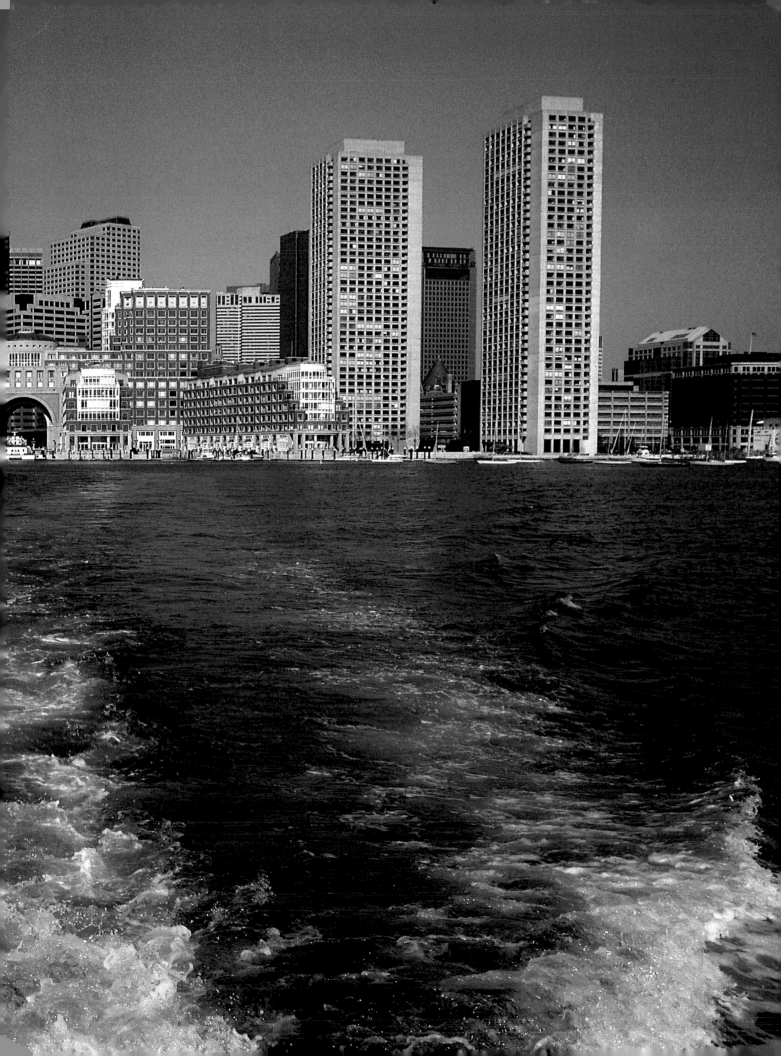

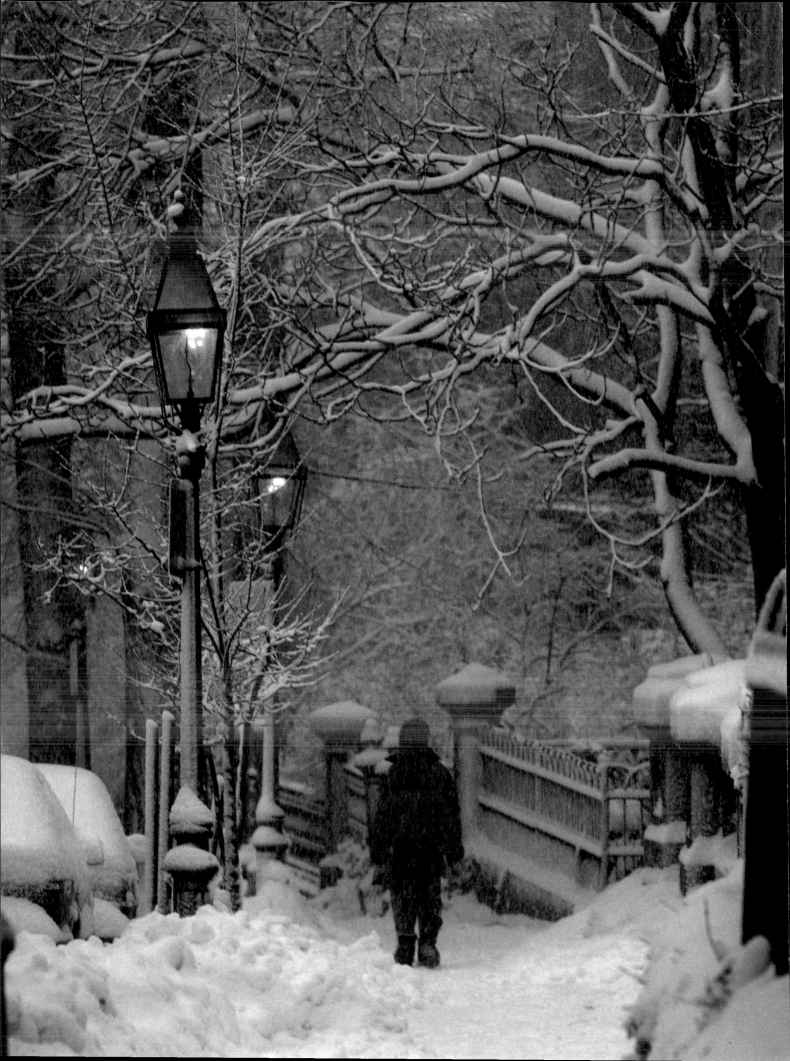

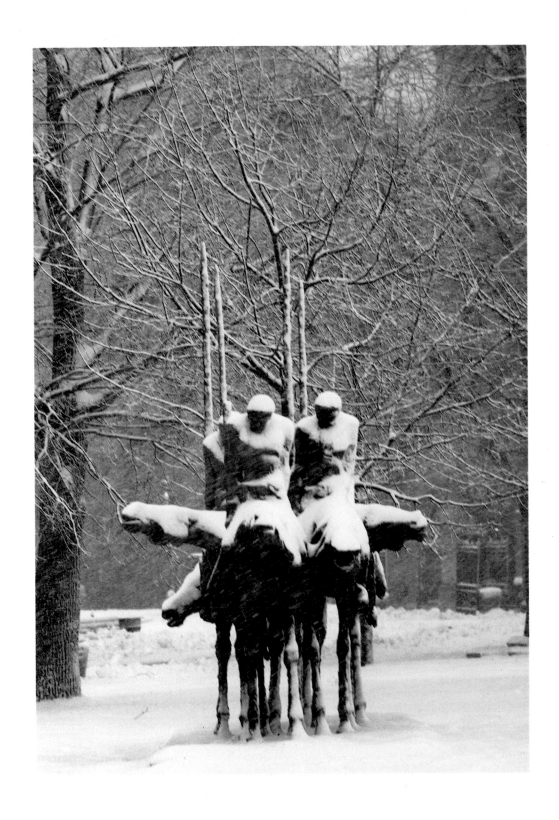

Page 192. Mount Vernon Street, Beacon Hill

Page 193. *Partisans,* by Andrzej P. Pitynski, Boston Common

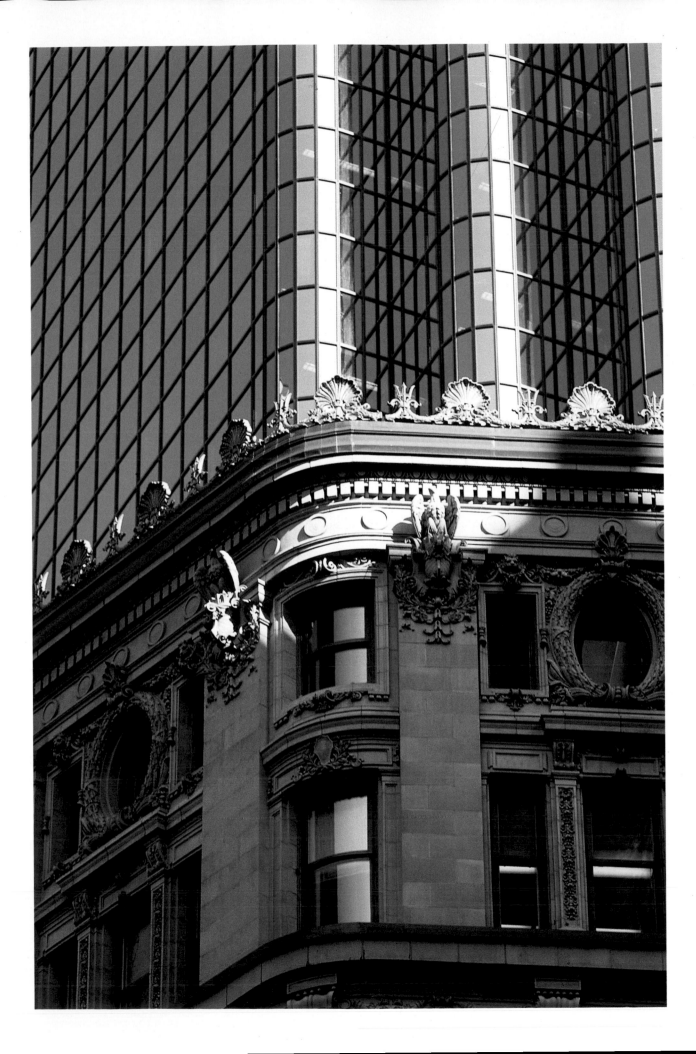

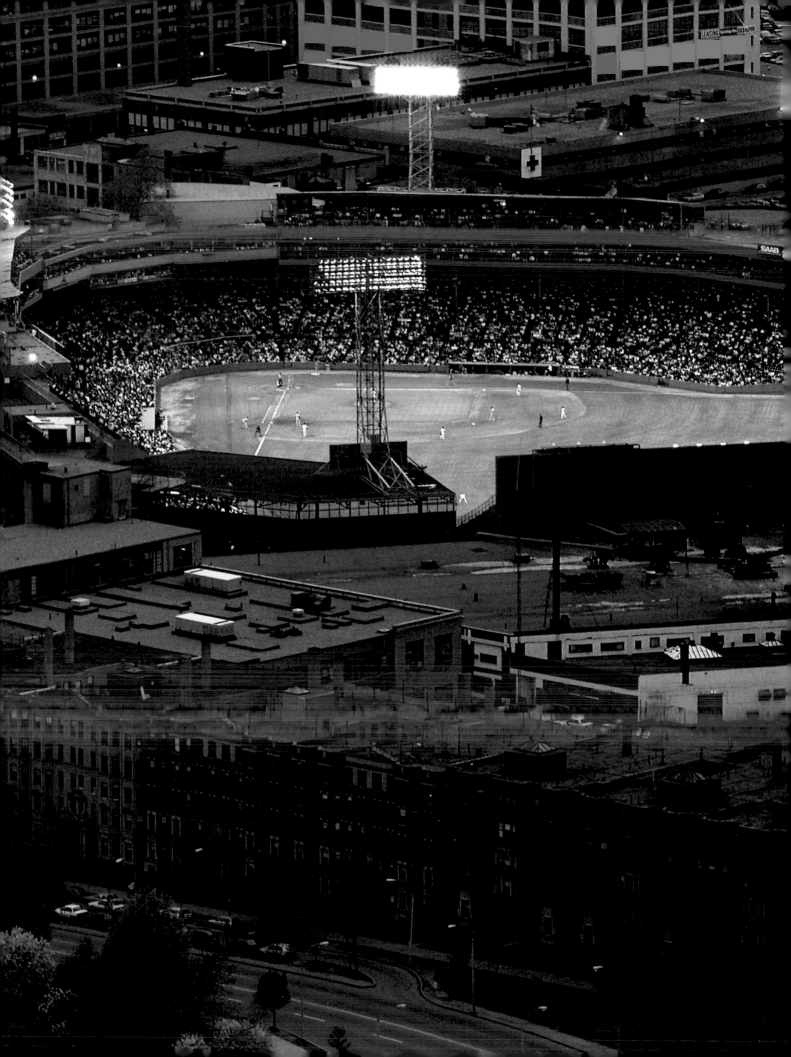

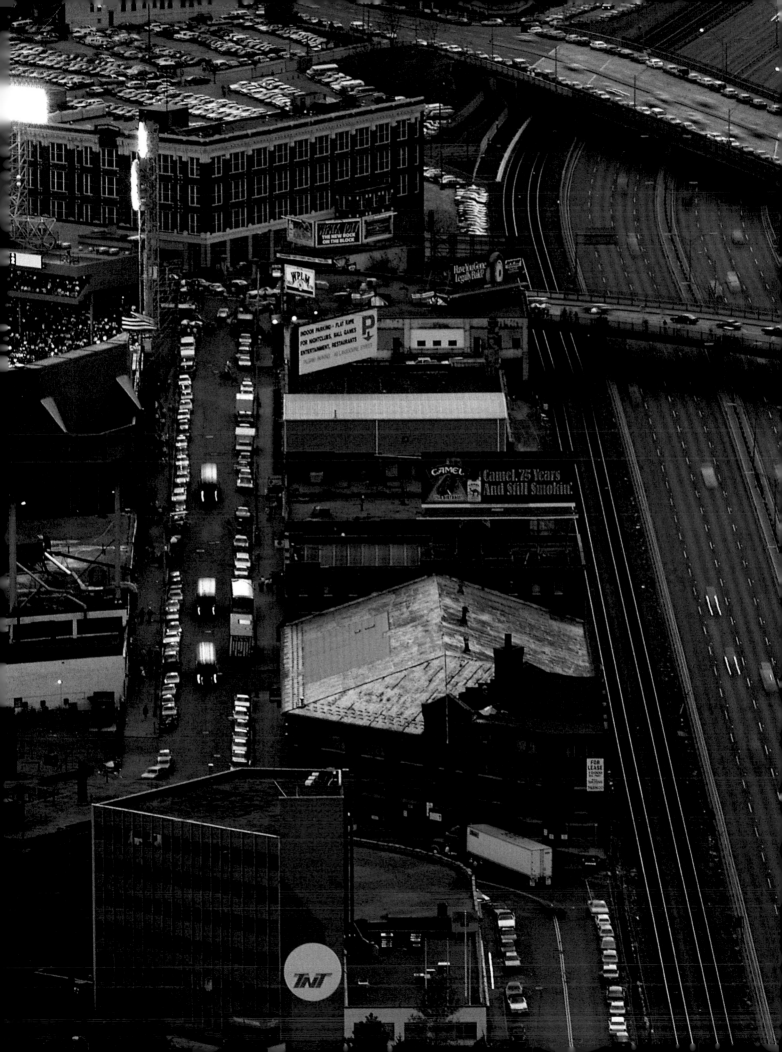

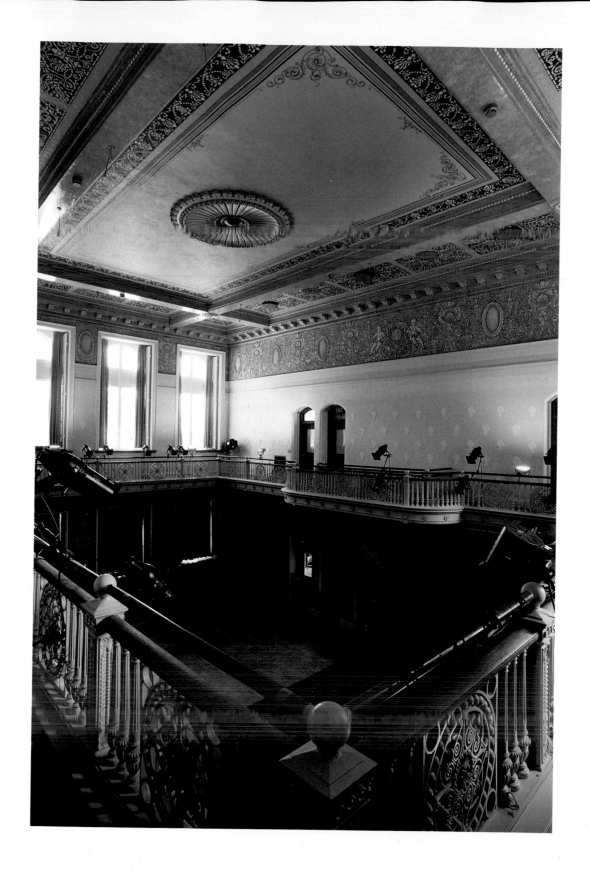

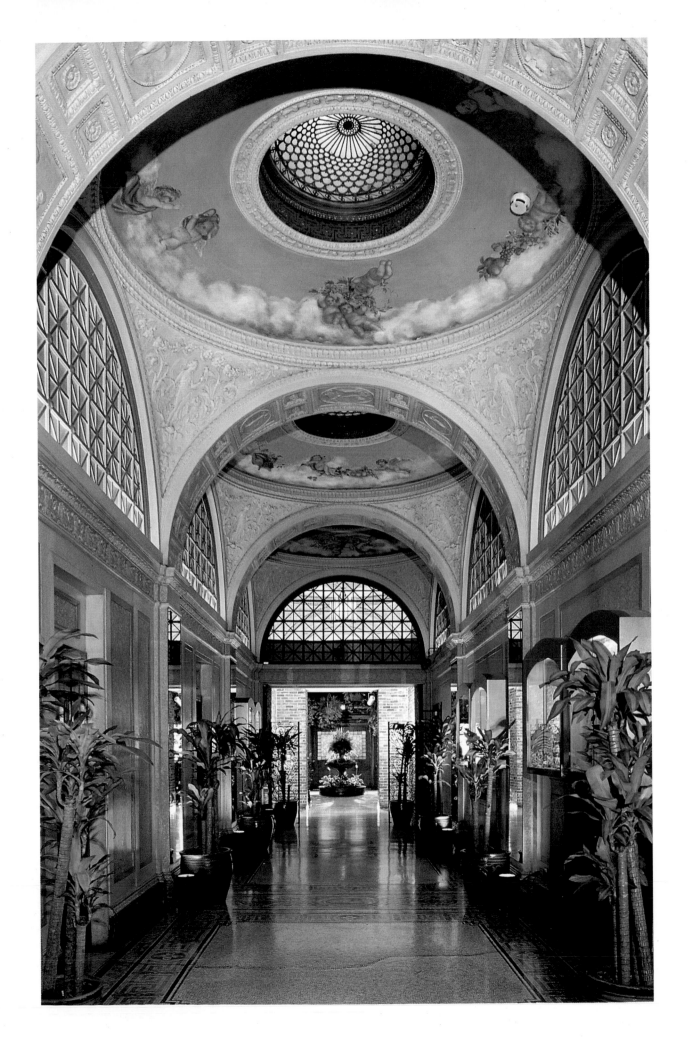

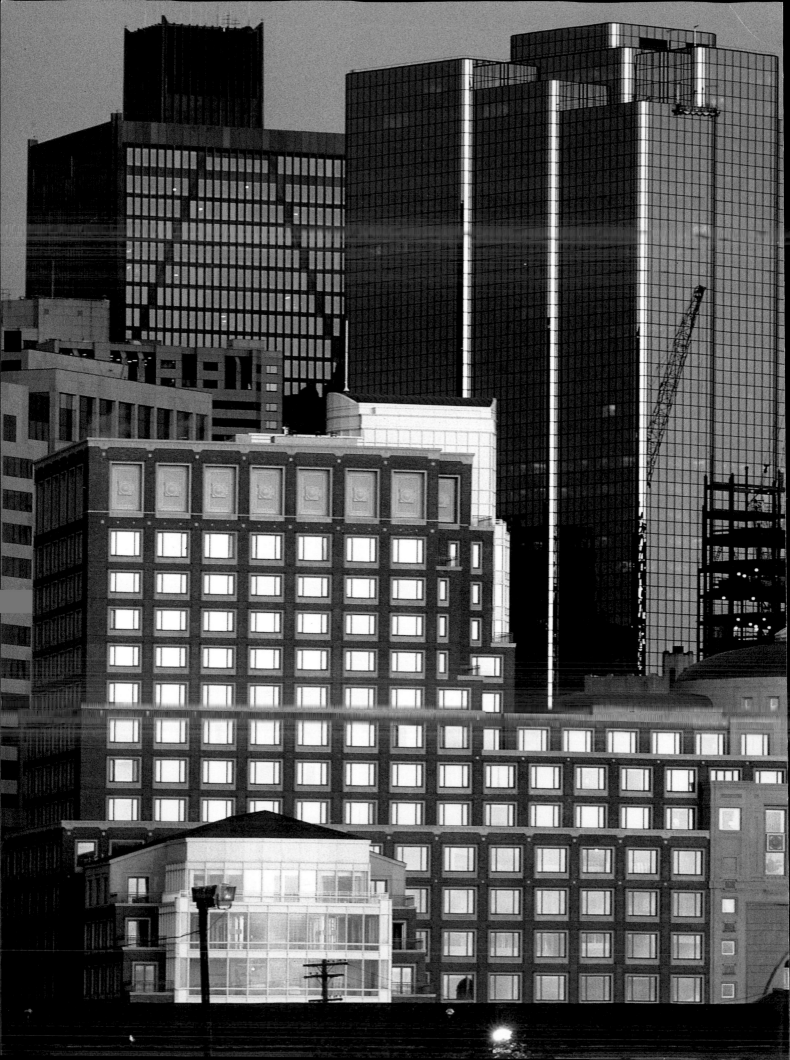

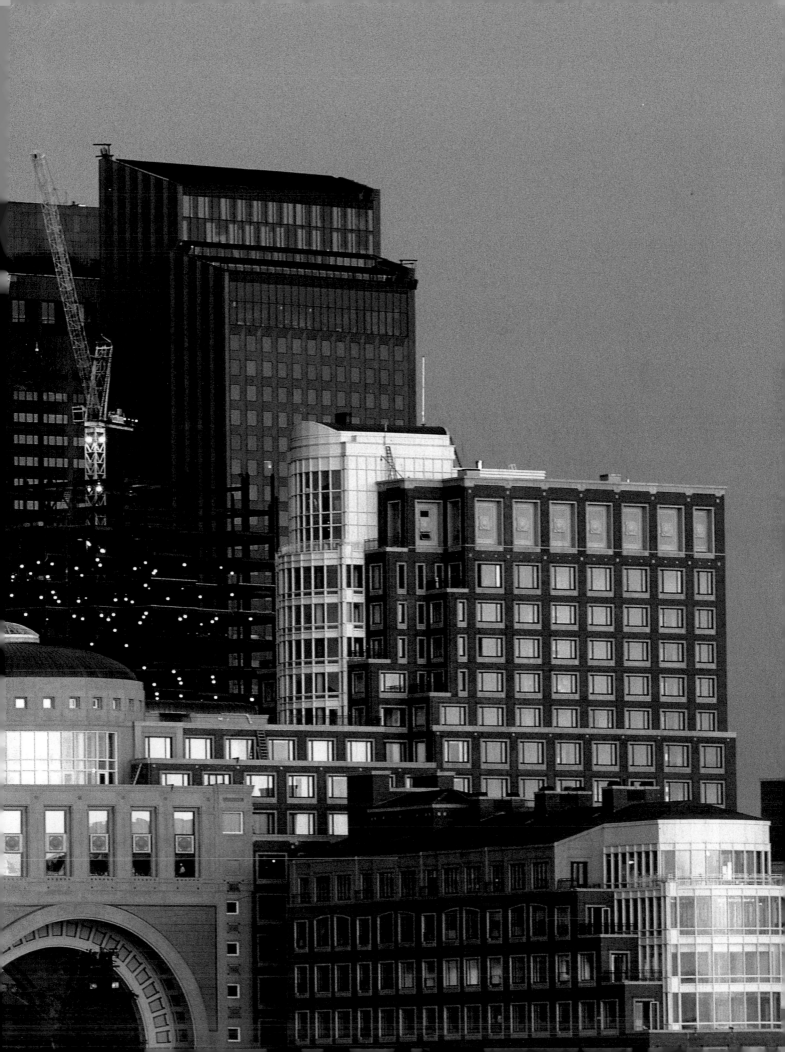

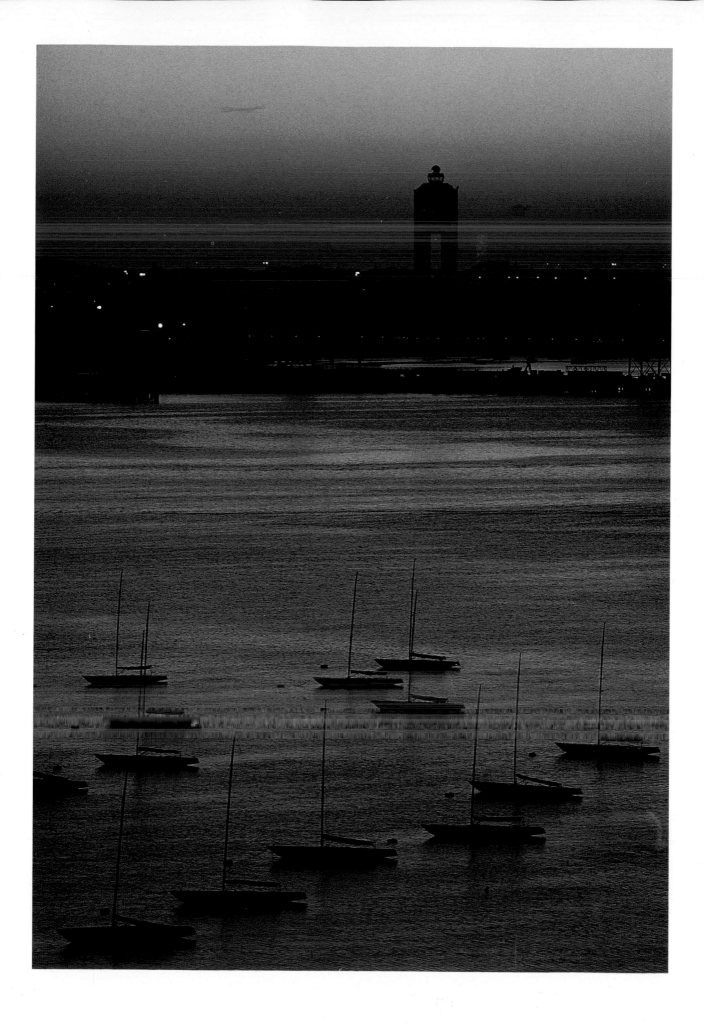

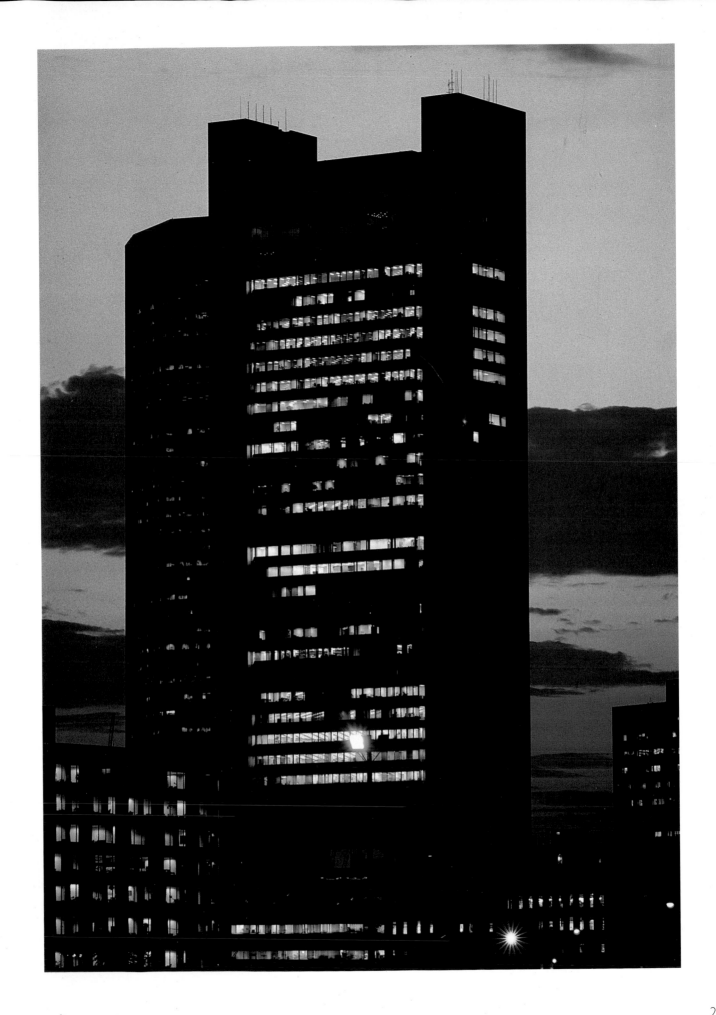

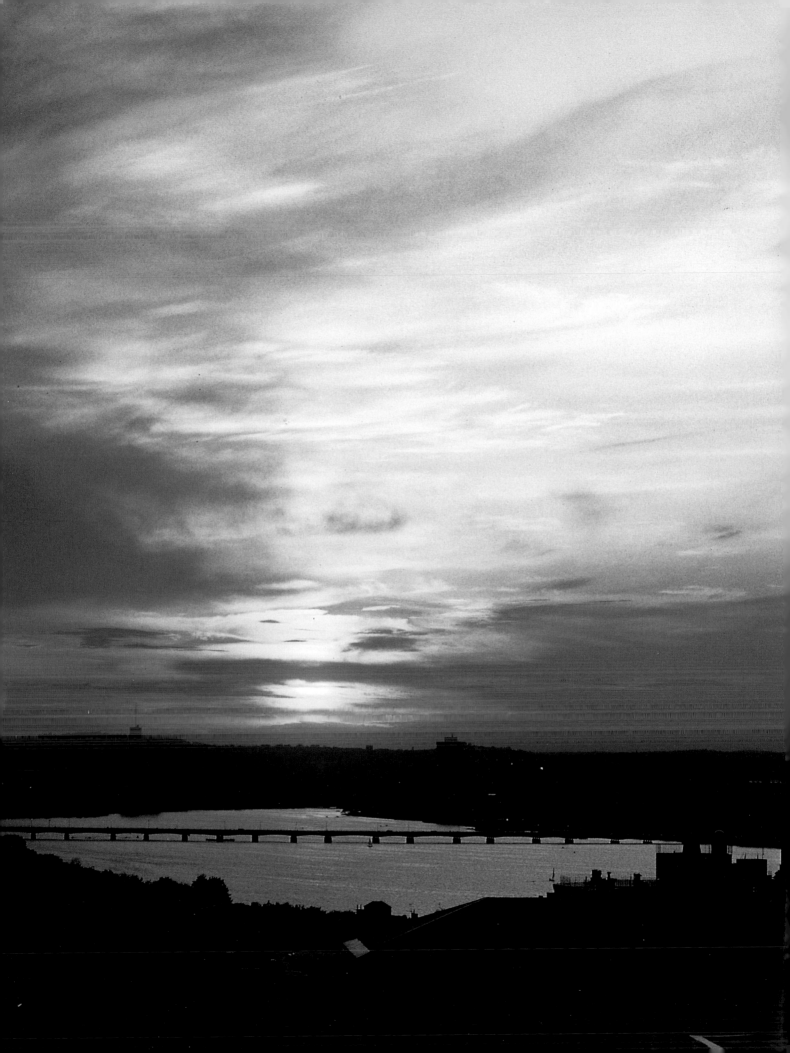

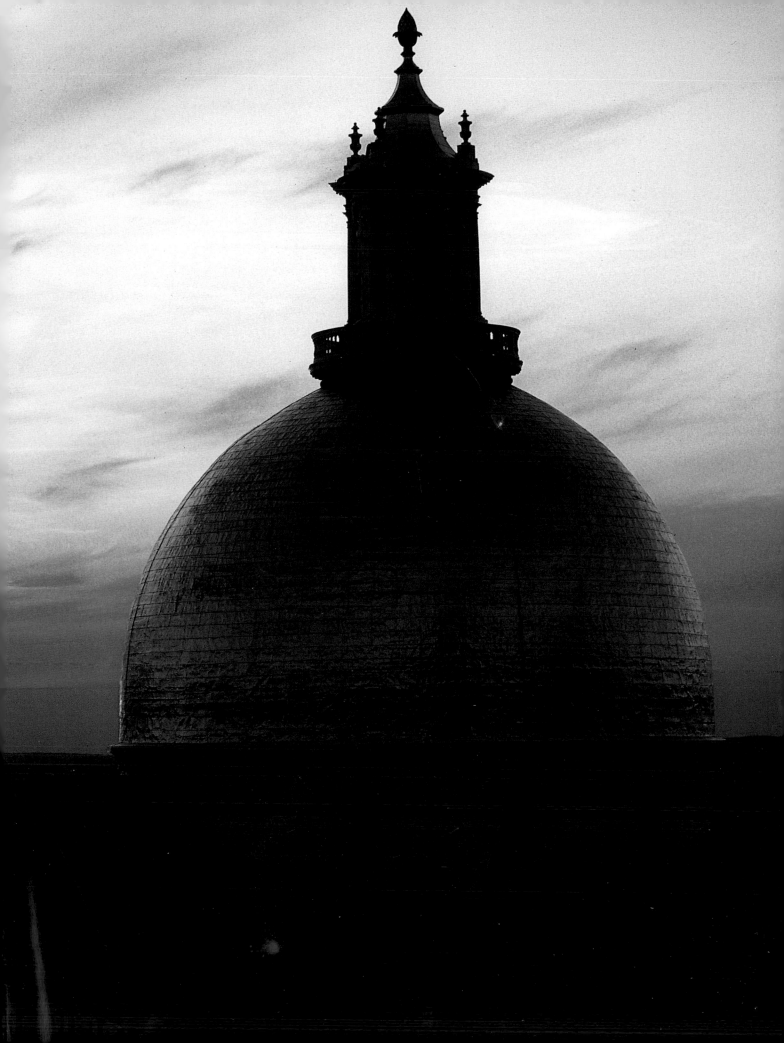

ACKNOWLEDGMENTS

To photograph a city is not an easy task, especially if one does not live there. There are hundreds of appointments to be made in preparation for each visit and thousands of sights to consider. Without the generous help of several friends I would not have been able to finish the project.

To these collaborators goes my appreciation and gratitude: Federico Antonucci, who came all the way from Italy to assist me; architect Rodolfo Machado, who acquainted me with some of the less well-known architecture of Boston; Tim Grafft of the Massachusetts Film Office, who showed me many good locations; and Noel S. Johnson of the City of Boston Office of the Arts and Humanities, who opened many closed doors.

Thank you to my publisher, Charles Miers; my editors, Jen Bilik and Jim Stave; the designer, Gilda Hannah; and the rest of the staff at Universe.

Very special thanks go to the Colonnade Hotel for its generous hospitality, and to the exceptional Thomas Boylston Adams, who gave enthusiastically of his time and knowledge and honors me with the magnificent introduction to this book.

Santi Visalli